# PROMOTION DESIGN THAT WORKS

Cheryl Dangel Cullen

ROCKPORT

# 38TH INTERNATIONAL FURNITURE FAIR OF VALENCIA SPAIN

From 24th to 29th September 2001

Septiembre de 2001

# PROMOTION DESIGN THAT WORKS
## Secrets for Successful Promotion Design

GLOUCESTER MASSACHUSETTS

ROCKPORT PUBLISHERS

Cheryl Dangel Cullen

First published in the United States of America by

Rockport Publishers, Inc.
33 Commercial Street
Gloucester, Massachusetts 01930-5089
Telephone: (978) 282-9590
Facsimile: (978) 283-2742

ISBN 1-56496-772-7

10 9 8 7 6 5 4 3 2 1

Design: Leeann Leftwich Zajas

Cover Image: Courtesy of Volkswagen of America

Printed in China.

# dedication

To Nancy and Jim—Without your encouragement and support, this book may never have been completed. We are deeply grateful.

C & R

# contents

# Introduction

What is the key to a successful promotion? Designers the world over could debate for hours without ever reaching any workable conclusion about what makes one campaign work and another fail miserably.

Is it money? Perhaps. A healthy budget can certainly buy more media, guaranteeing greater exposure, not to mention glitzy attention-getting printing, and a big, fat postage budget for a wide-ranging direct-mail campaign. But does that ensure success? Not always.

Of the twenty cutting-edge promotional campaigns in this book that actually proved they worked at reaching their target audience, few had budgets with more than a little room to spare. In fact, most succeeded despite their lean budgets. Why? Because limited funds seem to foster creative thinking; minds, not wallets, are allowed to prove their mettle.

That's not to say that promotions require only meager monies to succeed. Given that theory, clients around the world would be slashing budgets, leaving little but bread and water to sustain the creative minds they employ. No, successful promotions require something more.

The twenty promotional campaigns profiled here are vastly different, but they all share one thing in common besides success—a willingness to use a range of media to communicate. They don't rely on static graphic design alone. They incorporate everything from print, television, and radio advertising, direct mail, and signage to Web design, three-dimensional environments, and much more.

Some designers claim integrating all these aspects is key to a success, along with follow-up. Others claim that an element of fun, wit, and humor is paramount. Capturing the prospect's heart and mind is yet another tact. Others suggest surrounding yourself with talent.

Why did their promotion work? The designers profiled in this book share their thoughts:

"It addresses the bigger strategy issues versus just being nice graphics that decorate something."
—Sean Adams, AdamsMorioka.

"It [the promotion] made a huge splash and did everything it was supposed to do."
—Kelli Christman, Free Range Chicken Ranch

"It works because all the thinking was straight up front and it got rolled out without being
undermined or compromised."
—Frank Viva, Viva Dolan Communications and Design Inc.

"The promotion worked so well because it doesn't take itself too seriously. The campaign combines
a mixture of worktime and playtime and capitalizes on that."
—Michael Gorman, Square One Design

"The concepts, ideas, materials, and techniques used were innovative. Clutter continues to make it
hard for an advertiser's message to be noticed and harder still for it to be believed."
—Adele Wapnick, Cross Colours Ink

"This campaign worked ultimately because of the open communication Diesel Design developed with
[the client]. We were able to form an excellent understanding of Adomo's product and turn that into
a clearly communicated, distinguished brand."
—Amy Bainbridge, Diesel Design

"...an agency that was willing to give a 200 percent solution...We've given them the right tools to
make this campaign work on a continuing basis. That's why I think it really works."
—Ken Carbone, Carbone Smolan Agency

"The element of surprise has a lot to do with its success."
—Joshua Berger, Plazm Media

"...A successful promotion communicates a market position with unbridled enthusiasm. A great
campaign has a great personality and it has heart."
—Burkey Belser, Greenfield/Belser Ltd.

Their experience is vast. Their ideas are numerous. Their stories are ones you'll learn from and remember.

*Promotion Design That Works* takes all this good design advice a step further and adds the kind of cross-media
and marketing information that gives promotion and graphic designers the competitive edge.

How will you know you've succeeded? To paraphrase Larry Anderson, Hornall Anderson Design Works, "when you
hear word on the street that the competition is a little worried, then you know you've done a good job."

# SELF-PROMOTION FUELS TRADE SHOW EVENT

## The Client

"We needed something fun," remembers Chris West, art director on LPG Design's Performance Tested Graphics campaign that spotlighted the firm's creative capabilities to the automotive aftermarket industry, which is widely recognized as a lucrative market, albeit one that is also static and stale when it comes to graphic presentations. "We wanted something fun that would promote our point of view about design. It's a very dry market. You're selling hubcaps and transmissions. So, we were interested in ratcheting the excitement level up a little bit."

CLIENT:
LPG Design
(formerly Love Packaging Group)

DESIGN FIRM:
LPG Design

ART DIRECTOR:
Chris West

DESIGNERS:
Dustin Commer, Rick Gimlin, Lorna West

STRUCTURAL DESIGNER:
Mitch McCullough

PHOTOGRAPHER:
Jack Jacobs Photography

CAMPAIGN RUN:
October 1999 through March 2000

TARGET MARKET:
Automotive aftermarket business owners and/or marketing directors

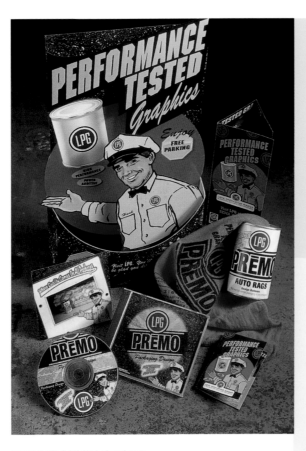

ABOVE: **A CD-ROM that played continuously in the booth during the show was also given away to interested parties wanting to learn more about the firm.**

## The Brief

A division of the Love Box Company, Wichita, Kansas–based LPG Design, formerly known as the Love Packaging Group, wanted to build on Love Box's reputation in the automotive aftermarket, where the corrugated manufacturer had made a name for itself. The SEMA (Specialty Equipment Market Association) trade show provided just the right opportunity to make a statement. Because of its relationship with the Love Box Company, LPG Design had plenty of experience designing corrugated packaging for the automotive market; now, its goal was to tap into that expertise and pursue the industry in its own right.

"Corrugated was our entrée into this market; it's huge and it needs improvement," explains West. However, complicating their message was that few prospects recognized that LPG Design did more than package design, it was also a full-service studio (which is one reason the firm subsequently changed its name officially from Love Packaging Group to LPG Design in October 1999). So, while their trade show message had to emphasize packaging, they also wanted to promote their capabilities with other collateral materials and advertising.

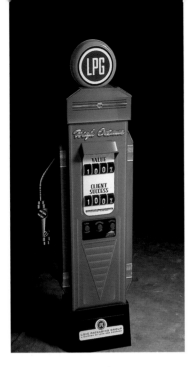

LEFT: Designers created and produced a full-size, 70 inch-tall x 22-inch-wide x 13-inch-deep (178 cm x 56 cm x 33 cm), 1940s-style gas pump constructed of corrugated substrated. Graphics came off a Displaymaker printer in four-color process before it was gloss laminated. Both the structural and graphic design of the piece included plug-in side panels, gas nozzle, laminated Mylar number wheels, plastic knobs, and mechanical workings, topped off with a 9 1/2-inch (24 cm) -diameter plastic globe displaying the LPG logo.

## Setting the Scene

The design team opted to pursue a multipart trade show campaign based on a retro, postwar service station theme. Designer/illustrator Rick Gimlin came up with the idea of creating a vintage gas pump of corrugated, and with that as the centerpiece item, designers quickly generated dozens of spin-off ideas.

Foremost, the team decided they needed a character to communicate their message and Gimlin created Hank, "your friendly service station attendant." Because the postwar-era gas station attendant is recognized as an American pop culture icon for incomparable quality, it was the perfect symbol for the campaign. "Remember the days when we had full-service gas attendants? That's what he represents," explains Jolynn Berk, account executive. The concept of full-service easily communicated LPG Design's core message, "meaning that we're reliable; we can provide all of your marketing needs. We're full service," she adds.

As the focal point of the campaign, Hank reinforced the slogan, "Performance Tested Graphics," which linked the automotive aftermarket with LPG's design capabilities in the minds of prospective clients. Designer Dustin Commer added the tagline—*Premo,* which he adapted from a 1920s advertisement he had seen. The word fit the theme perfectly, while communicating premium to its audience.

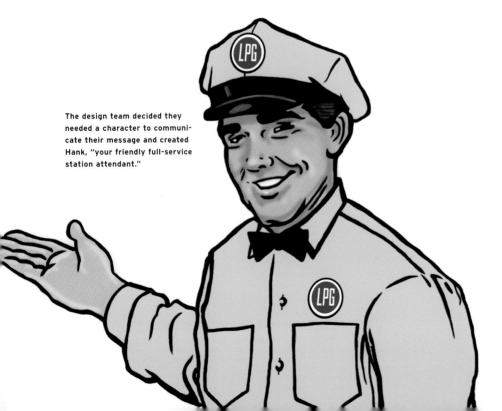

The design team decided they needed a character to communicate their message and created Hank, "your friendly full-service station attendant."

## Working with a Minimal Budget

While the campaign was a resounding success, it came with its share of challenges. LPG created this entire campaign in-house with the exception of screening the shop rag, purchasing the tin oil cans, and offset printing three brochures in four-color process—all of which were outsourced. Everything else was manufactured in-house, which allowed designers to produce a campaign with maximum impact with a minimal budget of $5000. Naturally, this covered only outside costs. All design work was completed during off-peak or downtime hours, while the box manufacturing capabilities were also absorbed in-house.

## Unusual Materials

The gas pump was among the trickiest pieces to produce, primarily due to its size. Commer's computer sketches went to the firm's structural division group on the Love Box side of the business, where it went through a few variations before it was finalized. From there, the design was sent via computer to a huge vacuum cutting table where the corrugated material was held in place while an automatic knife cut out the pieces like a jigsaw puzzle. "We have all of our pieces precisely die-cut on the cutting table, which is a competitive advantage we offer clients. If they have a prototype and they want to see something that is an idea or a concept, we can make their samples," says West.

In the meantime, the artwork was downloaded to a large format printer and was laminated to the corrugated. "When you deal with corrugated that is 70 inches (178 cm) tall and it's a three-dimensional subject, it is huge when you have it flat. So it was rather difficult to get it figured out, put together, and then get a print on it, laminate it, and get it assembled. But we were stretching the capabilities and that is what we have to show. We stretch the perimeters so that the client can see what we can do for them," adds West.

## The Creative Process

The biggest design challenge, according to West, was coming up with the whole marketing scheme in the first place and ensuring that all the elements that worked within the framework of LPG's communication goals while being fun and practical. "I think we did a good job integrating all the pieces," suggests Berk. "Everything is very well thought out as to what the purpose was for each piece."

So how did LPG integrate all these elements into one cohesive campaign? "We have a free flow of ideas and we work from a creative center. We start with our creativity and then we take the elements that need to be addressed within the scope of the project...and keep building on the theme. We had a specific agenda of elements that needed to be included in the whole scope of the project," says West. "We limited our designs to something we could afford and decided to be as creative as we could within that context."

"Everything we designed is producible," adds Commer. "Nothing is too far-fetched."

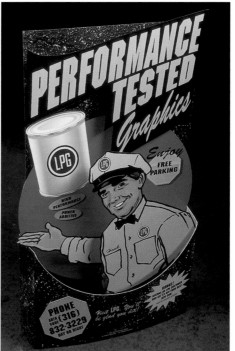

## The Build-Up

The campaign began with a teaser black-and-white, 1/8-page advertisement that ran in *SEMA News.* The preshow version with the headline, Performance Tested Graphics, listed LPG Design's booth number and appeared in the October and November 1999 issues; a second version, minus the booth information, appeared in the December 1999 as well as the January, February, and March 2000 issues.

Overlapping the advertising run, was a preshow mailer/ teaser that repeated the Performance Tested Graphics headline on a trifold brochure/invitation inviting show attendees to LPG Design's booth to take part in a customized giveaway offer: Visit the booth and register to win a miniature corrugated scale model of a vintage 1940s-style gas pump.

## At the Show

The theme was carried out further at LPG's booth. The show displays included numerous items primarily constructed of folding carton, a printable, white heavyweight card stock that is typically used for doughnut boxes, and corrugated, which is recognized by a sheet of fluting that is sandwiched between paper liners.

In the booth, Hank greeted visitors from a prominent 17-1/2" x 9-1/2" (44 cm x 24 cm) motion-activated display with vintage-inspired graphics using 22-point Carolina Board and a 3/16–inch (4.5 mm) foam core backing. A light-sensing device allowed Hank to wave Hi at passersby. The vintage signage again repeated the Performance Tested Graphics headline.

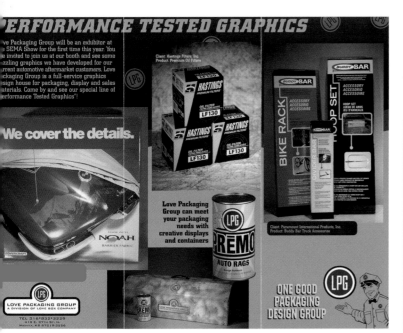

ABOVE: LPG Design created a preshow mailer that directed SEMA attendees directly to the firm's booth.

RIGHT: Hank, "your friendly full-service attendant," added personality to the campaign. Here, thanks to a light-sensor-activated motor, Hank's uniformed image waves at booth visitors from a 17-1/2" x 9-1/2" (44 cm x 24 cm) motion activated display with vintage-inspired graphics using 22-point Carolina Board and a 3/16-inch (4.5 mm) multiple plug-ins (graphic layers) gave the piece dimensionality for a total depth of 3 inches (8 cm).

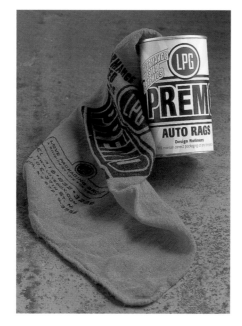

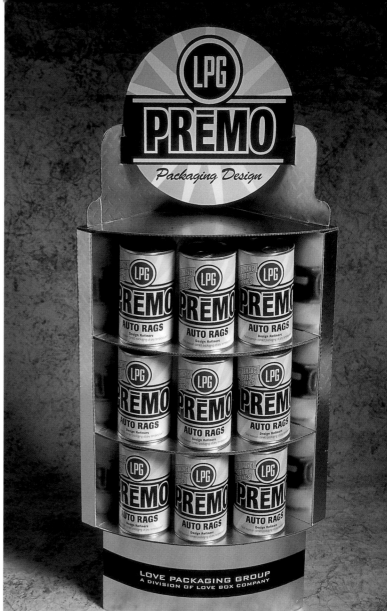

## Getting the Message Out

Nearby, LPG Premo brand oil cans were showcased in a replica of the steel, point-of-sale displays found in service stations. The display appears to be made of aluminum tread plate, but is actually made of corrugated that designers laminated with a silver foil. "We can't make a tread plate display, so we made it out of corrugated. That is what is so unique about it," says West. "We make corrugated look like aluminum or enameled metal or brushed aluminum. We try and push the envelope as to what corrugated can look like."

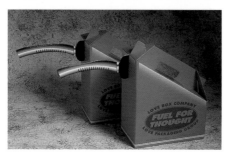

The cans were no ordinary oil cans, either. Open their pop-top and inside is a minia-ture pamphlet showcasing LPG's work in the aftermarket industry along with an authentic shop cloth that was screened with the LPG logo. The giveaway cans were distributed throughout the show—as an incentive to visit the booth—in a brushed-aluminum toolbox also made of corrugated and laminated with a brushed silver foil. The toolbox held about twenty-four cans.

Another show-stopping piece was LPG's gas can. Designers could have slapped their logo onto a plastic shopping bag, which is commonly seen at such trade shows for exhibitors to tote around all the literature and freebies they pick-up, but they weren't about to do anything so ordinary. They wanted to carry the gas station theme through everything—including the giveaway carryall, which they created to resem-ble a gas can, complete with a nozzle, using folding carton and corrugated. "We wanted something that could be used as a sales kit because that's another one of our direct-marketing tools that we have a lot of expertise in," says West. "We wanted to express our creativity in this arena so we took the whole idea one step further and created a device for collecting and carrying materials around. And, this one has a spout on it. How much more fun can you have with a sales kit?"

Of course, the centerpiece of the booth was the full-size, 1940s-style gas pump that inspired the entire campaign. Constructed predominantly of corrugated material, it stood 70 inches (178 cm) high and was topped with a round, plastic globe emblazoned with the LPG logo. The artwork for the pump was printed in four-color process on a large-format printer and laminated to the corrugated surface. Both the structural and graphic design of the piece included plug-in side panels, gas nozzle, and mechanical workings, topped off with the lighted globe that was perfectly accented by LPG's logo, which is also circular and sports a vintage styling.

An exact duplicate of the full-size gas pump was produced as a 40 percent scale model, measuring 30 inches (76 cm) high, 9 inches (23 cm) wide, and 5 1/4 inches (13.5 cm) deep. It was made of lighter gauge corrugated, but in all other details was an exact replica of the large version. After the show, LPG Design pulled a name from more than four hundred entrants who registered in the booth for the prize and designers then created and customized a tabletop version of the pump with the winner's name and logo, and then shipped the prize free of charge to their business.

## Taking LPG Home

In total, the show displays and giveaways proved to be ample demonstrations of LPG's capabilities. "These are all golden opportunities for a lot of direct-mail devices. It's a fun approach to showing what we can do with corrugated rather than just a box," says West. While all the fun twists on corrugated intrigued visitors, LPG Design did not want to ignore all of its noncarton and corrugated work done outside of the automotive industry and to reinforce its diverse capabilities, they produced a CD-ROM that played continually in the booth and was given away to interested parties wanted to learn more about the firm's creative efforts.

## The Finishing Touch

Capping off the campaign was a follow-up thank you that was hand delivered. From start to finish, the design portion of the campaign took approximately fifteen weeks.

ABOVE: LPG Design created a preshow mailer that directed SEMA attendees directly to the firm's booth.

LEFT: A follow-up thank you brochure was hand delivered after the show.

# The results

When the trade show ended, use of these promotional items continued as the campaign continued to gain new admirers. The six ad insertions resulted in forty-two qualified leads. More than 400 leads were generated from the gas pump giveaway registration. Qualified leads from booth attendance totaled 125. Moreover, seven new client contacts established at the event lead to further client meetings and work currently in progress.

"We even had people who wanted to buy the gas pump and put their own logo on it," says West, citing the fact that they received similar requests from the aftermarket for the toolbox. "In addition, we've been recognized nationally in graphic award publications, so from a designer's point-of-view, that's a measure of success. But from a strictly a bottom line point of view, it has generated a lot of interest in the corrugated end of our business with Love Box Company. It has also increased the awareness of what LPG Design and Love Box can do for a client in that particular market. So in our view, that is a level of success and if you look at our outlay costs, it was worth the investment"

## What Worked

So why does this promotion work so well? "I think all the pieces have to integrate well together and work well together in order to focus the theme throughout the entire campaign. And, of course, a very important element to the success of the campaign is follow-up. You can have a very successfully designed and implemented campaign, but if follow-up doesn't happen, the campaign won't be as successful as it could be," says Berk.

"It has an element of fun," cites West, as another reason for the promotion's success. What's his secret to a successful campaign? Simple—a clever use of graphics, concept, and design.

# Tips from the experts Integrated Pieces . . . Focused Theme . . . Follow-Up

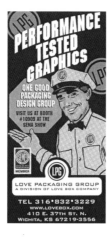
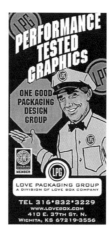
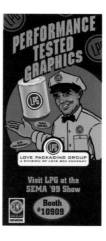
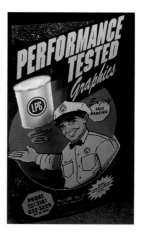

**GET THE WORD OUT EARLY**

Prior to the SEMA trade show, LPG Design ran a preshow black-and-white 1/8-page advertisement in the *SEMA News;* later, a second version without the booth information appeared in the publication.

**MAKE IT EASY TO FIND YOU, AND GIVE THEM INCENTIVE TO DO IT**

LPG Design created a preshow mailer that directed SEMA attendees to the firm's booth. Inside the mailer they not only took the opportunity to showcase their work, but they gave attendees a reason to visit them by offering a customized giveaway.

**CATCH THEIR EYE**

Hank, "your friendly full-service attendant," added personality to the campaign. Here, Hank's uniformed image waves at booth visitors from a 24" x 20" (61 cm x 51 cm) motion-activated display created of folding carton and corrugated, dressed-up with vintage-inspired graphics.

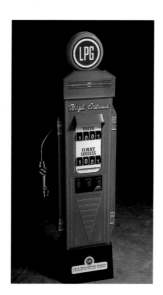

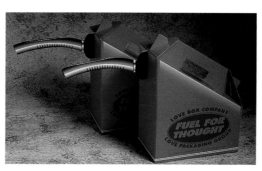

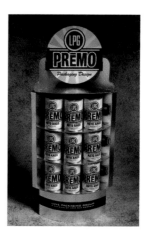

**PULL OUT ALL THE STOPS AND SHOW THEM WHAT YOU'RE CAPABLE OF**

Designers created and produced a full-size, 1940s-style gas pump constructed of corrugated and laminated with graphics printed in four-color process. The pump included plug-in side panels, gas nozzle, and mechanical workings, topped off with a lighted globe displaying the LPG logo.

**GIVE THEM SOMETHING THEY WON'T WANT TO THROW AWAY**

Designers wanted to carry the gas station theme through everything—including the giveaway carryall—which they created to resemble a gas can, complete with a nozzle, sporting the catch phrase Fuel for Thought.

**TAKE EVERY OPPORTUNITY TO DISPLAY YOUR CAPABILITIES**

A replica of a steel, point-of-purchase display holds the Premo oil cans at the booth. While the display appears to be made of aluminum tread plate, it is actually constructed of corrugated that has been laminated with a silver foil.

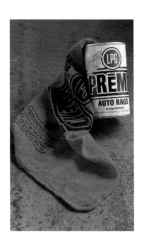

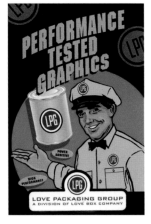

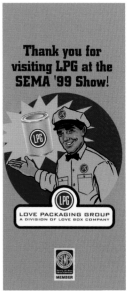

**MAKE THEM INTERACT TO KEEP THEIR ATTENTION**

Among the popular giveaways was a pop-top oil can that when opened revealed a minibrochure and an authentic shop cloth screened with the LPG logo.

**KEEP IT FUN, BUT DON'T FORGET YOUR MARKET**

Tucked into the oil can was a minibrochure showcasing LPG's work in the automotive aftermarket.

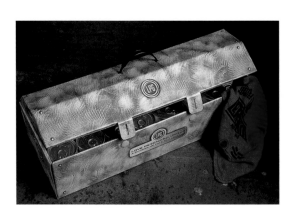

**MOBILIZE YOUR MESSAGE AND PULL THEM IN**

To distribute the cans as giveaways throughout the show—as an incentive to visit the booth—designers created a brushed-aluminum toolbox of corrugated that were laminated with silver foil and held about twenty-four cans.

**SHOW THEM YOU WANT THEIR BUSINESS**

After the show, LPG followed up with prospective clients by hand delivering a thank you brochure.

# IMAGERY CAMPAIGN
## TELEGRAPHS CLIENT INTO THE NEW CENTURY
(visual puns)

### The Client

HGV Design Consultants was given the job of creating an identity that would take the Telegraph Colour Library into the next century. The company's image needed a substantial facelift, having inherited its logotype from the *Telegraph* newspaper, which used an old-fashioned gothic script. The Library, which banks photographic images for sale to the media, graphic designers, and art buyers, needed a mark that would rejuvenate its appeal and assert its independence from the newspaper of the same name.

CLIENT:
Telegraph Colour Library

DESIGN FIRM:
HGV Design Consultants

ART DIRECTORS:
Pierre Vermeir, Jim Sutherland

DESIGNERS:
Dominic Edmunds, Mark Weathcroft, Pierre Vermeir, Jim Sutherland

PHOTOGRAPHER:
John Edwards

CAMPAIGN RUN:
1998 through 1999

TARGET MARKET:
Media, designers, art buyers

ABOVE: Images change as do their letter positions wherever the *Telegraph* logotype appears.

### The Brief

Designers conducted a visual audit of the competition searching for commonalties, differences, and inspiration, and in doing so, discovered that despite the arsenal of imagery at their disposal, none of the other photo libraries in the United Kingdom used graphics in their identity. If HGV designers could craft an identity from the Library's photographic imagery, they would not only differentiate their client from its competitors, but showcase the variety and quality of its products as well.

LEFT: **Proofs are sent in this yellow envelope when a loupe replaces the second e in Telegraph.**

BELOW: **No detail was overlooked as demonstrated by this mailing envelope with the copy "urgent photographic submission enclosed," which is reinforced by an image of a rocket replacing the *R* in Telegraph.**

## Selling to Designers

What would catch the eye and appeal to discriminating, visually literate media, design, and advertising agencies? That was the question at hand when HGV took on the assignment. The Library's target market is regularly assaulted with all kinds of gimmicky mailers and graphics that not only seize your attention, but refuse to let go. What could designers possibly dream up that would have the ability to compete visually in such a competitive market?

Designers grappled with the problem before finding their solution in taking a fresh approach based on using the library's own products as photographic puns to express its innovation and creativity. The idea was a winner. Not only did it look fresh and innovative, but with each successive incarnation of the logo, another image from the Telegraph Colour Library's bank of photos was advertised—successfully demonstrating just how varied the collection is.

new year, same
staff, new identity,
same service,
new images, same
day delivery, new
catalogues, same
quality, new cds,
same sweets...

**ROYAL MAIL**

**1**

POSTAGE PAID

LONDON
HQ 4605

**telegraph colour library**
the innovation centre
225 marsh wall
london e14 9fx
**sales direct line** 0171 293 2929
fax 0171 538 3309

## Creating Visual Puns

Designers tackled the job with a mix of design savvy and humor. The result: a logotype that uses cut-out photographic images as visual puns to replace letters within the word *telegraph*. Only the letters *t* and *h* would remain as static sentinels to give consistency to the campaign, the other letters in the word would be interchanged with images as deemed appropriate.

"The new identity had to communicate the experience of dealing with the Telegraph account handlers all of whom are extremely helpful, friendly, and interested in the creative services sector. Ideally, the identity also had to express the size of the image bank, a staggering 300,000 images to choose from," says Pierre Vermeir, who worked on the project along with other creatives. "Using cut-out images communicated fun and friendliness and was flexible enough to demonstrate the versatility and breadth of the library."

ABOVE AND RIGHT: **A postcard mailing rings in the New Year and proclaims a new identity and new images, but with the same staff and the same quality. Surprisingly, the logotype on the front of the card replaces all but two letters with photographic images.**

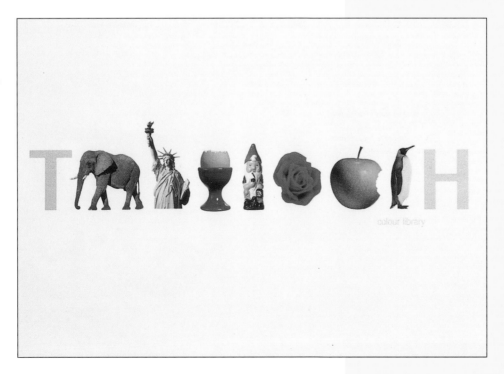

colour library

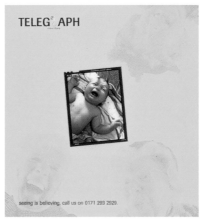

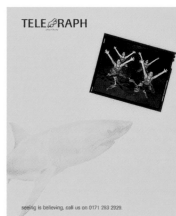

## Cut-Outs That Cut Up

The team individually designed each item of stationery and promotional marketing materials and fully exploited the new identity, capitalizing on the fun aspect of the identity and tying in the copy, images, and visual puns to the logotype. Equally important, the library's friendly service and immense range is suggested through the photographic puns used throughout the campaign.

All of the marketing materials were targeted to the creative services industry, business-to-business, and publishing sectors, and included product catalogs, direct mail pieces, print advertising, calendars, and gift items.

Designers didn't randomly pull images for the identity but took care to match the right visual pun with its relevant application. For instance, the logotype shown on an invoice uses a cutout image of an abacus while mailing envelopes showcase either a mailbox or a pigeon.

The print advertising demonstrates designers' wit by using existing images, which interact with the logotype, such as a child reaching for the udders of a cow.

The library's Elvis mailer uses existing *Telegraph* images of Las Vegas combined with related copy and photographs of an Elvis impersonator to promote a competition where the winner receives a trip to the gaming capital.

The dog and bone mailer also uses existing *Telegraph* images and relevant copy to promote the launch of a new catalog. The sports image catalog relies upon a pool game's eight ball set within the logotype; the piece was launched at a party held at a sports bar where Telegraph Colour Library clients received a magic eight ball as a gift.

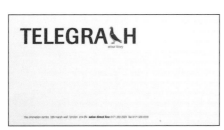

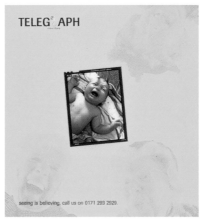

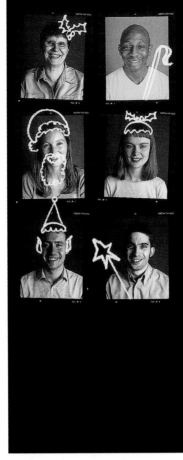

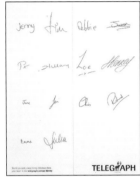

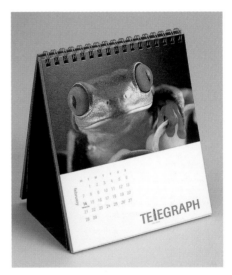

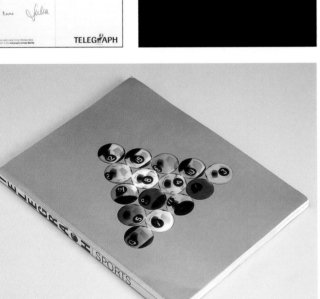

ABOVE: A catalog of sports images relies upon a pool game's eight ball set within the logotype; the piece was launched at a party held at a sports restaurant where Telegraph Colour Library clients received a magic eight ball as a gift.

## Integration

The identity, promotional materials, and the launch of new catalogs were all related. Designers ensured that the identity always used a relevant visual pun in the logotype, and where possible, the copy, imagery and format were designed to communicate the client's key messages: fun, friendly service and a broad range of photographic images to choose from.

Designers applied the logotype consistently across all applications, while demonstrating flexibility by taking different approaches, using unexpected imagery, and applying them to different promotional items. "The promotional materials were targeted to creatives, very sophisticated judges of graphic design, so they had to appear fresh, fun, and highly creative whilst championing the new logotype," says Vermier.

RIGHT: A sheet of stickers with Telegraph's address, sales line, and fax number prompt second looks thanks to the ladybug that is crawling across the company logotype.

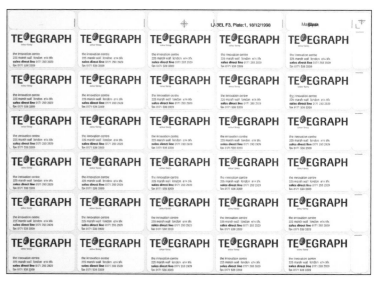

## The Budget

The overall budget for the new identity, application to catalogs, and promotional items was in excess of £65,000 or approximately $93,000. For designers, the budget was very workable given the scope of the job. "The initial budget was set out in the design proposal submitted to the client before any work was commissioned. In this way, HGV was able to design and implement all items within the scope of the budget across two years of launching the new identity," says Vermier.

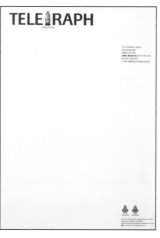

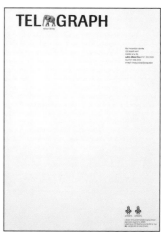

RIGHT: A sheet of notepaper features an apple where the A should be in Telegraph.

RIGHT: Instead of a bone, this dog carries in his mouth information from the Telegraph Colour Library. The direct-mail piece encourages recipients to request the company's new Stock 8 catalog. A British red phone booth, the icon used in the logo, subliminally messages the recipient, "Call us."

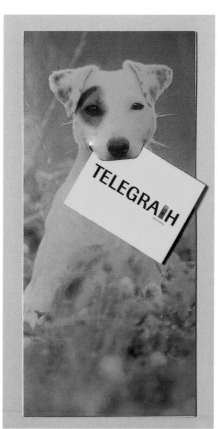

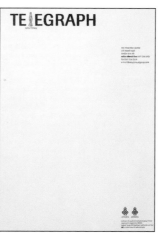

ABOVE LEFT AND RIGHT, AND LEFT: Three different sheets of letterhead each contain a different image including an elephant, a lava lamp, and a gnome.

# The results

When the new identity with its vibrant yellow signature debuted, it received an overwhelmingly positive response from 90 percent of existing library users, while telephone inquiries climbed by 40 percent as the result of the campaign. Likewise, clients responded positively as evidenced by the fact that image searches increased 30 percent and responses to direct mail also climbed—as a direct result of the campaign.

"It is interesting to note that each time a promotional mailer or a calendar was distributed to the client database of 20,000 people, sales of the *Telegraph* images shown increased," says Vermier.

## What Worked

Quite simply, the promotion worked because the target market responded to the wit and humor inherent in the new identity, especially in light of the fact that previous marketing pieces had long since become staid, dull, and predictable—especially to an audience consisting of creative-service industry professionals who are accustomed to being enticed by exciting, creative mailers.

# ABSTRACT GRAPHICS (pattern graphics)
# IDENTIFY DIVERSE PRODUCTS AS A COLLECTION

## The Client

One company came from France and the other from England to form Arjo Wiggins, the second largest paper company in the world. One of the company's brands, Argo Wiggins Fine Papers, is widely recognized throughout Europe where it enjoys high visibility and name recognition in the design community. So when the company decided to bring six of its most unique papers to North America, they thought they could follow the same marketing strategy that served them so well in Europe all these years.

Not so fast, cautioned Frank Viva, creative director, Viva Dolan, who recommended against marketing their products to North America by following the same tact that worked in Europe. Why? While the company was widely known throughout Europe, few designers in North America were familiar with its name, let alone its products.

**CLIENT:**
Curious Paper Corporation/
Arjo Wiggins Fine Papers

**DESIGN FIRM:**
Viva Dolan Communications
and Design Inc.

**ART DIRECTOR:**
Frank Viva

**DESIGNERS:**
Frank Viva, Dominic Ayre,
Natalie Cusson, Pam Lostracco

**ILLUSTRATOR/PHOTOGRAPHER:**
Photonica

**COPYWRITER:**
Doug Dolan

**CAMPAIGN RUN:**
1999 through 2000

**TARGET MARKET:**
Graphic designers

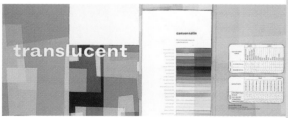

TOP AND BOTTOM: **The pattern created by Viva Dolan for Canson Satin, a translucent sheet, highlights the paper's transparent overlaying squares of color.**

## The Brief

Arjo Wiggins wanted to launch six new products on a very lean budget, which would be nearly impossible to accomplish successfully. Instead of launching six individual products, Viva Dolan counseled the company to package all six products under one new name. More important, the budget could support one brand adequately; if it was used for six individual launches, the budget would be spread too thin.

The idea didn't fly the way designers hoped it would. "We had one champion here who believed in our strategy, but others in England and France were very reticent because they were aware of the whole brand history. Some of these papers have a history dating back over a hundred years, Conqueror, in particular," says Viva. "It was hard for them to get out of that mindset of understanding the paper so intimately and its quirky history and the quirky history that lead to its current day branding. There was a bit of a fight, but they really didn't have the budget to launch and build equity in six new brands new to the North American market. They really only had the budget to, at the very best, build equity in one brand."

Viva Dolan suggested one overarching brand that would include all six grades of paper—Popset, Keaykolour Metallics, Canson Satin, Sensation, Conqueror, and LightSpeck—and proposed launching them to the design community as elements of the Curious Paper Collection. "We invented the Curious Paper name because it was a very diverse collection of papers. The grades are very unusual and very unique," says Viva, citing a shimmery letterhead paper that seemingly flips back and forth between colors. "There is nothing else available in North America like that."

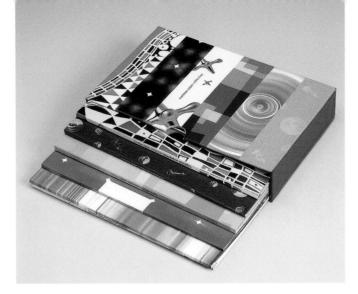

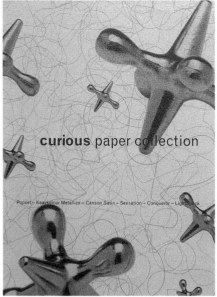

ABOVE: Swatch books for each of six grades of paper are presented in a slipcase as the Curious Paper Collection.

## Creating an Umbrella Brand

By placing all the grades under one umbrella collection, new, unusual papers could be added easily. Moreover, Viva wanted the single brand to draw attention to the fact that Arjo Wiggins is an innovator in paper technology. "We wanted whatever brand we came up with to speak to that issue, be memorable, and have positive associations in the North American design community," Viva adds.

The team at Viva Dolan developed a strategy to introduce the six grades of paper. Their recommendation: Organize the swatch books in such a way that designers only have to remember one name. From a design point of view, they also knew they had to craft a graphic element that tied the diverse stocks together. They found that if they could create a series of patterns for each paper, the six individual sheets would appear to be a system of papers. The patterns bring into focus the papers' unique characteristics. For example, Canson Translucent has transparent overlaying squares of color, which the pattern only accents. The same is true of Sensation, a sheet that reproduces full color very well even though it is uncoated and Keaykolour Metallics, which is distinguished by metallic flecks throughout the pattern.

While the graphic elements were paramount, Viva says that the use of humor throughout was equally important. The pieces don't take themselves too seriously and include sly reference to the curious aspect of the promotion including taglines on ads like, "Printed on one of the five colors of Popset Cover (we're curious to know which one)."

ABOVE, RIGHT, AND TOP RIGHT: Viva Dolan would have liked to blanket every issue of every design magazine, but the budget didn't allow for many media buys. Instead, they created ad inserts that ran seven times during a twelve-month period in targeted magazines.

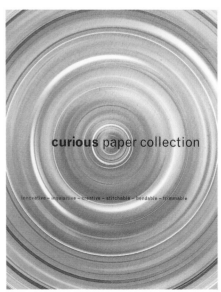

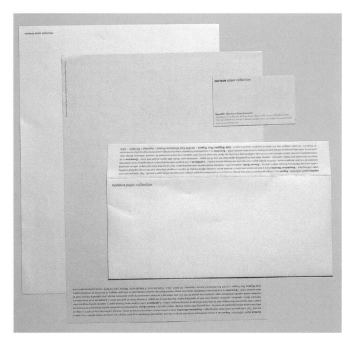

## Presenting a Collection

When rolled out, The Curious Paper Collection included a collection of individual sales items. The six swatch books were presented in an elegant slipcase—giving the impression of a paper resource. Other items included a stationery system, an advertising campaign consisting of full-page color ad inserts printed on Curious Paper grades, a detailed Web site that works for printers and designers at www.curiouspapers.com, and the Curious Designer Awards booklet, which perhaps is the best example of Viva Dolan's injection of humor into the project.

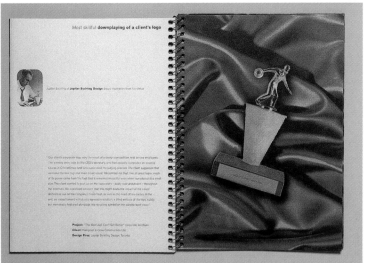

## The Budget

Even though they were gearing up for one launch, not six, the budget was still lean. Each grade still needed its own swatch book, which is among the most expensive items to produce because of its complexity including tricky folds, tiered waterfalls, and in this case, a slipcase that housed the books as a collection. Costs also escalate when special printing techniques are included that that show the paper performing at its best.

Designers recognized that some items would be costly. Yet, the team contained costs where they could without compromising the overall effort. Careful planning was key to their wise spending. They chose their media buys after reviewing the editorial content of targeted magazines. They strategically chose the best issues based on the most widely read and those that tied into paper concerns or color issues. "We would have liked to blanket every issue, but the funds didn't exist," says Viva. All totaled, they ran seven ads during a twelve-month period in major design magazines such as *Communication Arts* and *How*.

With plenty of forethought, they optimized the swatch books to make them exciting and interesting stand-alone paper promotions, reducing the need for additional collateral pieces before and after their debut. "We hope that the swatch books, besides being a tool, will ignite the imagination and build the Curious brand. We tried to make the swatch book work a little harder on the promotional side," Viva says.

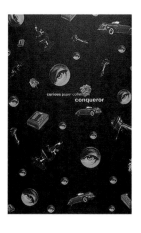
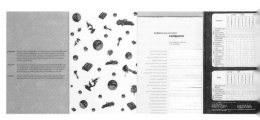

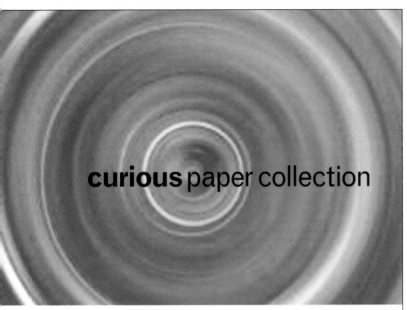

# curious paper collection

click if you're curious

## Finding a Common Thread

Selling the European company on the new direction—consolidating six papers into a single brand—was difficult. Anticipating this, Viva Dolan had strong arguments to support their stand. "They wanted to launch all these brands simultaneously. It just wouldn't be memorable. I can't believe that any designer in North America could be expected to remember all six of those names, so we tried to make it easy for the design community by housing the books in one slipcase and giving them only one name to remember," says Viva.

Once they had their okay to proceed, the next problem was how best to organize a collection of fine papers, all with existing brands into a cohesive memorable unit. "Each paper had a brand legacy in Europe that the client wanted to carry forward in North America. We convinced them to start fresh because there was no equity here," Viva explains.

"It seemed on the face of it to be a huge, insurmountable problem because there were all these existing brands and they all did have their own unique identities," he says. Some stocks came from France and some came from Britain, while others were cutting-edge-of-the-minute fashion papers and some were more traditional content, letterhead papers. Designers grappled at finding a common thread that would hold all these diverse papers together.

"We knew the strategy of launching one brand instead of six was right, but what's the glue that holds them all together?" asks Viva. "We couldn't hang our hat on an historic aesthetic because of the high fashion, of-the-moment papers, and we couldn't go that way because of the historical aspect." With no clear-cut solution, designers chose to use abstract graphics—a pattern—as the graphic middle ground that visually holds the diverse collection of papers together as a system. "There was nothing else—culturally or emotionally—that would work."

ABOVE AND RIGHT TOP, MIDDLE, AND BOTTOM: The Curious Paper Collection's Web site, www.curiouspapers.com, is geared to designers and printers alike.

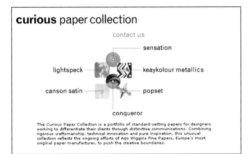

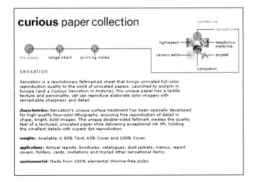

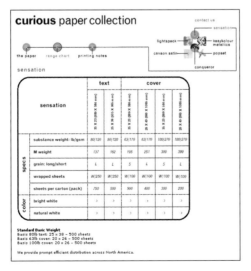

curious paper collection
popset

LEFT AND BELOW: **Popset is a unique pearlescent sheet that appears to alternate between different colors in shifting light.**

curious paper collection
sensation

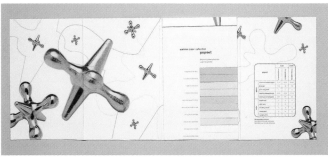

**RIGHT AND BELOW: Sensation reproduces full color very well even though it is an uncoated sheet, so a vivid color pattern was used as its identifying graphic.**

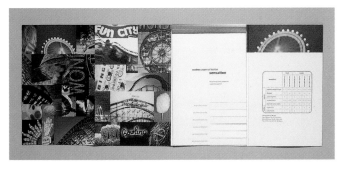

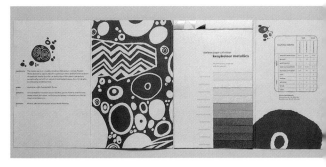

**ABOVE AND LEFT: Keaykolour Metallics is distinguished by metallic flecks throughout the stock, so a metallic pattern was chosen for its identity.**

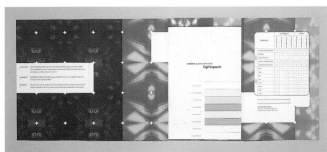

**ABOVE AND RIGHT: LightSpeck, one of the six Curious Papers, is the "original white-flecked" paper, according to company literature.**

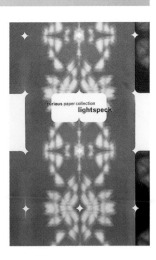

curious paper collection
lightspeck

# The results

Designers are certainly curious about the Curious Paper Collection. Tonnage sold has exceeded the year-end target by a margin of 45 percent. Paper merchant specification reps say it is memorable, and it has won industry awards. Operators logged in an average of 200 calls per day to the company's toll-free 800 number in the weeks after an ad runs.

Not surprisingly, the president of Arjo Wiggins Fine Papers likes the strategy so much, he introduced the Curious Paper Collection into South America and Mexico; local firms in Brazil and Mexico have adapted the Curious Paper name and artwork to their markets and have translated the materials into Portuguese and Spanish. There is unconfirmed talk about rolling it out in Asia and Europe as well.

"It would be an incredible feather in our cap...if this whole strategy that was designed just for North America with so much resistance was...introduced back in the Mother Country, if you will. The president is toying with the idea, but there may be resistance because they do have equity there," says Viva.

## What Worked

"When the thinking is really good up front...you have the buy-in from client, you roll out the strategy without shifting sands and changing direction midway through, and you roll it out with confidence, it has a better chance of working," says Viva. "It works because all the thinking was straight up front and it got rolled out without being undermined or compromised."

# REVITALIZING CAMPAIGN SPARKS SALES FOR WIDMER BROTHERS BREWERY

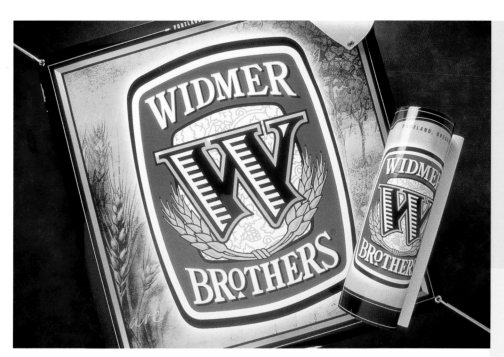

## The Brief

Specifically, Widmer Brothers asked HADW to create a strong brand architecture for a proprietary bottle to packaging for four of its core lines—packaging that would revitalize the brewery within the craft beer category. The team at HADW went to work, and the concept they presented to the client so redefined the craft or micro beer category that the project literally exploded when Widmer Brothers awarded the firm with more than three hundred of its other promotional components, including point-of-purchase displays, cooler stickers, metal signs, coasters, and much more.

LEFT: **Widmer Brother 3' x 3' (.9 m x .9 m) banner and corro-wrap that dresses up the bottom of grocery store pallets.**

BELOW: **Richly designed tap handles heighten brand visibility.**

CLIENT:
Widmer Brothers

DESIGN FIRM:
Hornall Anderson Design Works, Inc.

ART DIRECTORS:
Jack Anderson, Larry Anderson

DESIGNERS:
Jack Anderson, Larry Anderson, Bruce Stigler, Bruce Branson-Meyer, Mary Chin Hutchinson, Michael Brugman, Kaye Farmer, Ed Lee

ILLUSTRATORS:
John Fretz, Susy Pilgrim Waters, Jeff Yeomans, Steve Hepburn, Michael Sternagle, Tom Reis

COPYWRITER:
Pamela Mason Davey

CAMPAIGN RUN:
February 2000 to Present

TARGET MARKET:
Consumers 22 to 38 years old

## The Client

"Widmer Brothers came to us to not so much for rebranding as to make their brand stronger and they wanted us to revitalize their look, not from an identity standpoint, but from a packaging standpoint," says Larry Anderson, senior designer/project manager, of the challenge presented to Hornall Anderson Design Works, Inc. by Widmer Brothers, a brewery and beer distributor. "When we looked at the packaging, it didn't have a lot of punch," he admits.

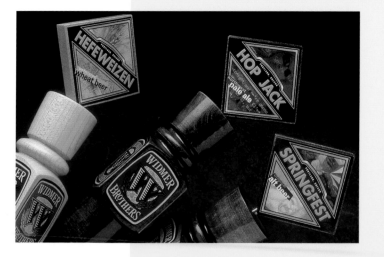

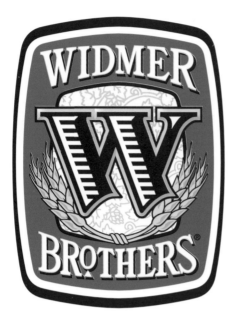

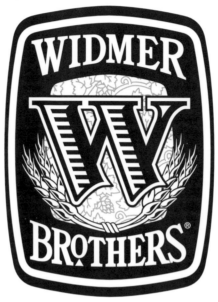

### The Problem: Art on a Box

Everyone agreed that the current packaging wasn't
as strong as it should be. The company's core brand,
Hefeweizen, featured tone-on-tone imagery of a wheat
field on its six-packs, while the seasonal flavors fea-
tured scenes designed to remind consumers of pleasant
times growing up or enjoyable experiences—a feeling
that Widmer Brothers wanted HADW to retain to some
degree, but, hopefully, execute more effectively.

"Jack Anderson coined a phrase, 'You've got art on a
box, just like everyone else,'" says Hornall Anderson
of the dilemma. The team mulled the situation over
and finally concluded that if you want someone to
remember something, why not go a step further and
try to create the moment rather than just a memory. It
was this lightening bolt moment that inspired the idea
of freezing a moment in time from which, they would
develop the look and feel for the revitalized identity.

### The Concept

Once polished, the concept HADW dreamed up, which so enthused Widmer Brothers
and won the firm more than three hundred additional components, was replacing
the original scenes with stories that tell of a moment in time and reflect the inherent
characteristics of each of the blends—a seemingly endless tale told in text and
graphics that would wrap around the packaging. The "moment in time" wouldn't
appear on one panel, but would continue around the entire package.

### A New Logo

Yet, there was one more hurdle to overcome; designers felt that the current mark
didn't fit the new concept. "If we're redesigning everything else, why aren't we fresh-
ening up the look of their mark? It seemed a bit dated and inappropriate for where
we were going with the design," says Anderson. The team convinced Widmer to
allow them to also review the mark, reenergize it, and give it a sense of heritage
by emphasizing the history of beer, including wheat, hops, and the client's filigree.
Heritage and craftsmanship were emphasized to give it a back-to-basics look and feel.

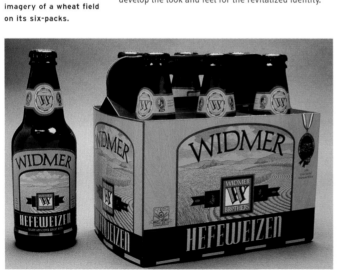

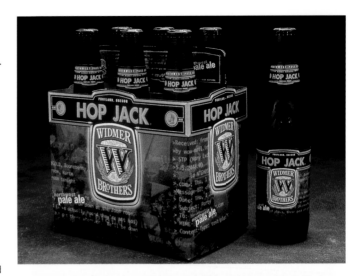

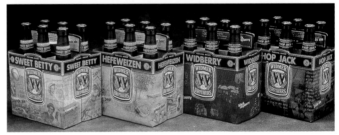

## Using Illustration to Hone the Message

Unique to this promotion is the attention to detail devoted to each six-pack carrier design. The illustrations that freeze various moments in time allow each six-pack to tell a story and generate a feeling associated with the beer's characteristics. The illustration on the box becomes more than just packaging graphics, but communicates a lifestyle brand that makes the beer memorable to the consumer. The rich illustrations lend a personality to each blend that extends beyond its taste to the packaging's visually stimulating graphics.

Hefeweizen, the brewery's best-known core brand, is a wheat beer usually served with lemon. The tale told in its graphic packaging is the transcript of a phone call between the two Widmer brothers, where one invites some friends over for an impromptu gathering on a summer afternoon. The illustration shows an open house with an inviting deck and umbrella table, a dock stretching out onto a lake, lemon wedges, cheese and crackers—all layered over a written message transcribing the conversation taking place. The combination of atypical beer packaging graphics, combined with an interesting story, are the factors that will motivate consumers to pick-up the package and look at it, according to HADW.

Hop Jack, another core brand, is treated in the same manner. The graphics on the six-pack reference the twenty-three to thirty-year-old crowd, potential buyers of the brand. Background photos show active, young adults having a good time. Being the computer-oriented market that they are, the story includes snippets of an e-mail message from one brother to his coworkers inviting them to a local nightclub after work to wind down. The e-mail message about the get-together is the story behind this hip blend.

The Sweet Betty brand gets the same graphic treatment, but the story takes a different approach. Here, sepia-tinged illustrations conjure up scenes one might envision while listening to an old-time radio broadcast of a baseball game in the 1940s. Graphic elements included in the wraparound pictorial are baseball cards, ballpark tickets, baseball equipment, banners, peanuts and popcorn, and the announcer. Sweet Betty, herself, is given a persona; she is portrayed as a wholesome, postwar housewife, similar in style and appearance to Doris Day or the fictional June Cleaver in the 1950s. The background includes copy similar to that used in scripts read by radio announcers.

Widberry, a black raspberry–flavored beer, appeals to a demographic more populated by women. The intent of this six-pack design was to portray a café scene where the background copy reads like the specials of the day with suggested beverage choices to complement the menu. Wrought-iron bars and checkered tablecloths are layered with the copy over a rich burgundy background to emphasize the berry flavor blend.

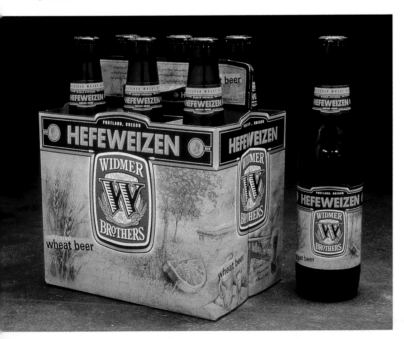

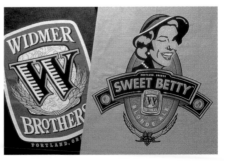

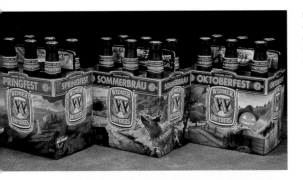

LEFT: The six-pack wrap-around artwork is displayed on three of Widmer Brothers' seasonal beers, Springfest, Sommerbrau, and Oktoberfest.

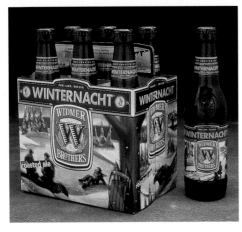

LEFT: Winternacht features traditional winterscapes that remind buyers of the heartwarming occasions of the season, including horse-drawn sleigh rides and building snowmen, while boasting a cool color palette.

The theme for Springfest, one of the seasonal brands, plays on the oft-repeated forecaster of March weather—comes in like a lion; goes out like a lamb. The lamb and lion are illustrated as cloud shapes on either sides of the carton. The graphics take advantage of the seasons by using scenes and colors congruent with spring, such as a woman holding an umbrella in the wind and rain.

Summerbrau, another seasonal brand, showcases a swimming hole on a late-summer afternoon where friends have gathered to cool off. The package gets its punch from an image of the sun.

Oktoberfest, too, takes advantage of the season and its imagery, using traditional autumn visuals such as Halloween images, including a pumpkin-head character with personality, as well as harvest time. Its color palette employs a combination of blue/gray, gold, and orange.

Winternacht features traditional winterscapes that remind buyers of the heartwarming occasions of the season, including horse-drawn sleigh rides and building snowmen, while boasting a cool color palette.

## A Cohesive Look for Many Items

As one might suspect, integrating graphics onto more than three hundred items that keep each brand distinct yet part of a cohesive whole, is not an easy feat, but was accomplished with strategic planning. "[When] we developed this vocabulary of creating a moment in time for the core brands and had this freshened up identity, we ended up with a kit of parts. We had the belt buckle with the lockup of the logo. We've got the product descriptor in there; and we've got some imagery that pertains to that individual product. With these components, you can create guidelines that give a cohesive look and feel to all the pieces, which can also be passed onto the client, who can extend them further," says Anderson.

## The Belt Buckle

The "belt buckle" that was among the designers' kit of parts, also helped the team establish a hierarchy of the first, second, and third read when first looking at the bottle or package. Designers felt that the original packaging failed in this area; consumers saw the Hefeweizen name, but the Widmer logo didn't stand out. To give each element equal visual footing, designers created a "belt buckle" layout with a strong banding system at the top of the design that locks up or houses the Widmer logo along with the type of beer it is. As a result, there is a very strong read behind the two elements—What kind of beer is this and who makes this?—from a branding and a product standpoint.

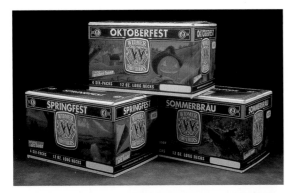

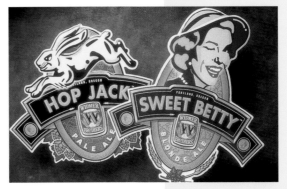

ABOVE: The only time a rabbit appears on the Hop Jack materials is on this Hop Jack enameled metal sign, shown here alongside a metal sign for the Sweet Betty brand.

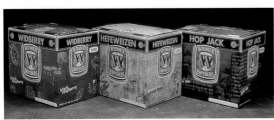

TOP AND BOTTOM LEFT: Artwork on product half-cases and full cases carry through the moment in time theme.

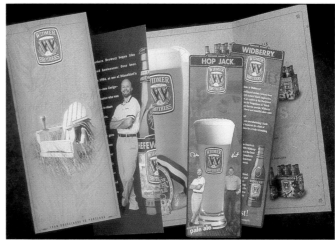

## Continuity throughout

The newly revised logo and illustrations were applied to hundreds of program elements, including everything from a comprehensive stationery system, bottle labels, six-pack packaging, case and half-case packaging, the corporate brochure, six-pack stuffers, data sheets, gift promotions, tap handles, T-shirts, coasters, posters, cooler labels, metal signage to ancillary materials such as blank reply cards, banners, and corro-wraps that dress-up grocery store pallets, among other items.

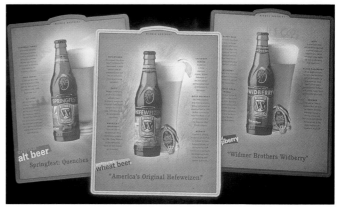

## The Budget

Initially the project entailed creating a packaging structure for four of Widmer Brothers' six-packs, including labels, bottle design, and mother cartons within a budget of $90,000. Once the project took off, however, Widmer added additional seasonal brands, plus branding for the new Widberry and Sweet Betty lines, along with more than three hundred other promotional and collateral pieces—all of which more than doubled the budget. The budget for the initial scope of the project was adequate and as the campaign expanded, the budget remained sufficient to cover work and expenses, but it didn't afford a lot of cushion. To maintain quality, HADW credits its skilled and talented staff that delivered quality work without exceeding budget limitations. "A competent team that follows through can make all the difference," says Anderson.

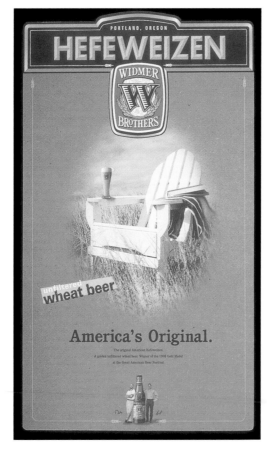

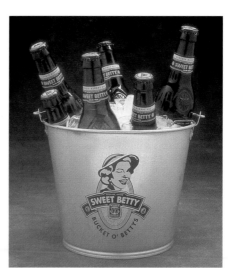

# The results

The imagery for the campaign is undeniably eye-catching, but the promotion does more than provide visual stimulation. It actually works—something not all pretty campaigns do. This campaign is strong because of its unique combination of branding presence, coupled with the prominence of the brand. These things, combined with the product descriptors that create a moment in time, differentiate the Widmer brand from other products on beer shelves. "I don't see anyone out there doing that. This was the brand difference we thought would make them stand apart," says Anderson.

It appears that the work accomplished just that. When Widmer was founded in 1984, it was a keg only brewery; bottles were not introduced until 1996 and while sales were good, the goal was to have bottles and kegs each account for 50 percent of sales. Through October 2000, bottles had climbed to 45 percent of sales. "The packaging redesign really helped us increase our bottle business," says Tim McFall, vice president of marketing, Widmer Brothers. "It helped us gain more distribution and it helped us increase sales in our existing distribution," he adds, citing a total increase of bottles sales of 30 percent, well over Widmer's projections in its distribution areas including Oregon, Washington, California, New York, Michigan, and several midwestern states.

## What Worked

"To make a campaign of this scope work, you have to surround yourself with talent," says Anderson. "When I remember where we started and where we ended up, [I realize that] this really elevated the brand, raised the bar for the client, and redefined the craft beer category for them and for the people out there. They're making waves, and that's the satisfying part about it. When you hear word on the street that the competition is a little worried about Widmer, then you know you've done a good job."

# ATTENTION-SEIZING MAILERS COMPETE AMID THE CLUTTER

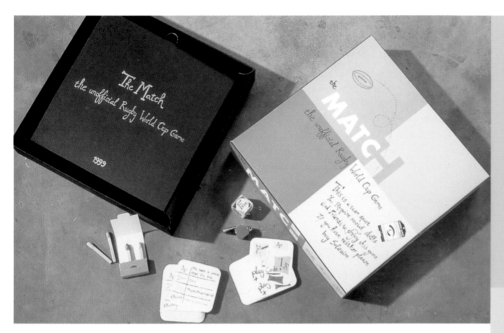

**CLIENT:**
Oracle Airtime Sales

**DESIGN FIRM:**
Cross Colours Ink

**DESIGNERS:**
Joey Pastoll, Carina Comrie, Justin Wright

**COPYWRITER:**
Craig Wapnick

**CAMPAIGN RUN:**
1999 through 2000

**TARGET MARKET:**
Media directors, advertisers

## The Client

Oracle Airtime Sales, part of MultiChoice—the only satellite-television company in South Africa—needed a blockbuster campaign to sell all of its advertising airtime via independent and advertising agency media planners and directors to three major events airing on South Africa's premier sporting channel, SuperSport-Rugby World Cup, Cricket World Cup, and soccer's British F.A . Cup.

Together, Oracle Airtime Sales and SuperSport are leaders in their industries. The SuperSport brand image is central to the success of the events, and people have come to expect leadership and innovation from the brand, which raises the bar for the design team that is creative enough to land the job. Cross Colours Ink, based in Johannesburg, won the assignment, then assessed the situation and recognized that the process of design was not to simply style promotions but to develop and innovate.

**ABOVE: The copy on the front of the game box proclaimed: "The unofficial Rugby World Cup Game: This is a team sport. You require social skills and friends to enjoy this game. If you have neither, please buy solitaire!"**

## The Brief

The three components of the overall campaign are sporting events, but beyond that they share little in common. In fact, each has its own unique personality, which is mirrored in its television-viewing audience. Designers strategized and quickly realized that one tactic they could use would be to capitalize on the differences between each of the three sports. While they debated approaches, one fact stood to the fore—whatever strategy they developed, it had to be strong enough to break through the clutter and myriad promotional material that regularly besieges marketing directors. Designers needed to craft a pitch that would entice and intrigue and above all, sell itself and airtime in each event.

"It meant looking at the required promotions and capitalizing on the respective sports, rather than attempting to do anything singular," says Adele Wapnick, managing partner, Cross Colours Ink.

## Finding a Common Thread

Developing cohesive promotions for three vastly different sporting events proved to be the toughest challenge to overcome. Yet, designers managed to solve the problem by choosing the nontraditional route to a creative solution.

## Dare to be Different

Rather than structuring a promotion that conforms to the industry, they strove to be different, sending nontraditional promotional pieces of direct mail that were more likely to generate attention and spur a reaction, thereby ensuring an airtime purchase from what otherwise is considered a traditional means of communication.

"Integration was done by means of innovation and all under the banner of the hero brand SuperSport. The three promotions did much to continue building Oracle brand equity in two dimensions—by awareness and image," says Wapnick.

## The Lineup

From concept to art direction, production values to execution, each element in the campaign stood out from all the other mailers competing for attention at the recipients' desks. "They were each treated in a different style and execution, hence, bringing new attention to each sporting feature without the campaign becoming tedious. But, throughout the campaign, Oracle Airtime Sales was known as the media owner that holds the best advertising airtime and opportunities in sport, by means of SuperSport," says Wapnick.

### The Match: Rugby World Cup

First up—designers had to sell airtime on the Rugby World Cup. Rugby is an extremely physical and vigorous sport with aggressive players. Television audiences are dominated by lager-drinking males, who love the sport although they don't play it. To reflect the personality of the game and its fans, Cross Colours Ink developed The Match, a board game promoting the event that integrated plenty of humor and playfulness into the message. The game was dynamic and socially interactive and included characteristics of well-known games such as mime, charades, and Pictionary.

The copy on the front of the gameboard box proclaimed: "The unofficial Rugby World Cup Game: This is a team sport. You require social skills and friends to enjoy this game. If you have neither, please buy solitaire!"

The game included a board on which players move forward from Kick Off to Final Whistle. Players draw cards and, depending upon where they land on the board, have the option to either Say, Act, or Draw the required statement, adjective, noun, verb, and so forth. The game pieces were handcrafted matches, and the dice was a perspex square onto which the game owner needed to place numbered stickers before beginning the game. Designers also included a referee's whistle for fun.

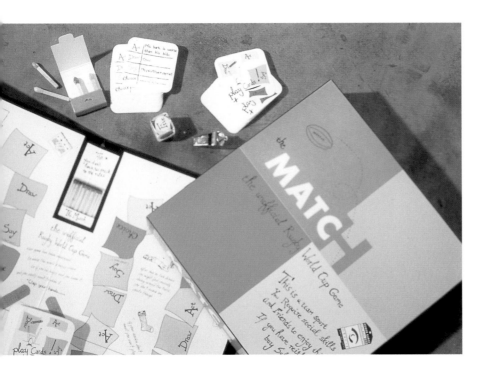

LEFT: The game included a board on which players move forward from Kick Off to Final Whistle. The game pieces were handcrafted matches, and the dice was a perspex square onto which the game owner needed to place numbered stickers before beginning the game. The question and action cards involved the recipient and tested his or her knowledge of rugby. Designers included a whistle in the game for fun.

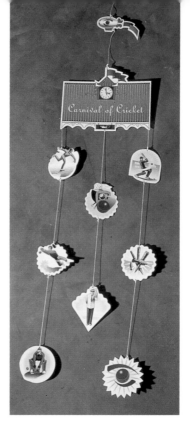

## Match Point

Where's the serious side of all this game? The call to action was tucked into the game as a booklet illustrating the airtime packages available for sale. Reinforcing the sales pitch was a fold-out poster listing all the dates and times of the matches. The game was matte aqueous varnished to give it a feeling of quality and luxury, book bound, and the box cosmetically mounted. When finished, it was direct mailed to five hundred recipients.

"The budget was sizeable and allowed the designer and writer to fulfill their creative requirements in terms of concept and execution," says Wapnick. "The main concept lay in the games' ability to reflect the nature of the sport and its sociable audiences."

## The Case: Cricket World Cup

At the opposite end of the sports spectrum from rugby is cricket. While the game is dynamic, it is considered a "gentleman's sport," where both players and fans are less aggressive and more refined. "The whites worn, the pavilions graced by spectators, and the greens of the pitch have a greater sense of refinement than the sport of rugby," Wapnick explains.

## Stating the Case

To sell airtime to the Cricket World Cup, designers crafted a mobile and sent it out in a paper briefcase. A booklet accompanied the mobile including information on the time schedules, a graphic representation and description of umpire positions and hand motions, and several pages on the product-airtime packages available to advertisers. These pieces were placed inside a blue, corrugated briefcase, which was held together with elastic bands and a wooden handle. The logo and an illustration of a cricket ball were debossed on the front cover. The piece was wrapped in blue tracing paper, which provided the finishing touch. "Both the gift and the art direction, including the style of illustration and typography, reflected the nature of the sport," says Wapnick.

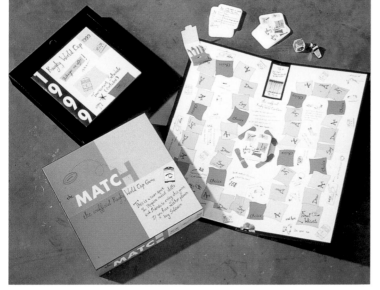

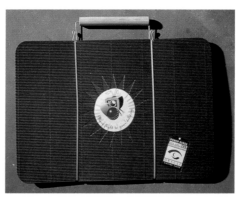

## Packaging on a Budget

Designers created and mailed 300 briefcases, but unlike the budget for the rugby project, this one was limited and did not allow designers to create the three-dimensional version of the mobile they had originally envisioned. The one-dimensional mobile did just as well, but to ensure that the concept wouldn't be lost due to lack of funds and that quality and style prevailed, designers monitored costs closely to make sure the budget could afford some extras such as die-cutting, embossing the cover, and the tracing-paper wrapper.

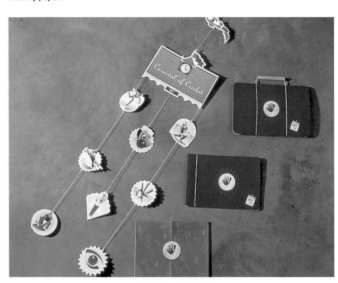

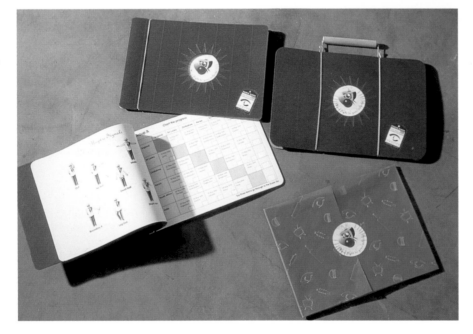

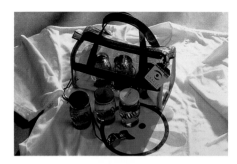

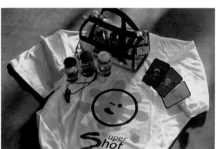

## Take a Shot: British F.A. World Cup Final

"Football, or soccer, once again celebrates the male lager lout," says Wapnick, citing the third phase of the three-part promotion—this one to sell airtime on the British F.A. World Cup Final. In this instance, designers drew their inspiration from *Shooter* magazine and built the promotion around "shots," capitalizing on the pun for shots, meaning shooting soccer goals or throwing back a shot of liquor.

Cross Colours Ink developed the promotion around a party held at a local bar. Designers created 300 invitations in the form of referee cards and sent them with a VIP wrist device, similar to a hospital wristband. The wristbands worked as a gimmicky, attention-getter, but also dissuaded party crashers and ensured that only those with an invitation gained entrée to the event.

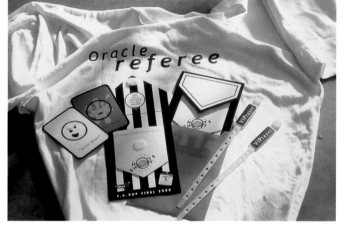

Oracle staff wore referee T-shirts and distributed clear plastic 'tog' sports bags to guests as gifts with three different alcohol shots inside along with a sweat towel, referee whistle, and information on the event. Free Shots and Kick Off Posters transformed the local bar into a promotional venue where even the signage, along with the rest of the collateral material, reflected British football.

"Again, this element grabbed the attention of the media directors as having that point of difference. The budget was adequate and was all that was needed to produce a workable promotion," says Wapnick.

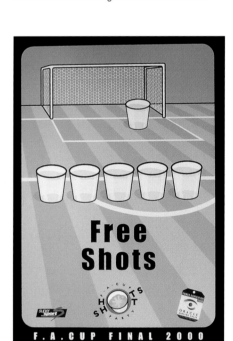

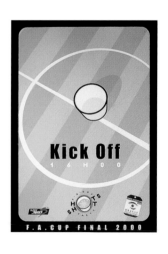

# The results

When the results were tallied, the three promotions hit their respective goals. All available airtime on all three events was sold out in record time. Media buyers were not only inspired to purchase but they liked the approach. "There was an additional response of absolute delight in receiving the packages," says Wapnick. "It makes our job that much more enjoyable to execute. With the both practical and emotional aspects of the promotion, it will ensure that the marketers will remain very brand loyal to Oracle Airtime Sales, in a media-owner market that is cluttered."

"The markets reaction was excellent. The Match was reputed to be one of the best media packages ever," says Anthea Petersen, marketing manager, Oracle Airtime Sales. "Packages for Rugby World Cup were sold out months prior to the event. With Cricket, Oracle took ownership of the event, even though the national broadcaster shared some of the matches. For the F.A. Cup, there was 90 percent attendance—the awareness created for Oracle Airtime Sales was enormous. We were extremely proud."

## What Worked

According to Wapnick, the campaign worked because, "The concepts, ideas, materials, and techniques used were innovative. Clutter continues to make it hard for an advertiser's message to be noticed, and harder still for it to be believed. There is a myriad of sincerely represented claims with little or no credibility. These sporting promotions stood proud of the general clutter and spoke with authority and conviction. They found ways in which to extend the value of the Oracle Airtime Sales and SuperSport brands, in ways which were exciting and provocative."

# VOLKSWAGEN'S BEETLE
## GETS EVEN SMALLER AND WINS BIG AUDIENCES

(a bug's life)

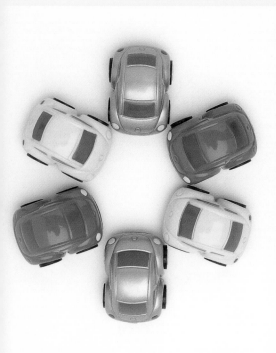

**CLIENT:**
Volkswagen

**DESIGN FIRM:**
Volkswagen Design Studio

**DESIGNER:**
Hartmut Warkuss

**CAMPAIGN RUN:**
Ongoing

**TARGET MARKET:**
Media, Volkswagen enthusiasts

Volkswagen's Pull and Go New Beetle has seized the market's attention and isn't about to let go anytime soon. What began as a simple promotion for the launch of the redesigned Beetle has grown into a marketing gimmick of Rolls Royce proportions.

The idea for a pull-and-go toy was born in Germany amid the Beetle's car designers, who tossed around ideas for a fun promotion that would add a dash of pizzazz to their highly anticipated launch. Their idea for a toy car made its way to Hartmut Warkuss, director of Design Center of Excellence, Volkswagen Design Studio in Braunschweig, Germany, who so loved the idea that he approved it for production on the spot. As a result, moving the car from concept to reality was unusually fast—not at all the norm for typical promotions, but this car was far from typical. "The head of design wanted it done so it was a very speedy decision," says Karla Waterhouse, public relations specialist in Volkswagen's Detroit office.

Volkswagen's designers, accustomed to creating performance automobiles, fashioned the look of the toy car in-house and sent it to various toy manufacturers around the world for production. When the day came to launch the new Volkswagen Bug, the toy cars were featured giveaways in dealerships and were given free to members of the press, drawing nearly as much attention as their full-size counterparts.

Unique to this bug's story is that its life didn't end after the launch. Volkswagen continues to use the toy as giveaways for other promotions, distributing them primarily as media gifts—they recently included the toys in Easter baskets prepared as promotional gifts for the press.

Fortunately, you don't have to possess a press badge to get your hands on this appealing promotion. The palm-sized car, available in six colors—yellow, black, blue, red, silver, and metallic green—are sold for $5 in dealerships as well as through *Driver Gear* magazine, a publication for Volkswagen owners. The car manufacturer has also sold the toys at its booth during Detroit's annual auto show, donating all the proceeds to Detroit's Children's Hospital.

"Executives love them," says Waterhouse of the toy's appeal. "They keep them on their desk and drive them around during lulls in meetings."

Did this promotion work? "Yes," says Waterhouse without hesitation. "It was a success and still is a success. The cars are still being produced. It's a low-cost item that appeals to a lot of people," she adds, noting that the cars are intended as an adult toy and are not suitable for children under the age of three.

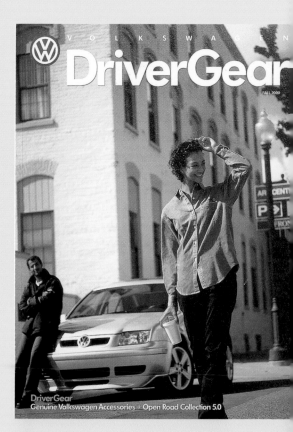

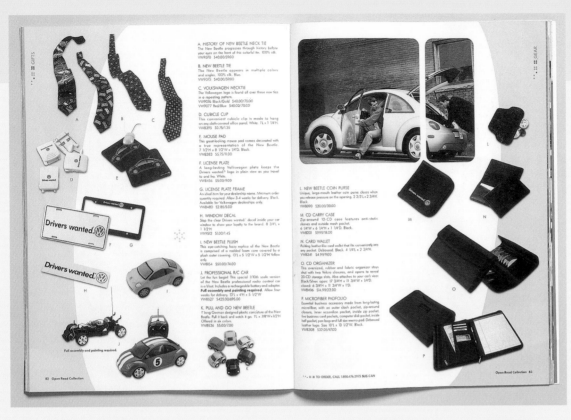

**ABOVE:** "Pull it back and watch it go," proclaims Volkswagen's *Driver Gear* catalog, which showcases the 1-inch toy that sells for $5.

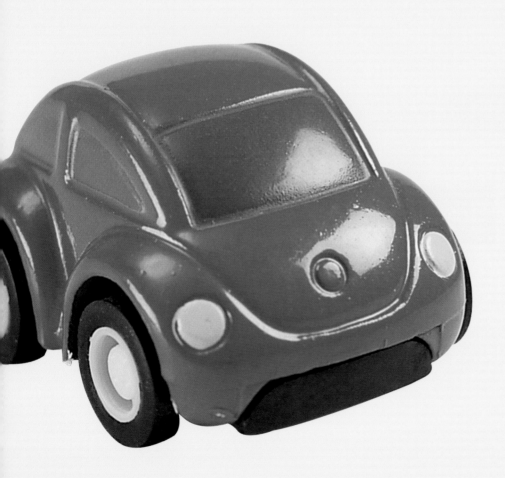

# INTERNATIONAL POP CAMPAIGN LAUNCHES FOSSIL'S BIGTIC™

### The Client

Some Fossil executives doubted it would sell, but nevertheless, they put money behind a new watch called the Bigtic™. Why Bigtic? Because it was among the first watches with large, digital ticking seconds and analog hands. "We felt the product had a futuristic feel and was very different from any other watch made by our competitors or us," says Stephen Zhang, art director on the project. Skepticism reigned as to whether or not this new product would succeed, but the one thing everyone agreed upon was that they needed a winning point-of-purchase campaign to increase the odds of its success. The responsibility for creating and executing such a persuasive promotion fell upon the shoulders of Zhang and designer John Vineyard, both of whom agreed to make the watch's unique face the focus of the campaign.

CLIENT:
Fossil

DESIGN FIRM:
Fossil in-house design studio

CREATIVE DIRECTOR:
Tim Hale

ART DIRECTOR:
Stephen Zhang

DESIGNER:
John Vineyard

FOSSIL INTERNATIONAL DESIGNERS:
Gabriella Fortunato (Italy), Stefan Muller (Germany)

ANIMATION:
Reel FX

PHOTOGRAPHERS:
David McCormick, Russ Aman

CAMPAIGN RUN:
January 2000 through December 31, 2000

TARGET MARKET:
Consumers 16 to 24 years old

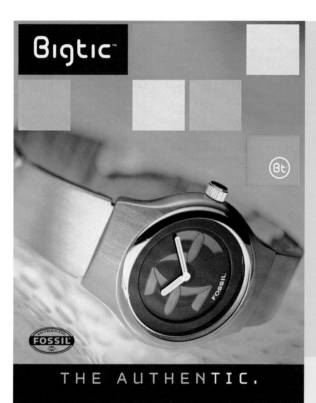

THE AUTHENTIC.

### The Brief

Three factors stood out as Zhang and designer John Vineyard assessed the task assigned to Fossil's in-house design team. First, they needed to skew the watch to a younger audience than is typical for most Fossil products and target teenagers and twentysomethings. Second was the uniqueness of the watch. "This watch was an experiment. You see the tick, but don't hear the tick," says Zhang, citing the watch's primary feature that bewildered so many. Fossil developed the all-new technology where seconds are visually counted off with big ticks. Aside from offering innovation that differs from other digital technology, the watch didn't provide any new functions; yet it was undisputedly unique and kids would want it, which led to the third and final consideration. Could they use to their advantage the futuristic, techno look of the watch to play to the current trends in technology so irresistible to today's younger consumers?

Vineyard conducted his own research to find a color or colors that graphically expressed the trend toward youth-oriented, high-tech, futuristic gadgetry. At the time, Fossil had four or five product lines already in existence, each targeting a different market segment and differentiated with its own color scheme, so some colors were already taken. Vineyard's search for a shade that visually shouted "techno" yielded a recommendation, but surprisingly, it was not the steely gray, silver, or metallic blue hues that are commonly associated with state-of-the-art technology. Vineyard's color of choice—green—a shade readily associated with conservation, ecology, health, and wholesomeness but rarely, if ever, seen as being cutting edge.

ABOVE: A point-of-purchase poster kicked off the campaign and other elements were added from there.

LEFT, TOP AND BOTTOM: In-case cards and small and caseline static stickers.

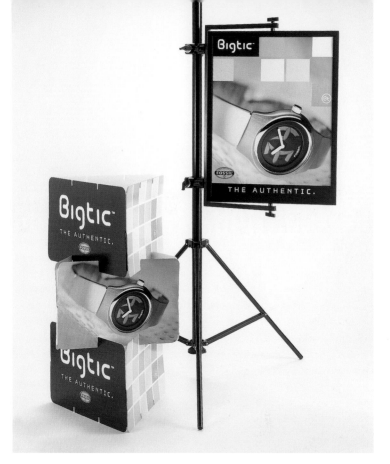

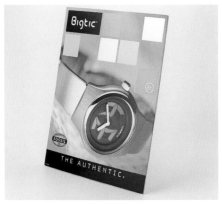

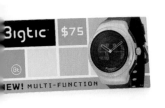

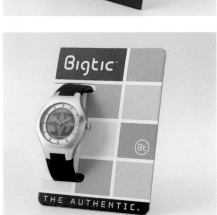

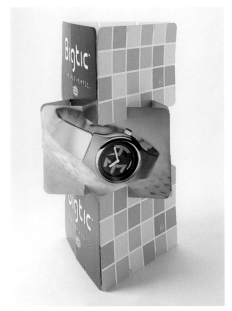

## Pulling Everything Together

Initially, Fossil ran few magazine advertisements for the Bigtic before a logo and color scheme were developed. Later, a marketing kit with more in-depth photography and graphics were added to the mix. A point-of-purchase poster kicked off the campaign and other elements were added from there.

Before long, there was a comprehensive kit that was provided to department stores including a poster display along with Bigtic top-of-counter and watch cuff standees, a ledgetop display, in-case cards, and small and caseline static stickers.

These singular items were combined with the product displays to create a cohesive presentation at point of sale.

"[The promotion has] a different look than anything else we'd really done and the look of the posters and the look of the campaign was really different from the look of our stores," says Vineyard, pointing to the retro packaging and merchandising that Fossil has used in the past with considerable success. In fact, the company has built so much equity in the retro look that the move to a futuristic image spurned more skepticism and called for considerable convincing on the part of the design team. "The watch had a digital techno look that was different from anything else that we had done and so called for a campaign that was different from what Fossil has done previously."

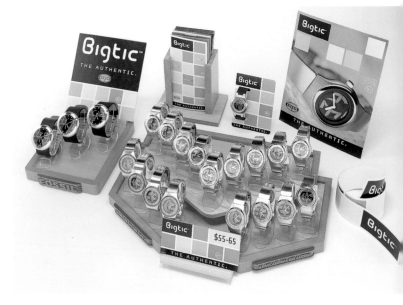

## The Sales Pitch

Despite the eye-catching appeal of the sales package, the primary challenge remained gaining acceptance for the product. Selling it internally was hard enough, but the sell-in proved equally difficult as department store buyers expressed their doubts. "'What is it for? What does it do?' Nothing," says Zhang, remembering how they had to field this question from insiders as well as department-store buyers over and over again. "So it wasn't easy to get it launched." To soften the sell, designers created a twisty puzzle (reminiscent of a Rubik's Cube) that echoed the repeating square pattern of the promotional collateral as a gift for department-store buyers.

"The challenge for John was to present this product, which is rather ambiguous…and hard to explain to people," adds Zhang. "The challenge was to visually make it connect to those people, distinguish the watch visually, attract attention, and get consumers to see the watch. Rather than promoting the product from a function standpoint, John created a campaign from a lifestyle, aesthetic, and fashion point-of-view. That's why…the translucent green was really hot. You could see it everywhere in New York, particularly, the small, trendy shops in Soho."

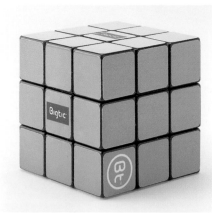

ABOVE: Individual items were combined with the product displays to create a cohesive presentation at point of sale.

LEFT: To soften the sell, designers created a twisty puzzle (reminiscent of a Rubik's Cube) that echoed the repeating square pattern of the promotional collateral as a gift for department-store buyers.

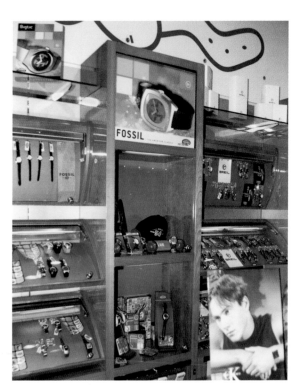

ABOVE AND LEFT: In-store displays from Italy's Coin department store.

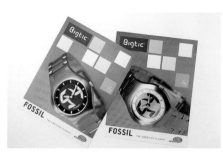

TOP AND BOTTOM LEFT:
Flyer and magazine
advertisement from
Italy.

BELOW: Bigtic interna-
tional brochure that was
used in several countries
outside of the U.S.

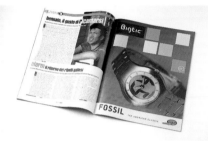

## A Global Effort

Zhang and Vineyard, located in Fossil's Texas headquarters, set the standards for the international advertising and promotion and annually publish a *Standards Guide*. In this case, they provided files and transparencies to other Fossil design departments around the world to replicate as needed. Simplifying matters is that collateral material is always designed to a common size so that posters, countertop displays, and so forth, have the same dimensions regardless of the product line. In some cases, foreign design offices are allowed to use their own discretion in executing the materials so they can be adapted to individual environments, while maintaining consistency with the established design. So uniform is the collateral from country to country that it is hard to distinguish where various materials come from as evidenced by the top-of-counter standee from Japan, flyer and magazine advertisement from Italy, in-store displays from Italy's Coin department store, and Bigtic international brochure that was used in several countries outside of the U.S.

Fossil is acutely aware that to succeed, a global presentation must transcend language barriers, especially when selling across borders and when so much of the company's collateral material is shared. A case in point is a television commercial created by Fossil's U.S. design team for placement on German and Italian television and as advertising in cinemas there prior to showing the feature film. As in all the collateral, the primary message of the television spot was Bigtic's futuristic/techno appeal.

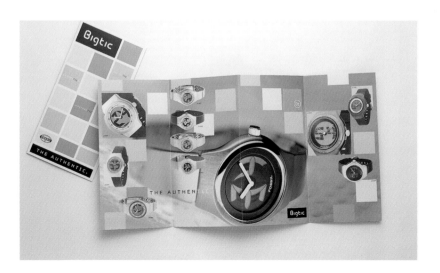

## The Creative Process

Vineyard decided to focus on unique look of watch through mood photography to lure consumers into the promotion. "We thought the watch was so interesting and looked so interesting, we really wanted to focus on its uniqueness in the photography and everything we did we had to build around that. The watch in the case almost sells itself. So, we didn't want to do anything with the graphics that would take away from that," says Vineyard.

"The watch is so strange and so new, we wanted the watch to speak through the photography," explains Zhang, adding that in addition to the photography, the basic elements of the design include the logo, color palette, and the graphic squares that "abstractly represent the digital, techno style of the watch."

## The Photo Shoot

While the futuristic/techno look was considered the campaign's key ingredient, achieving this look through photography presented its own set of challenges. Vineyard spent a great deal of time experimenting with different lights, techniques, and backgrounds before finalizing the lighting setup. Ultimately, he decided to light the background from underneath the watch as well as from other angles, place green gels on specific lights, and remove the crystal from the watch to avoid reflection from the unusual lighting set up. To add a subtle texture and extra depth to the photo, he draped a shower curtain with a bubble wrap–like texture over a sheet of transparent green Plexiglas.

"We had to really work to angle the watch and the camera in a position where we could achieve the selective focus we wanted so that the bubbles in the shower curtain wouldn't reflect off of the watch's black face," remembers Vineyard.

"The strength of the photography in addition to the simple, yet effective, square pattern created the atmosphere we were trying to achieve in this campaign," says Zhang. "The fact that we were able to use the squares on pieces that were too small to use photography effectively helped maintain consistency and interest throughout the campaign."

Screen grabs from a television commercial created by Fossil's U.S. design team for placement on German and Italian television and as advertising in cinemas there prior to showing the feature film.

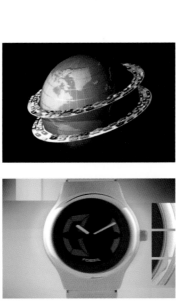

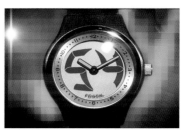

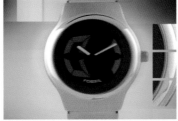

# The results

The Bigtic watch is one of Fossil's biggest success stories. "Once launched, it sold easily. It sold out quickly," remembers Zhang. Consequently, the Bigtic has become one of the company's most popular watches worldwide and has been imitated by several of Fossil's competitors. Fossil isn't disclosing any figures, but simply says "sales were phenomenal." While the watch appealed to a young generation, it is clear that the point-of-sale graphics attracted buyers from all age groups.

### What Worked

"In malls or department stores, there is so much going on…so much clutter, we had to really do something to stand out. We felt like the watch would sell itself, but we needed something that would grab attention so that you would see the watch and it would stand out from all the other products and all the other brands," adds Vineyard. "I feel like this campaign did that."

"In essence, John's design is a campaign, but it is also an identity for this line. The watch sells itself because people see other people wearing it and if they like it, they will go look for it," Zhang adds. "But I think because the design is distinctive as well as the layout, color, and the execution is very consistent, you can go in and easily spot Bigtic and go to the right place. As an identity, I think it is very successful especially in the international sales environment, where watches are sold primarily in smaller jewelry stores—people usually spot a product on the street through windows."

# Tips from the experts  Innovate...shun the skeptics...integrate

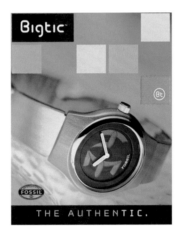

### BE CREATIVE WITH PHOTO PROPS

To achieve they look they were after, designers lit the background from underneath the watch as well as from other angles, placed green gels on specific lights, and added a subtle texture and extra depth to the photo by draping a shower curtain with a bubble wrap-like texture over a sheet of transparent, green Plexiglas.

### SOFTEN THE SELL

Designers gave department store buyers a twisty puzzle as a promotional gift.

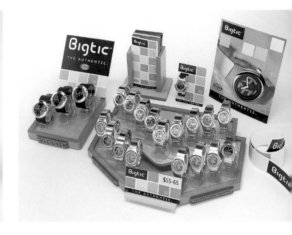

### BEWARE THE SKEPTICS

Even Fossil executives doubted the ability of the Bigtic to sell, but it ended up being one of Fossil's biggest success stories.

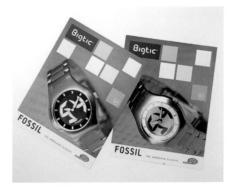

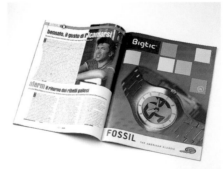

### GIVE FOREIGN DESIGN OFFICES LEEWAY

Fossil allowed its foreign design offices to use their own discretion in executing the materials in order to adapt promotions to their market while maintaining consistency with the established design.

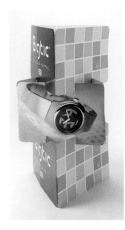
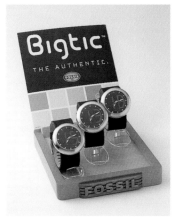
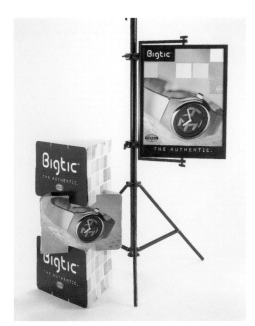

**CONSIDER A NONTRADITIONAL COLOR PALETTE**

Fossil shunned traditional color palettes of steel gray, silver or metallic blue hues that are commonly associated with state-of-the-art technology and opted instead for green, a shade readily associated with conservation, ecology, health, and wholesomeness but rarely, if ever, seen as being cutting edge.

**BUILD ON THE PRESENTATION**

Fossil took singular items and combined them with product displays to create a cohesive presentation at point of sale.

**START SMALL AND GROW FROM THERE**

The Bigtic campaign started with a poster and grew from there, until Fossil had a comprehensive kit to provide to department stores.

# PHOTOGRAPHY REINVIGORATES (photo graphics)
# MATURE BRAND WITH SENSUAL, YOUTHFUL GRAPHICS

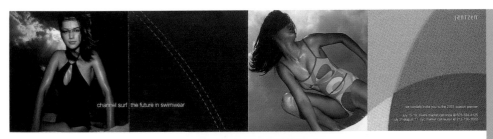

**The Brief**

Jantzen supplied Plazm with plenty of market research, which helped narrow down the objectives. Plazm was to redirect the marketing to a younger demographic, develop the next generation of Jantzen customers, nurture downstream business, and build future advocacy. In short, Jantzen retained Plazm Media to transform the company's matronly image into one that represents the forces that shape and define today's fashion—all in time for the company to reemerge in the marketplace.

**CLIENT:**
Jantzen, Inc.

**DESIGN FIRM:**
Plazm Media

**ART DIRECTOR:**
Joshua Berger

**DESIGNERS:**
Joshua Berger, Niko Courtelis, Enrique Mosqueda, Pete McCracken

**COPYWRITER:**
Kristi Klainer

**PHOTOGRAPHER:**
Nicola Majocchi

**MODELS:**
Tilly, Shkara, Christine, Jolijn

**MAKEUP:**
Jamie Melbourne

**HAIR:**
Azuma

**STYLIST:**
Sabina Kurz

**CAMPAIGN RUN:**
July 2000 through July 2001

**TARGET MARKET:**
Women 15 to 25 years old

**ABOVE AND LEFT:** "Channel Surf the Future," a direct-mail piece announcing Jantzen's new line, invited industry insiders and the media to Jantzen's 2001 season premier and featured extreme close-ups of fabric swatches.

**The Client**

Does this swimsuit look like one your grandmother has worn for years? Jantzen, Inc., the company who pioneered the development of commercial swimwear for women back in 1910, is betting the answer is no. However, to strengthen its hand, Jantzen tapped Portland, Oregon–based Plazm Media to reinvigorate and reposition the mature brand.

## The Concept

The Jantzen brand has existed for nearly one hundred years and was in need of a facelift, yet it possessed a very deep and unique heritage. "Jantzen is responsible for the prevalence of swimming in this country in the same way that Nike is responsible for jogging," says Joshua Berger, art director. "In the last fifteen years or so, the perception of the brand has really stagnated. Most of the research that we did and the client did indicated that people perceive it as an older brand."

To combat its aging persona, designers opted to retain the company's heritage—which lent itself to Jantzen's Riviera line, swimwear inspired by vintage styling—while communicating that Jantzen is about fashion. Designers crafted the relaunch to address the overlap between fashion and culture, while paying attention to style and fabric. Fabric was deemed integral to this campaign, as it was part of the product offering. To illustrate its importance, fabric swatches were scanned in and rendered in extreme close-up in the direct-mail piece as well as other campaign components.

ABOVE: An invitation to a personal viewing of Jantzen's Riviera line, a fourteen-style collection that brings back the classic lines and handcrafted fashion from the 1940s and 1950s in modern fabrics.

LEFT: A limited-edition poster was silk-screened and letterpressed to announce Riviera line, a line of swimwear that interprets fashion patterns of the 1940s and 1950s with modern fabrics. Designers wrapped it in a silvery art paper for an elegant appearance.

## Perception vs. Reality

Designers had to fight hard to overcome the perception that the Jantzen brand had grown old and musty, but most importantly, they had to fight the battle amid budget constraints on the creative end, as well as limited resources for media buys.

"We pursued a grass roots marketing plan, including guerilla marketing, and reached out to a list of popular figures and industry influencers. We showed the suits in a new way that speaks to a younger demographic, focusing on the confluence of fashion and culture."

## Limited Funds

Working with a limited budget and trying to have impact for a global brand was tough. "Other companies have a big enough budget to do brand advertising all year around on a global level, including TV and print advertising," says Berger. "Jantzen doesn't have this kind of budget. We don't have enough money to run ads all year round...let alone get items produced for retail needs, sales needs, trades needs, and on a consumer level. We're doing it at reduced rates because we're excited about the product. The photographer, the models, the stylist, everyone gave 110 percent to make it happen."

"Creatively, if we're excited about something, that's the best you can have."

## Influencing the Media

When a client has a limited budget, the only alternative is to find a creative way to optimize funds. Plazm did just that by including an influencer program in the mix. This effort reached out to people designers determined were key influencers within the world of contemporary culture and fashion including filmmakers, musicians, actresses, and models. These people were sent a copy of the look book and a catalog of suits accompanied by a personal letter inviting them to sample the products. In addition, Plazm targeted costumers of television and motion pictures to include the suits in their wardrobe departments.

Jantzen .01

## Using Voyeuristic Photography

Photography is the primary communicator in this campaign where the copy is kept to minimalist subheads. At first glance, the shots are just about beautiful women sporting Jantzen suits, but there's more. The idea was "to capture a moment before an action takes place and make it really intimate, almost voyeuristic," says Berger. "The person you're looking at in these shots is engaged. It's unexpected. There's something about to happen. This differs from other photography in the swimwear category that is styled to the point it is hyper-real. It's not attainable. It is beyond reality. On the other side, there are lifestyle shots...people on the beach playing. These are created moments that attempt authenticity. Jantzen's ads fall somewhere between these two."

THIS PAGE: Suits featured in Jantzen's oversized look book, *Jantzen .01*, sport such names such as Me Jane, Eclipse, Hooked on You, Concentricity, Traffic Jam, Rangoon, Tattoo You, and Rubberband Man—all of which are skewed to appeal to a younger consumer.

THIS AND NEXT PAGE: **Each image in the series of six trade advertisements has a different color tone. For instance, the ad titled Pre-Modern has a greenish hue background. This technique, developed with the photographer, uses a filtered background and reverse filtered model so the end result appears very neutral.**

## The Youth Movement

The project includes trade and consumer print advertising, marketing collateral, internal sales promotions, trade show design, retail point-of-purchase, and a runway show, as well as related guerilla marketing. *Jantzen .01,* Jantzen's oversized look book, and related collateral demonstrate an awareness of fashion sensibilities: style, color, fabric, cut, and line drawn together by young, modern photography, which combined with an aggressive, youth-oriented presentation capitalizes on the element of surprise.

Copy is regulated to punchy taglines. "Preview the future," the tag that appears on all the ads, coupled with the headline "Life begins at 80°," which appears inside the *Jantzen .01* look book, reinforce the theme of a newer and younger Jantzen. Names given to each swimsuit follow along the same lines—Me Jane, Eclipse, Hooked on You, Concentricity, Traffic Jam, Rangoon, Tattoo You, and Rubberband Man—are not the names of swimsuits of old.

Not only does Jantzen's campaign show-off its new styles, new colors, new fabrics, new cuts, and new lines, but the campaign is notable for its modern imagery, which is sensual, fashion-forward, and, designers hope, engaging enough to draw people in on multiple levels.

### Build from the Product

Designers created all the components to build out from the product. Each image in the series of six trade advertisements has a different color tone. For instance, an ad titled Pre-Modern has a greenish hue to the background. Working with the photographer, designers filtered the background and reverse filtered the model so that she appears in a normal light without the background hue. The result creates contrast and mood. "It's all understated, but the effect builds off the product," says Berger.

"[The ads]...aren't product advertisements, they are product driven, which bridges a gap between strict product advertising and brand advertising. The client doesn't have a big enough budget to have those different levels, so it all has to be one thing," says Berger.

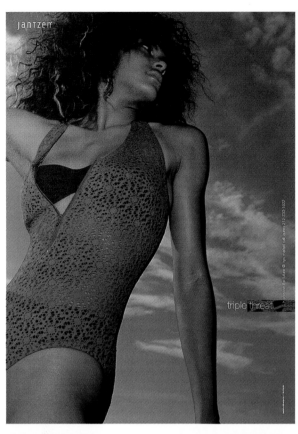

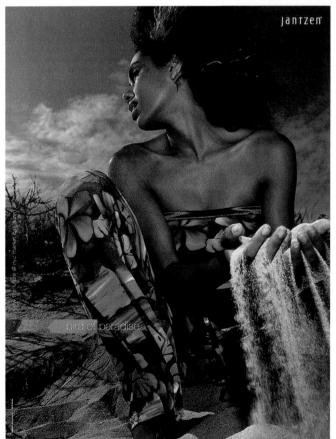

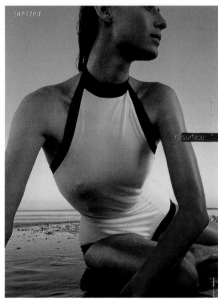

# The results

Both Jantzen and Plazm Media are pleased with the success of the promotion, which effectively spread the word that Jantzen was back—stronger and more youthful than ever. Plazm points to the media blitz that resulted from the campaign—as well as interest among Hollywood types who suddenly are seeing Jantzen suits in a new and sexy light.

## PR Hits

The new campaign created a stir among the fashion-conscious media, netting numerous editorial mentions with headlines that garnered publicity that couldn't be bought and further stretched the budget. *W* talked about the new "Jantzen," while *Women's Wear Daily* opined "Jantzen Revamp: Young and Sexy" and *Fashion Market* proclaimed, "Jantzen to Strengthen Brand." The company also benefited from plenty of ink and photos in the *Swim Journal's* Cruise Preview issue, *California Apparel News*, and *Jane* magazine where the fashion market editor was first introduced to the Riviera line at the Miami Market. After reviewing the video of the fashion show, the editor decided to feature Jantzen's Arabesque, The Vina del Mar, and Fatale styles in the magazine.

Since then, the media has revisited the story with editorial following up the initial launch. One such example is *Women's Wear Daily*, which had an editor on-site at Jantzen for two days of interviews and photo opportunities.

## Going Hollywood

The media isn't the only group talking up Jantzen's merits; it appears Jantzen has gone Hollywood, too. The annual "Marketplace" gala for the Set Decorator's Society, a group of television and motion picture professionals in Los Angeles, clothed their models/hostesses in Jantzen suits and cover-ups. In addition, each Marketplace attendee took home a copy of Plazm's *Jantzen .01* brand book.

## Major Film and TV Product Placements

Jantzen suits have been placed into a variety of motion pictures including Columbia Pictures' *The Glass House* starring Lee Sobieski, Diane Lane, and Rita Wilson; *Inferno*, an independent film featuring two young, up-and-coming actresses; MGM Studio's *Bandits* starring Bruce Willis, Cate Blanchett, and Billy Bob Thornton; *Zoolander*, a Ben Stiller comedy about male models, as well as television series such as *Baywatch Hawaii* and *Freakylinks*.

"Overall, the reaction has been really strong. People are definitely talking within the industry. Editors are calling the client to find out what's going on." exclaims Berger.

## What Worked

"The element of surprise has a lot to do with its success. The promotion took an aggressive stance and it stands out as unique in a really difficult marketplace. For a brand with the perception of being older, more established, not young and hip, to come out and print a 17" x 22" (43 cm x 56 cm) huge book with this kind of content in it is pretty aggressive and makes a bold statement for Jantzen," says Berger.

"Also, we had the element of surprise on our side. We completely changed the visuals and the attitude that the brand has been putting forward, so the element of surprise is really important," adds Berger. "We told Jantzen, 'This is what we think will achieve your objectives.' They gave us a problem and we solved it."

# CAMPAIGN ZEROS IN ON 2000 IOWA STATE FAIR

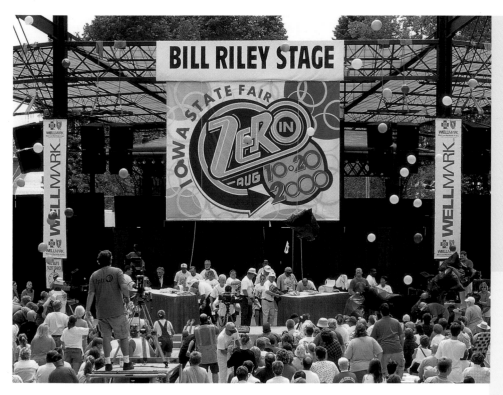

### The Brief

Fortunately, the event's theme changes dramatically each year. The theme chosen for 2000 was Traditional Meets Technology—which provided an interesting juxtaposition of ideas and concepts—a salute to technology, such as cellular phones and the Internet, in addition to the best baked pie and prize cow. Because the fair was in August, the design team recognized that eight months into the year all talk of the millennium would be over, but they still felt it needed to be recognized since it was a once in a lifetime opportunity. By the same token, everyone was sick of millennium mania so even a salute to the millennium had to be tactfully managed through design.

Surprisingly, when designer/illustrator John Sayles evaluated the details of the 2000 event, the graphic theme fell into place almost immediately. "The theme was a natural," says John Sayles, art director, designer, and illustrator on the project. "I saw all the zeros in the date of the fair—August 10–20, 2000—and we 'zeroed in' on it right away!" The zeros not only reflected the dates of the event, but also in terms of the millennium fair itself, they paid a subtle homage that wasn't overblown or made to appear like old news. Since the focus of the 2000 event was tradition and technology, Sayles used a futuristic style for his graphics. A curving arrow draws the eye around to the logo and the theme, Zero In!

**CLIENT:**
Iowa State Fair

**DESIGN FIRM:**
Sayles Graphic Design

**ART DIRECTOR/DESIGNER/ILLUSTRATOR:**
John Sayles

**CAMPAIGN RUN:**
September 1999 through August 2000

**TARGET MARKET:**
Consumers of all ages, particularly families

### The Client

How do you keep a campaign fresh, particularly for a 146-year-old event that you've promoted three times before? That was the challenge facing Sayles Graphic Design when it came time to generate awareness, excitement, and attendance for the 2000 Iowa State Fair. The fair marked the fourth consecutive event for Sayles, and although the event was the state's millennium fair, by August 2000, interest in talking about the millennium was long gone.

ABOVE: A giant banner was unfurled from the main stage on the Iowa State Fairgrounds to announce the theme of the 2000 event

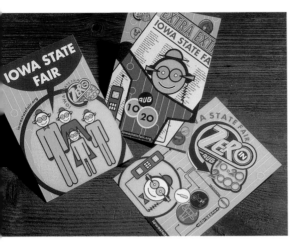

## Using Color to Differentiate

Since 1997, when Sayles Graphic Design began working with the Iowa State Fair, Sayles has distin-
guished each year's event with a variety of colors and graphics that all work to generate excitement
and anticipation in the event, which has been dubbed America's Classic State Fair. For 2000, layers of
bright colors—yellow, lime fuchsia, and purple—draw attention to the visual and complement Sayles'
hand-rendered type. Designers chose the color palette deliberately to break thorough more traditional
color schemes for fairs, as were the graphics, which Sheree Clark, managing partner, Sayles Graphic
Design, terms "unexpected" for such a traditional event. "We wanted to do something that seemed a
little out of character for [the event], not expected. Other fairs are more predictable," explains Clark,
who suggests predictable graphics tend to be stoic and more realistic in style, similar to Grant Wood,
or are amateur-styled artwork or line art reminiscent of what might be gathered through a children's
art contest. "No one thinks [that kind of art] is unusual. So doing something graphic in itself is a
departure from the usual," she adds.

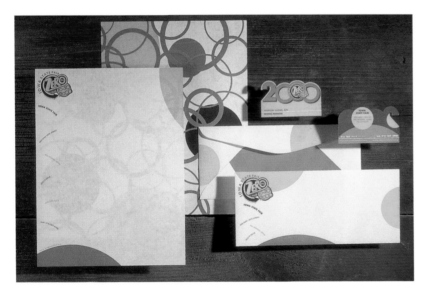

ABOVE: Stationery for the 2000
Iowa State Fair incorporates the
bright colors and lively visuals
developed by John Sayles.

## Getting Everyone to Agree

The Iowa State Fair board involves a group of ten to fifteen
individuals with competing thoughts and ideas, so sometimes
getting a consensus on which designs to use is challenging, but
once an agreement is struck, the board allows Sayles and the
design team to run with it. The easy partnership between the
Iowa State Fair and Sayles Graphic Design also helps keep the
campaigns fresh each year—by far, the biggest challenge in an
annual event of this nature and scope.

"We've developed a kind of shorthand and a way of working
together that's good and expeditious. The not so good part is
that there exists a comfort factor that's not always a good
thing," says Clark. To ensure ideas stay fresh and to encourage
communication, the design team and the client agreed to spend
a half-day retreat sequestered in a hotel suite where they
mulled over past years' campaigns and evaluated what worked
and what didn't. "It was a true collaborative effort in every
sense of the word."

## Managing Time and Profitability

The retreat worked so well when planning for 2000 that they
used it again when they started planning for the 2001 event with
the theme, It's A Winner. While the theme itself is nothing out-
standing according to Clark, the execution of the new campaign
is unique and unusual. Moreover, tying the 2000 and 2001
events together is a transitional color palette that was chosen
to give the 2000 and 2001 events continuity. What's different for
2001 is the team's approach to tackling the project. Since 1997,
they did things in a piece meal approach, reacting and creating
elements only when they were needed. For 2001, the firm real-
ized that the best way to manage design time, profitability, and
continuity was to work on the campaign as a campaign.

"All of the graphics, all of the visuals that we know we'll be
using for 2001 were completed by November 2000," says Clark.
Sure, designs will still be tweaked and refined, but as a result
of the new approach, Sayles Graphic Design has dramatically
increased its efficiency and profitability. "Before we were react-
ing, but, you get smarter," she adds, noting that when they start
planning the next year's event two weeks after the current one
closes, there's a tendency to view time as a luxury.

## Planning for the Unexpected

Despite the best planning, the team has learned to build extra
time into the schedule for the unexpected. Because the Iowa
State Fair is a state entity, it is required by law to solicit a mini-
mum of three bids for all outsourced production, including
printing and premiums, and are obligated to go with the lowest
bidder. "That creates it own challenges because sometimes the
low bidder isn't always the most qualified for the project," says
Clark. Sayles will work with the Iowa State Fair to help them
choose the right vendors get the bid specs, but the situation
inevitably requires that the designers allow extra time to
accommodate any unexpected situations that might arise.
"Planning helps. Sometimes the client helps, which works
because we have that kind of relationship," says Clark.

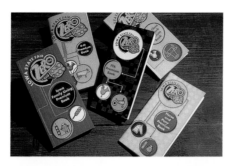

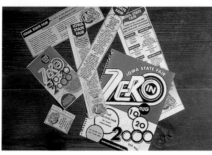

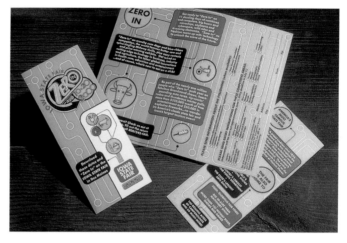

## The Rollout

Principle work on the 2000 event began in September 1999, two weeks after the close of the 1999 fair, but the actual roll out began even sooner. At the conclusion of the 1999 event, a giant banner was unfurled on the main stage of the Iowa State Fairgrounds to announce the theme of the 2000 event.

Then, throughout the year leading up to the August 2000 event, a multitude of items were rolled out.

Stationery for the 2000 Iowa State Fair incorporated the bright colors and lively visuals developed by John Sayles, while the staff at the Iowa State Fair used special 2000 postcards for informal correspondence.

Likewise, the fair's primary brochure and competition guidebooks were printed in a variety of colors and graphic combinations. Not everything, however, relied upon abundant color. Black-and-white ads made the most of the Zero In! logo and theme, both in copy and visuals.

To promote the 2000 Iowa State Fair, Sayles developed a poster encouraging people to buy their tickets early. Billboards across Iowa exclaimed, Zero In! and bus transit posters took the message on the road.

Sponsored by the statewide newspaper, The *Des Moines Register*, shopping bags for the 2000 Iowa State Fair boasted eye-catching colors.

Buttons from the Iowa State Fair have long been collectible, and the 2000 buttons were no exception, while other novelty items, including Frisbees, slinky toys, key chains, T-shirts, and sweatshirts encouraged kids of all ages to Zero In on fun.

Interestingly, John Sayles didn't stop there. He also transformed the circles from the Zero In! logo into ornaments for the Iowa State Fair's Christmas greeting card.

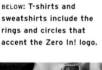

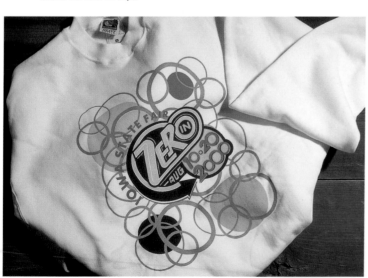

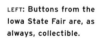

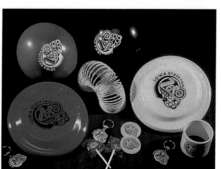

# A Timeline of Iowa State Fair Logos

**1997**

Sayles Graphic Design has worked with the Iowa State Fair for a number of years. The firm's work for the fair has included updating the corporate logo with layers of primary colors around a stylized ribbon. The new mark was placed onto the fair's corporate stationery, which replaced the original corporate identity that was designed in 1977. Sayles, however, is best known for creating individual looks for each year's fair since 1997. Looking back on the theme logos from 1997, 1998, 1999, 2000, and 2001, one can see how each has its own individual characteristics yet appeals to the fun and family values inherent in a state fair.

**1998**

**1999**

ABOVE: **Updated corporate identity.**

ABOVE: **To promote the 2000 Iowa State Fair, Sayles developed a poster encouraging people to buy their tickets early.**

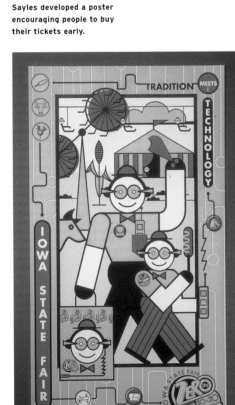

**2000**

**2001**

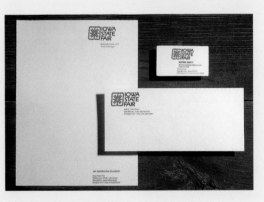

ABOVE: **Original corporate identity.**

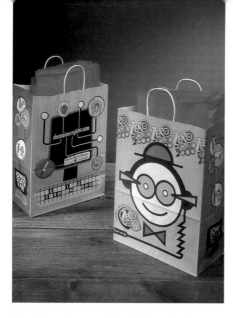

## Avoiding the Cookie-Cutter Syndrome

Interestingly, while the color palette and the basic logo remain consistent throughout each campaign component, the elements avoid the cookie-cutter syndrome, as each is uniquely translated onto everything from a business card to a billboard. "We don't subscribe to the theory that you design a logo or one item and then you pick it up and plop it on absolutely everything. Our philosophy is that each individual item is designed for its own use and purpose. A billboard has a different purpose, size, and configuration than a brochure. It gets pretty dull if all you're doing is slapping a logo on things. So we change things on purpose. [It's] very deliberate and is done to prevent boredom," says Clark.

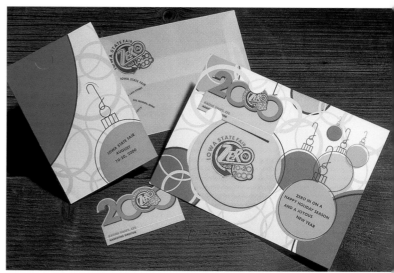

So how does the team maintain continuity between components when each is treated differently? Clark says the client keeps them honest, but also credits the firm's creation of their own graphic standards that mandate components must always be recognized as part of the campaign. "The whole reason to have a campaign is to capitalize upon impressions and build on the last impression, the last visual that makes everyone think, 'I've seen this before. I've heard this before. I know what the dates are.' We don't want to lose that opportunity; we're conscious of it."

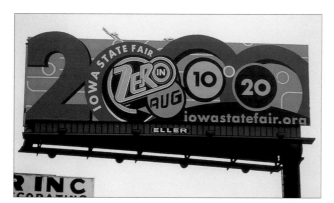

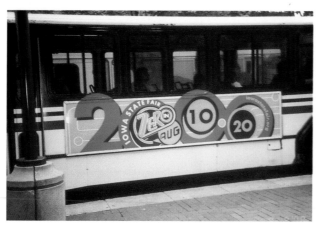

# The results

There's little doubt why Sayles Graphic Design continues to win back the Iowa State Fair's business year after year. Attendance at the fair has increased steadily each year; the 2000 fair attracted 978,841 visitors, the largest number in history of the 146-year-old event, and the overall attendance in 2001 is expected to exceed one million visitors. The 2000 attendance figures beat 1999's record of 969,523 by 1 percent, according to Marion Lucas, manager Iowa State Fair. "While we didn't hit the magical million mark, we know we sparked millions of memories with our strong line-up of entertainment, track events, and contests, plus this year's special emphasis on technology and tradition," Lucas says.

Tickets sold in advance topped 150,000, a new record. Initial reports show concession and exhibit revenue up 3.5 percent over 1999 (and 12 percent over 1998). Midway income rose 11 percent. Sales of KYO Admission Kits, including gate admission, food and beverage coupons, plus ride tickets, increased a whopping 55 percent in their second year. More than one million hits were made on the fair's popular Web site-www.iowastatefair.org—during the eleven days of the fair, according to Kevin Duis of Ioweb Publishing Co. Unique visitors topped 278,000 from forty-six countries. Two grandstand shows were sellouts, including Christiana Aguilera plus 70s rock duo Styx and REO Speedwagon. Truck and tractor pulling drew nearly 6,000 fans. More than 9,400 people took in two nights of PRCA Rodeo, including a Thursday-night performance by Sawyer Brown, filling in for the ailing Chris LeDoux.

## What Worked

"Because it was a millennium fair, they did find money in the budget or shifted resources to do some additional things," says Clark about the event's record-breaking success. Small little things that added incrementally to the success included the addition of rotary billboards to the mix among other things. Promotions were distributed earlier and the team actually introduced the 2000 theme officially at close of the '99 fair with a formal media announcement, something they had not done before.

"Then, there are the things that we had no control over," Clark adds, citing the weather —sweltering heat and humidity on the first weekend where the heat index on the first Saturday hit 95 degrees and rose to 100 degrees on Monday. "But that's good fair weather."

# NICKELODEON QUIETLY BREAKS (minimalist graphics) THROUGH THE CLUTTER OF KIDS' TV PROGRAMMING

## The Client

When Nickelodeon debuted in 1984, it was a one of a kind—the only television network for kids. It was different, irreverent, fresh, and very successful. Since then the market has grown and there are plenty of new kid networks on the block. Nickelodeon, while still on top, had lost some of its irreverence and wanted a strategy to recapture its edge before it was too late.

**CLIENT:**
Nickelodeon

**DESIGN FIRM:**
AdamsMorioka

**ART DIRECTORS:**
Lisa Judson, Niels Schuurmans, Matthew Duntemann, Sean Adams, Noreen Morioka

**DESIGNERS:**
Sean Adams, Noreen Morioka, Volker Durre

**ILLUSTRATORS:**
Various

**PHOTOGRAPHER:**
Blake Little Photography

**PRODUCTION:**
Nick Digital

**COPYWRITERS:**
Sharon Lesser, McPaul Smith

**AUDIO:**
Voodoo Productions

**CAMPAIGN RUN:**
March 1999 through September 4, 2000

**TARGET MARKET:**
Children 4 to 12 years of age

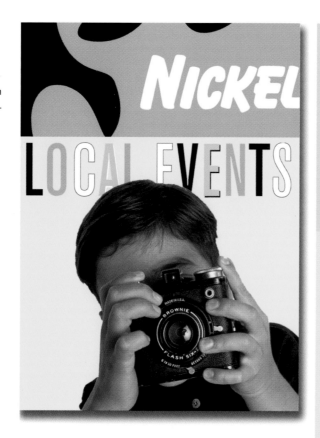

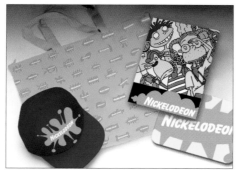

## The Brief

The network retained Los Angeles–based AdamsMorioka. The assignment: reevaluate, reposition, and restructure the Nickelodeon global brand. "The objective was to evolve the Nickelodeon brand visually and maintain its leadership position in an increasingly crowded competitive marketplace for kids' programming and entertainment. A primary objective was to remain true to the Nickelodeon attitude of flexibility and creativity, while increasing its visual presence," says Sean Adams, partner, AdamsMorioka.

"As opposed to many corporations that address issues of branding strategy after things stop succeeding, Nickelodeon was, and is, the leading network for children's programming. It has maintained a high level of expansion and success in new arenas such as movies, themed environments, on-line presence, consumer products and sister brands Nick at Nite and TVLand. The problem lay in the future. The need was to refocus and reclarify the Nickelodeon message during this extreme growth and expansion," he adds.

ABOVE: **A press kit was created to highlight local events.**

LEFT: **The new identity was applied to a variety of promotional items including hats, bags, and mouse pads.**

## Nine Months of Research

The final concept was born out of nine long months of painstaking research before designers started putting anything on paper. They conducted scores of interviews with Nickelodeon staff from people in the mailroom to the president of the network to determine where the brand was and where it should go, all the while keeping Nickelodeon's overall brand strategy and positioning top-of-mind. Most important, the brand had to become more focused and more proprietary now that there are other competitors on the market who weren't there ten years ago like the Disney Channel, Fox Kids, or Cartoon Network.

Designers watched hours of Nickelodeon's on-air programs such as CatDog, SpongeBob, and Rugrats —shows that have become network icons—as well as new programming still in development to try and get to the heart of Nickelodeon's identity. In addition, they audited hours of competing programming to get a sense of where they were going and to ascertain what messages were borrowed from Nickelodeon. "Nickelodeon once had ownership of kids' programming. We had to pull it back and re-own it and get to the heart of the story Nickelodeon is telling," says Adams.

## Minimalist Graphics

What they found was chaos. According to their research findings, the current marketplace of children's entertainment is literally exploding with opposing patterns, colors, and text layered together as often as possible. Designers queried, "What if we take the opposite tact?" Would a system composed of a very reductive color palette, simple typographic palette, minimal shape choices, and overall minimalist compositional vocabulary appeal to kids?

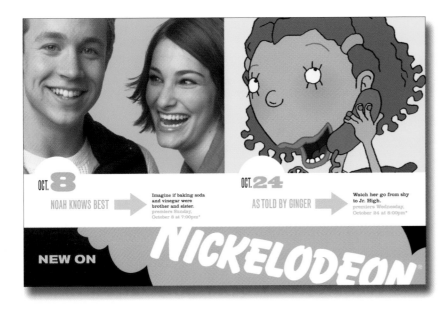

ABOVE: **Designers created this ad to raise awareness for new programs premiering on Nickelodeon.**

## Maintaining the Spirit

"The idea of creating a system for a brand built on irreverence, surprise, freedom, and creativity is challenging," says Adams, claiming that their biggest problem was trying to maintain the spirit of irreverence and flexibility that is inherent in the Nickelodeon system. "From the 1980s on, Nickelodeon always had amazingly fresh, innovative work. We wanted to keep that and make sure that the designers in-house didn't feel stifled by the system. When Nickelodeon was just a television network, it could get away with doing everything under the sun. That's part of the corporate culture—take risks, do new things, surprise us.

## Pulling the Design Back to Center

"We didn't want to lose that, but at the same time, Nickelodeon had grown beyond being simply a television network to a global brand, and that lack of focus was starting to dilute the brand. We had to figure out a way to refocus and pull it all back to center without losing that sense of irreverence and creativity."

Adams wanted to build a system that he could turn over to Nickelodeon's in-house design teams (consisting of about 300 designers in the off-air and on-air design departments, as well an advertising agency among others) that inspired creativity as opposed to stifling it. Rather than giving them a system that is very regimented, the idea was to give them a kit of parts. "The final system was, in fact, not a system, but a set of parts, a foundation for ideas rather than a collage, to be brought to life," he says.

In the end, AdamsMorioka turned the standards over to Nickelodeon's designers and said, "Here are all the parts, make something of them."

"I hoped I would see things that I would never expect...that we would be surprised all the time...that people would push it [the system] to its limits. We give them just the bones. We want them to breathe life into it," says Adams. "The graphic language is so strong in this, you can't screw it up. As long as you stay within the specific vernacular, everything is going to tie together. At the same time, everything should be different. It's television. It should be entertaining. It's not supposed to be hard-edged. We don't want to whitewash the network. We want to make sure there is variety."

## Implementing the Plan

AdamsMorioka thought so and established a strong set of criteria for the brand's growth, recommending several action steps, including refacing the on-air environment utilizing a strong proprietary system. The system was designed with the entire brand and all of its parts in mind. The first phase was the on-air environment, followed by implementation and planning for the system off-air (print media), consumer products, and international on-air components.

## Keeping it Simple

The basic concept came down to simplifying the color palette to make orange a more prominent color and simplifying the shape system so that the Nickelodeon logo, which changes shape all the time, doesn't have to compete with the background, and to push forward the product, which for Nickelodeon is its program characters, like CatDog and Rugrats. "These things together make the basic visual system hold together," says Adams.

BELOW: The do's and don'ts of Nickelodeon's visual system point to its simplicity in everything from the flexible logo to the use of simple typography and shapes.

## Clutter-Free Graphics

AdamsMorioka began the project in March 1999, but the result of their work did not hit the airwaves until September 4, 2000. The system as designed by the firm includes the identity positioning, identity usage refinement, on-air identity usage guidelines, five-second on-air bumpers, on-air promotions, on-air credit crunch, printed promotional collateral usage, and printed collateral.

In all instances, these items were created as prototypes for the new visual system. Some were used as is, while others work as primary examples for additional pieces to be created in-house. One such example is a poster featuring the character of Spongebob Squarepants, which was created as a prototype for an ad system intended to run in *Nickelodeon* magazine, a publication by and for the network. The basic ad format lent itself to most messaging and required only minor tweaking when Nickelodeon designers tailored the ad to include an announcement of a sweepstakes promotion targeted to people in the advertising sales department to generate regional ad revenue. The ad appeared in flyer form in Nick's internal magazine and communications.

## Cleaning up the Digital Clutter

Within the system, there are many unique aspects including the motion-free on-air promotions. Only still frames are used. The audio was also pared down from "big music" to sounds from a kid's life like ringing bells and barking dogs. "Slowing television down to a quieter place amidst the chaos that is utilized by most children's marketing was a brave choice on Nickelodeon's part," says Adams. "This reductive attitude in print also elevated Nickelodeon's overall visual equity amongst the thousands of patterns, different typefaces, and digital clutter.

"Kids are smart. I don't buy this thing that kids are idiots who will respond to flying shapes and lots of colors. They, like everyone else, want to be talked to intelligently and with respect," adds Adams.

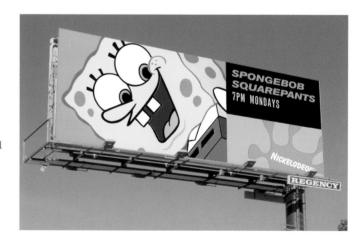

ABOVE: Billboard advertising promotes Nickelodeon's evening programming lineup.

RIGHT: This ad promotes
Nickelodeon's program,
Brothers Garcia and its
new timeslot on Tuesdays.

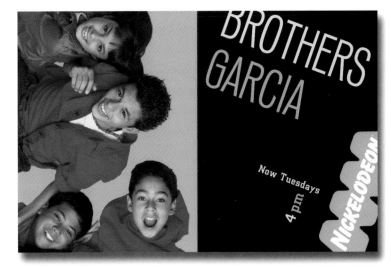

Similarly, AdamsMorioka created billboard advertising promoting Nickelodeon's evening programming lineup. Nickelodeon is no stranger to billboard advertising, having previously placed outdoor advertising in high-profile markets including Los Angeles, New York, and Orlando to promote new programming, special events, and environments like Blast Zone at Universal Studios, Florida.

Print advertising was also part of the mix. Adams Morioka created a variety of advertising prototypes for execution by Nickelodeon's in-house designers including one to promote the premiere of new programming and another variation to promote an existing program's new timeslot.

AdamsMorioka's press kit design provided the framework for a grassroots public relations spin-off campaign that was used to highlight local Nickelodeon events "coming soon to a town near you." "Local events are part of Nick's larger initiatives that promote and celebrate kids' power and ability to make change. The Big Help is a good example, serving as a catalyst for change; cleaning up the neighborhood, collecting canned food for the homeless. These initiatives were generated and made successful by real kids across the country," says Adams.

Finally, designers provided examples of how the new imagery would play on promotional items that Nickelodeon relies upon—including calendars, T-shirts, hats, bags, and mouse pads—which are regularly distributed to advertisers, affiliate networks, such as CBS and MTV, as well as Nick's creative partners.

Every element in the campaign—whether created as a prototype or used as is—features a reductive minimalist palette and shape library versus lots of flying things for a much more focused appeal. This graphic treatment not only marks a departure from competing children's networks, but also is a clear delineation from commercials, which are chaotic, too.

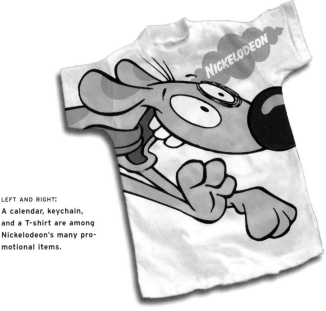

LEFT AND RIGHT:
A calendar, keychain,
and a T-shirt are among
Nickelodeon's many pro-
motional items.

On-air promotions consist of still frames only; there is absolutely no motion. Five-second on-air bumpers play like a slide show, all of which sets Nickelodeon apart from its competitors because it presents an abrupt calm. When channel surfing, one can't help but stop on Nickelodeon because it is paced so differently. "We could have made it louder and faster, but then, where would that stop?" asks Adams.

### Reaction—Inside and Out

The system has received critical praise from the business community and increased advertising revenue. Among Nickelodeon's in-house designers reaction has been varied. "There are those who embrace it wholly —and those that are more resistant," says Adams. "You can't design a system and allow more than three hundred designers to have input, but it seems that those who were not aware of the project, the marketing strategy, and brand issues behind it are a little more resistant to it.

"For someone to come in and say, 'Be creative, but you only get to work with five colors and this minimal typeface collection,' particularly when the previous dictate had been do anything you want, can frustrate designers who want free creative reign," Adams acknowledges. "Now it is getting a pretty good response. Those who were frustrated at the outset are finding that it has made their lives easier. It has stopped being a matter of 'I don't like that' and has become an issue of 'Are we communicating the things that the system should be communicating at all times?' It has taken some of the subjectivity out of the hands of the people who are handing out the assignments.

### Inspiring Creativity

"We found that by giving designers who are working on it fewer choices, it forces them to actually start thinking more about ideas as opposed to simply relying on a collage. This system was meant to be turned over to hundreds of people to implement, and we wanted to make sure that they were forced to think through a narrative storyline or come up with a funny punch line or interesting point of view as opposed to 'I'll take this pattern and this pattern and throw them all together.' The concept of ideas—not collage—seems to be working very well."

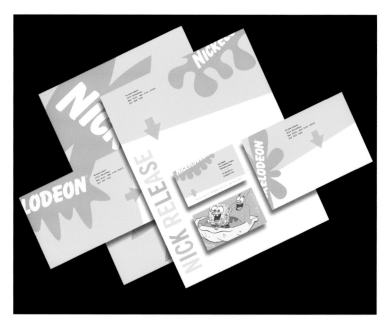

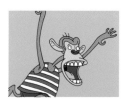

# The results

"Typically, it is difficult to point to higher ratings and increased revenue and claim that the redesign and focus of the brand is responsible. In the end, Nickelodeon's high quality of programming and product is responsible for this success," explains Adams.

The strategy and visual system added to this success in several ways. Primarily, clarifying the message internally promoted all decisions ranging from programming choices to the design of an ad to follow the Nickelodeon promises. The visual system increased brand recognition and ownership of properties on-air dramatically.

## What Worked

"[The system] works well because it addresses the bigger strategy issues versus just being nice graphics that decorate something. All of the elements are born out of a specific marketing need and are coming from a long-term goal," says Adams. "Television networks can fall into the trap of trying to look cool, so you just get this cake decoration on everything. We're happy that the system cuts to core of who Nickelodeon was and what it wanted to become and started a foundation to build on.

"This isn't the last iteration [of the system]. It is only the beginning of the project."

# CHILDREN'S TELEVISION WORKSHOP (equity graphics)
# GETS A NEW NAME AND IMAGE IN IDENTITY CAMPAIGN

CHILDREN'S TELEVISION WORKSHOP

**CLIENT:**
Sesame Workshop

**DESIGN FIRM:**
Carbone Smolan Agency

**ART DIRECTOR:**
Justin Peters

**DESIGNERS:**
Tom Sopkovitch, Christa Bianchi

**CAMPAIGN RUN:**
June 5, 2000 to Present

**TARGET MARKET:**
Media, partners, and licensees

## The Client

The Children's Television Workshop, a respected entity in children's television programming, enjoyed the equity it had built in its name, but at the same time, the name that had become so widely recognized for quality television programming, had also become limiting—leading the marketplace to think of the organization in terms of television only, while ignoring its other successful endeavors. It needed a brand identity that spoke to a larger audience and a short list of new names was developed. But, Children's Television Workshop knew this was not a project it could manage on its own; it needed help and turned to New York's Carbone Smolan Agency to craft a new name and launch an entirely new identity

ABOVE: **Children's Television Workshop was a good name with a great deal of built-in equity.**

OPPOSITE: **Carbone Smolan's early work showed the graphic possibilities of using just the words *Sesame Workshop,* all of which was positively received.**

## The Brief

When faced with the challenge of developing a new name and brand identity for Children's Television Workshop, designers at Carbone Smolan Agency faced the facts, and the truth was Children's Television Workshop was a good name with a great deal of built-in equity. In 1969, CTW made a significant impact on television that changed children's viewing forever by packaging educational programming in such a way that it appealed to children's natural attraction to a new electronic world.

Since then, children's media choices have expanded well beyond television, and once again, CTW is leading the way by seeking new ways to make the world of media more valuable to children. "Children's Television Workshop had been effective for three decades as an institutional descriptor, but its institutional nature had become a liability," says Ken Carbone, cofounder and executive creative director, Carbone Smolan Agency. "Additionally, CTW recognized the need to function as a brand with a name and identity that has clear and specific meaning to audiences and opinion leaders."

### Establishing a New Identity

"Research showed that for those who recognize CTW at all, it is virtually interchangeable with public television and other brands that produce children's programming. In these fast-paced times, parents (and kids) need brands that signal quality and trust. With a powerful global brand in their portfolio —Sesame Street—that represents a cultural touchstone synonymous with a dedication to children, education, and fun, CTW sought to capitalize on this shorthand equivalent for excellence in children's media," says Carbone.

The short list of alternative names included Sesame & Co., Sesame Unlimited, and Sesame Workshop. CTW felt each one worked because each borrowed upon CTW's equity in Sesame Street while suggesting an entity that was more than television programming, but devoted to multimedia. Carbone Smolan's proposal cover captured this and was instrumental in helping them win the business. But when the list had to be narrowed, representatives of Carbone Smolan felt that neither Sesame & Co. or Sesame Unlimited were distinctive in any way, but neither did they advise starting over with an entirely blank slate. Instead, they suggested CTW build on the equity of Sesame, known internationally, plus Workshop, which connotes energy and a place where new things are created, invented, experimented with, and built. The name provided a good foundation by which to imbue it with all kinds of character and visual cues that would suggest what the new mission was—to become a new multimedia enterprise.

Research also revealed that the word *workshop* was rich with meaning. It connotes a creative, stimulating, and active environment. The new name, Sesame Workshop, fuses the best of CTW's past while providing a branding platform for the future.

Moreover, it included part of the original name—Children's Television Workshop—that gave the new name even more value. Carbone Smolan's early work showed the graphic possibilities of using just the words Sesame Workshop, all of which was positively received. But then, designers started rethinking using only letterforms for the mark and wondered what else they could do creatively to bring brand essence or some kind distinctive character to the name. When the team looked at the competitive landscape, they found a lot of icons, symbols, and characters. "So we said, 'Let's try to develop a mark or symbol that is more embraceable by this particular audience, which is kids and parents, than just a name,'" says Carbone.

### Weighing the Value of Feedback

"Consumer testing was one of the obstacles when our very simple house started to take on characteristics that made it look like a chateau," jokes Carbone. Comments received in early testing suggested changes to make the house appear more global, more fun. "You have to know how to sift through all that and there were some bumps in the road, but in some cases we were trying to translate, too literally, the requests, which compromised the simplicity [and] the clarity that the logo needed to have. The design team delivered a revised house based on all the recommendations set forth in the testing, presented it alongside the original house, and asked "Which feels more vibrant and warm?" It was unanimous—stick with the original concept. "I think of it [feedback] for reference, not direction," advises Carbone.

### Navigating Tight Deadlines

Also complicating the project was its urgency. CTW wanted to launch the new image by June 5, leaving only about six weeks of production time. Then, there was the International Film and Programme Market for Television, Video, Cable, and Satellite (MIPCOM) exposition in Cannes, France, where Sesame Workshop's trade show booth made its debut— in record time as well—marking the first three-dimensional expression of the brand.

### Giving Voice to the New Identity

The word *workshop* suggested a place, a shelter, a safe haven, but what kind of place should it be, designers wondered, a spaceship or some other vehicle that can take you places, or a house? They ultimately decided on a house so full of energy and creative activity that it is literally exploding through the roof. A shooting star soars past the roof to suggest a source of ideas and inspiration. "The new logo symbolized the visceral and intellectual benefits of CTW's work in the lives of children," says Carbone. "It really defined the brand. It has a luminescence about it. It has its lights turned on. There's also a graphic innocence that appeals to this audience; it is bold and bright. It is also unadorned, but rich. It's not complex and dense. The voice, meaning the editorial voice, is all about being witty and clever."

### Play by the Rules. Have Fun. Love Sesame Workshop.

It is that kind of direct language that is found throughout this brand, so the voice of the brand is very much embedded in the voice behind the workshop. "We also made it lean, in that a lot of its properties are character-based, very fluffy, kid focused, so that when it has to be used with Big Bird or Elmo or other character-based brands it isn't too cute or saccharine, but kid friendly," says Carbone.

### The Creative Process

With the basic logo in hand, designers developed the brand architecture, an analytical process that included finalizing the color palette, typography, and testing how it worked with other partners such as Sony and Nickelodeon. In addition, designers looked at how the mark would work in one-color, against a background and test how it would work in print, on air, and digitally. We have a primary palette, secondary, and tertiary palette that allow people to work with the brand, depending upon the environment. As a result, a palette of primary colors was chosen for the identity that included both the constant elements and those that would evolve in response to different contexts in which the mark is used. The new mark was then applied to identity materials, advertising, press kits, signage, a new home page, among dozens of other pieces.

### The Internal Launch

The identity program was launched internally to 500 in-house staff, board, and partners—totaling a 2500-unit mailing to introduce people to Sesame Workshop. The team focused as much on the internal launch as the external one because both are equally important to building a brand. Overnight the change took place. One day employees walked out of Children's Television Workshop and the following workday they showed up for work at Sesame Workshop. Everything from business cards to memo pads had changed. Employees received new materials and everything they needed to do business, as well as a handsomely designed "thank you" brand book from the president and CEO that recognized how difficult change can be while reassuring employees that CTW's original mission was still intact.

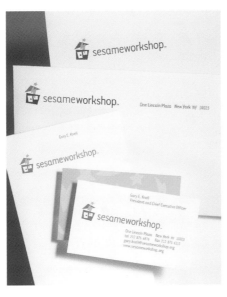

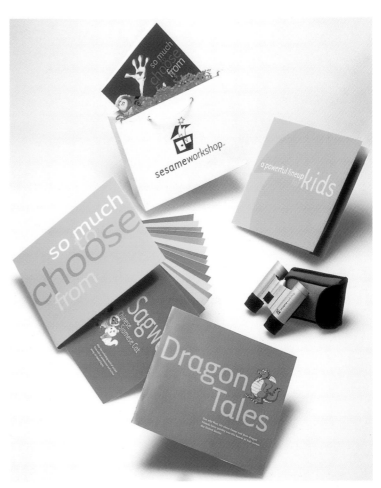

Why the focus on the internal audience? "You want to change naysayers into cheerleaders," says Carbone. "I work with corporations who have all kinds of money to throw at their brand launches; all kinds of resources to make sure things happen efficiently, on time, and in a way that the whole culture of the company embraces. It isn't easy. Change is difficult. You have to manage that change very carefully so that everyone from the receptionist to the CEO can embrace it and get behind it and, essentially, become ambassadors of the new brand. I see many companies who don't do this very well. This organization is nonprofit with limited resources. They are always strapped for staff to do these kinds of things, yet with all these obstacles, they launched this brand 100 percent on the day they made the announcement. When people came to their offices June 5, they already had the new letterhead and business cards…it was a wonderful moment because the

momentum that's built with that and the goodwill that's built was invaluable. As an organization, they were terrific in getting behind this and understanding the value in not letting it trickle out.

"This wasn't about dropping a pebble in the pond and watching the gentle ripples emerge from it. This was about throwing something substantial in the pond and making a big splash and having the ripple effect be controlled the way you want it to be. Over a weekend, the culture changed, the brand essence changed. The only thing that was missing at the launch was the redesign of their home page, which wasn't launched until November 2000."

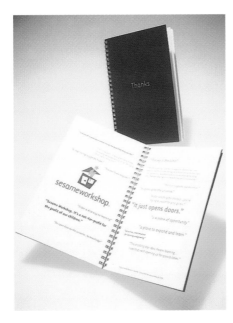

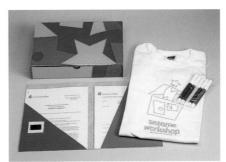

## The External Launch

The logo itself is deceptively simple. On paper, it is reproduced in simple four-color process, but Carbone says that it is its simple, unadorned nature that makes it successful. Which is a plus, because the mark was applied to a range of paper elements from the new corporate identity to program literature, as well as T-shirts that were distributed to Sesame Workshop's external audiences.

A media launch kit including a box with a T-shirt and set of markers for coloring in the logo line art, press kit, and folded card announcing the name change from Children's Television Workshop to Sesame Workshop was distributed to media, partners, the Board of Directors, various potential sponsors and sponsors including the Corporation for Public Broadcasting. An announcement card spread the word of Children's Television Workshop's name and identity change. Similarly, print advertising was placed in a diverse collection of media ranging from *Parents* magazine to *Variety*, and the *New York Times* announcing the new Sesame Workshop name and identity.

The debut of Sesame Workshop's trade show booth at the International Film and Programme Market for Television, Video, Cable and Satellite (MIPCOM) show in Cannes, France, marked the first three-dimensional expression of the brand. There, a custom branded pair of binoculars was gift packaged and distributed by the hotel staff and left as a surprise gift for potential partners to find upon returning to their hotel rooms. The gift was packaged in a custom pouch with Sesame Workshop's URL emblazoned on it along with the tagline, "For more than bird watching" to encourage prospects to think of Sesame Workshop as more than Big Bird, particularly in light of its three new programs being launched at the show.

Throughout the creative process, designers had to ensure that the brand would work in myriad applications from two-dimensional art to a digital, animated version used at the end of the shows, in broadcast, as well as in three-dimensional environments. To ensure accuracy in all its forms, Carbone Smolan laid out the do's and don'ts for the new Sesame Workshop logo and identity in its *Standards Manual*.

BELOW: Print advertising announced the new Sesame Workshop name and identity.

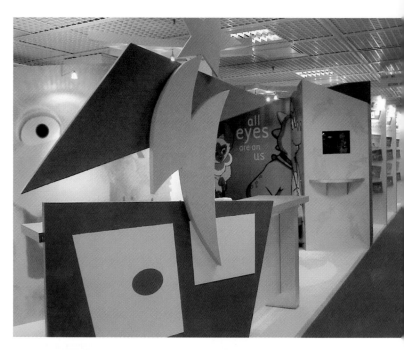

TOP, MIDDLE LEFT AND RIGHT, AND LEFT: The debut of Sesame Workshop's trade show booth marked the first three-dimensional expression of the brand.

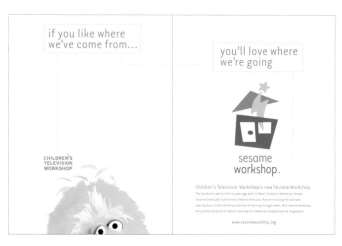

## The Budget

As for the budget, "It's never enough, but for this organization, they put in the proper investment," says Carbone. "[It was a] careful balancing act of giving them a 200 percent solution while being careful of the time. The brand was not built to be extravagant. I'd like them to put their money into their programming. I have two-year-old twins so I'm immersed in this. I like the fact that we've given them a brand that doesn't require eight-color printing. It doesn't require elaborate packaging and promotion, it can be done simply and effectively."

# The results

Throughout the process and after the launch, the client was so happy with the work that it has continually awarded Carbone Smolan more work, which is always an indication of satisfaction.

## What Worked

Without digging too deep, one would be inclined to cite the obvious factors to explain why this promotion worked so well: A strong belief in the concept that was not swayed to its detriment by focus-group feedback; a client who backed a launch 100 percent instead of letting it dribble out; an adequately funded budget; and an agency that was willing to give a 200 percent solution. But there are other reasons why the promotion worked, according to Carbone.

"[The promotion] helped what we call legacy brand. It helped navigate a complex maze where we have 100 percent buy-in across the organization. The materials that we gave them—from the overall brand essence to the way the trade show was built-on a tactical level, everything we did was on brand and showed anyone who worked with the brand in the future that this is the way it should be done. This is the vocabulary," says Carbone.

"We've given them the right tools to make this campaign work on a continuing basis. That's why I think it really works. The brand platform that we developed is something that can grow organically over time without losing its basic foundation. They work with a lot of different companies, so it's important that they have a viewpoint that can be embraced by others and work. If this brand had been more designer-ly with bells and whistles, it would be bound to fall apart. In its simplicity, it has a great chance of succeeding for a long time."

# INTERNET SERVER LAUNCH (ancient asian graphics)
# COMBINES HIGH-TECH WITH ANCIENT ASIAN SYMBOLOGY

## The Client

iAsiaWorks, a leading Internet data center and hosting services provider across the Asia-Pacific region, came to Gee + Chung Design in search of an identity and a name. They also needed help positioning the start-up company as setting the standard for Internet data centers and hosting services providers across the Asia-Pacific region, while supporting their tagline of Global Technology. Asian Focus.

The Gee + Chung design team had a special interest in this prospect because AUNET, as iAsiaWorks was then known, had an Asian background. Gee + Chung Design was well skilled in high-tech clients from its work with IBM, Oracle, and Apple but rarely had the opportunity to do much work that utilized the firm's own Asian roots. Here was the opportunity they were looking for, but there was one hitch. The work had to be done quickly—which posed little problem for this firm, which thrives on tight deadlines.

CLIENT:
iAsiaWorks, Inc.

DESIGN FIRM:
Gee + Chung Design

ART DIRECTOR:
Earl Gee

DESIGNERS:
Earl Gee, Kay Wu, Qui Tong

PHOTOGRAPHERS:
Kevin Ng, Kirk Amyz

PRINT AND WEB PRODUCTION:
Adrian Fernandez

COPYWRITER:
iAsiaWorks, Inc.

CAMPAIGN RUN:
January 1, 2000 through Present

TARGET MARKET:
Multinational corporations, Asian businesses, and leading Internet companies

## The Brief

The foremost objective was to develop a name and identity. Designers didn't waste any time getting to work on name suggestions and placing them into logo form. InAsia was a top choice as was PanAsia. The client researched the availability of URLs for each name in all the countries they wanted to target while Gee + Chung Design visually interpreted the name as possible logos. Treatments ran the gamut from those that used various interpretations of the Chinese yin yang symbol to graphics of a Pacific wave, rising sun, Chinese lantern, the Chinese symbol for man, and even a collage of interlocking letterforms. Unfortunately, AUNET couldn't secure a URL in all their target countries for either name, but it was only then that they discovered the possibilities of the name iAsiaWorks, which worked as well if not better than the previous names.

As designers settled in to develop the logo for the chosen name, they reviewed the original motifs and decided to borrow an earlier design with interlocking letterforms—stylized capital P's-initially prepared for PanAsia—worked equally well with iAsiaWorks. It was a classic motif and aptly communicated connectivity and high-tech circuitry.

LEFT AND BOTTOM OF OPPOSITE PAGE: Gee + Chung visually interpreted the possible names InAsia and PanAsia as possible logos. Treatments ran the gamut from those that used various interpretations of the Chinese yin yang symbol to graphics of a Pacific wave, rising sun, Chinese lantern, the Chinese symbol for man, and even a collage of interlocking letterforms. When AUNET couldn't secure a URL in all their target countries for either name, they opted for the name iAsiaWorks.

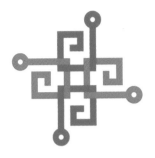

# iAsiaWorks
## *Global Technology. Asian Focus.*

ABOVE: The iAsiaWorks logo and variations of it were carried through each element of the campaign to create a visual that when combined with an integrated circuitry pattern functions as a visual metaphor for linking Asian cultures through technology.

RIGHT: The iAsiaWorks stationery system utilizes an outline pattern of the logo simulating gold embroidery on red silk and a dot pattern derived from the logo and representing an ancient Chinese door.

### Creating a Visual Metaphor

Because the design objective included communicating the Global Technology. Asian Focus message in the logo as well as each succeeding campaign component, designers decided to include Asian-inspired images as visual metaphors that when combined, compared, and contrasted with high technology images, created unusual and unexpected juxtapositions of graphics. Gee + Chung created several of these design elements that were used consistently throughout the entire campaign.

One such element is the use of a universally accepted Asian color palette of red, gold, and black, which is prevalent throughout many Asian cultures and connotes such positive characteristics as good luck, good fortune, prosperity, and longevity. The word iAsia was set in red type because it complemented the word *Works* in black and the color break played to the logo's advantage. A modified extension of the logo form— an outline—was replicated as a gold outline on a red field, simulating gold embroidery on red silk, and was established for secondary uses. The secondary system also employed a pattern of reversed out, embossed circles—representing the pattern on an ancient Asian doorway and symbolic of a gateway to Asia—which gave the presentation folder a dynamic tactile aspect.

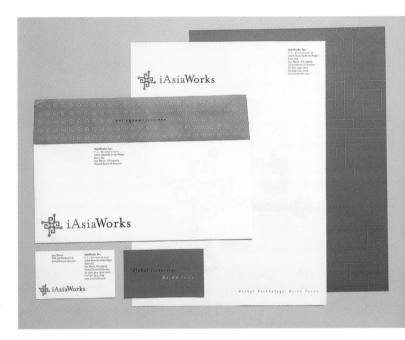

### Tying the Imagery to the Message

The iAsiaWorks logo, its outlined version, and other Asian-inspired graphics were carried through each element of the campaign to create imagery that when combined with an integrated circuitry pattern, functions as a visual metaphor for linking Asian cultures through technology. For example, the iAsiaWorks stationery system utilizes both the standard logo as well as the outlined version simulating gold embroidery on red silk and a dot pattern derived from the logo, representing an ancient Chinese door. The presentation folder uses the logo to form a string tie clasp, transforming the folder into a special gift for potential clients. The inside pockets have embossed dots simulating the rivets on an Asian door, and the curved flaps convey a Chinese moongate motif.

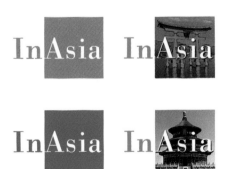

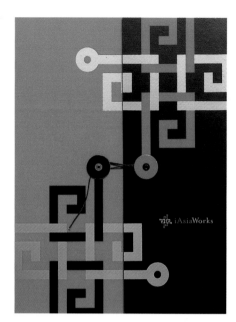

LEFT AND BELOW: iAsiaWorks'
presentation folder uses
the logo to form a string
tie clasp, transforming the
folder into a special gift for
potential clients. The inside
pockets have embossed dots
simulating the rivets on an
Asian door, and the curved
flaps convey a Chinese
moongate motif.

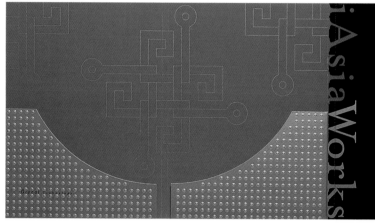

BELOW: Product data
sheets juxtapose similar
graphic elements. Where
one photographically
compares and contrasts
the spherical shape of
a Chinese fan to the
globe, another compares
and contrasts Chinese
firecrackers to a fiber
optic cable.

BOTTOM RIGHT: With a lim-
ited budget, Gee + Chung
Design put their creative
minds to work and devel-
oped iAsia's party invita-
tion in the form of a large
drink coaster. They used
letterpress printing on
thick blotter paper, cre-
ating the effect of a Chi-
nese seal on parchment.

The trade show promotion uses an accordion-fold for-
mat to define who and what iAsiaWorks is—placing
its mission statement on one side, while the reverse is
a handy reference guide for business travelers in Asia,
detailing the language, climate, currency, and business
protocol in the twelve regions in which iAsiaWorks has
facilities. Originally, this piece was intended to be as a
24" x 36" (61 cm x 91 cm) mission statement poster for
hanging on office walls. When Gee + Chung presented
the design, they did so at half size, like they do many
of their comps. The CEO took hold of the miniature
mock-up, which was still readable at its reduced size,
and thought it was a nice size to keep handy in one's
pocket, luggage, or on a desktop. The obvious question
arose: What if we were to build in some utility and
function to this piece? As a result, the idea of a poster
was discarded in favor of the palm-sized piece. This

piece, too, perpetuates the Asian influence and reads front to back as well as back to
front. Because it has a lot of folds, designers developed a handsome sleeve that pro-
vides a tidy and compact way to hold it together securely and compactly.

Product data sheets use an interesting juxtaposition of two similar graphic ele-
ments—which vary from one data sheet to the next. Where one photographically
compares and contrasts the spherical shape of a Chinese fan to the globe, another
compares and contrasts Chinese firecrackers to a fiber optic cable.

The Web site, www.iasiaworks.com, incorporates a vertical navigation menu on the
right side of the page, reflecting how Asian cultures read from right to left.
Conceptual headers combine Eastern and Western visuals through the site. As the
viewer clicks on map locations, news about iAsiaWorks in each region pops up.

iAsiaWork's party invitation provided entrée to a must-attend event at ISPCON, a
major industry trade show. The budget was limited so Gee + Chung Design put their
creative minds to work and developed an invitation in the form of a large drink
coaster. They used letterpress printing on thick blotter paper, creating the effect
of a Chinese seal on parchment. The low-tech, tactile, craft-oriented appeal of the
letterpress printing was a dramatic departure for the high-tech Internet industry,
making the invitation a big hit and drawing twice as many attendees as expected
while generating plenty of talk about the company.

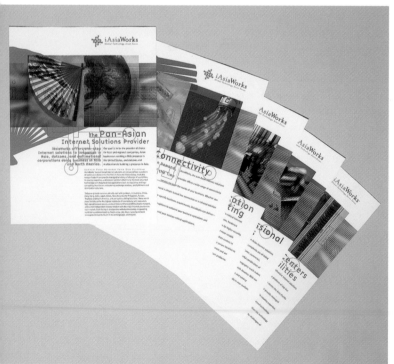

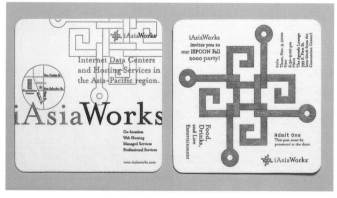

Integrating all these pieces wasn't as tough as one might think; designers treated each piece as a separate project versus a component of a campaign. They did this to avoid using the same elements over and over again, which can lull designers into treating designs as applications versus standalone items. "Keeping things fresh requires looking at each piece individually even if it is part of the graphic vocabulary," says Earl Gee, art director on the project.

**ABOVE, RIGHT, AND TOP OF PAGE:** The trade show promotion uses an accordion-fold format to define who iAsiaWorks is on one side, while the reverse works as a handy reference for business travelers throughout the twelve regions where iAsiaWorks has facilities, detailing the language, climate, currency, and business protocol. Because the brochure has a lot of folds, a sleeve provides it a tidy way to hold it together securely and compactly.

## Two Messages—One Campaign

"Our biggest problem was the challenge of communicating the dual messages of Global Technology. Asian Focus. We needed to create solutions that were not specifically Chinese, Japanese, or Korean, but concepts that would resonate with and be embraced by as many Asian cultures as possible," says Gee. "We solved the challenge of Pan-Asian communications by determining that China was, by far, the market with the largest potential for our client, and a majority of Asian cultures share elements of the Chinese culture. Consequently, designs with Chinese derivations could work effectively across a number of Asian cultures." Gee specifically points to the photographic elements on the data sheets as a prime example of mixing the high-tech aspects of the project, such as a fiber optic cable, with the Asian focus, graphically communicated by a Chinese firecracker. As the program continues and is extended in other venues and collateral materials, Gee doesn't worry about running about of material. "There are an infinite number of ways to compare and contrast the two messages," he says.

## Location, Location, Location

A related obstacle was geography. While iAsiaWorks has an office in San Mateo, California, not far from Gee + Chung's San Francisco office, the company's chairman and CEO, JoAnn Patrick-Ezzell, is based in Hong Kong, a full sixteen hours ahead of Pacific Standard Time in San Francisco. "Our development time frames were severely truncated as iAsiaWorks was a startup in the emerging space of Internet data centers and Web hosting with a very small window of opportunity to make their mark," says Gee. "Five P.M. conference calls became the norm to keep client feedback and approvals on schedule. Our previous experience with the accelerated timeframes of dot-com startups enabled us to work efficiently and quickly to deliver the corporate identity in two weeks (with three name changes along the way), the stationery system in three days, and the presentation folder in a day."

## The Budget

As for the budget, Gee + Chung, having worked with a number of Internet start-up launches, found it to be reasonable. But more importantly, particularly in light of the timeframe, the client was efficient with feedback and approvals. Still, the designers were always seeking ways to maximize the budget, primarily by gang printing data sheets and other items whenever possible to economize printing costs.

THIS PAGE: The Web site, www.iasia-works.com, incorporates a vertical navigation on the right side of the page, reflecting how Asian cultures read from right to left. Conceptual headers combine Eastern and Western visuals through the site. As the viewer clicks on map locations, news about iAsiaWorks in each region pops up.

# The results

Gee + Chung's materials for iAsiaWorks have impacted the industry from the moment they hit the street. "Our client has been able to launch a successful IPO while expanding operations from three countries to fifteen countries throughout Asia in only a nine-month span. They have also grown from twenty employees to 250 in the U.S. and Asia," says Gee.

## What Worked

"Chairman and CEO JoAnn Patrick-Ezzell credits our unified graphic team as being 'instrumental in iAsiaWorks' expansion and acceptance across Asia, creating communications that convey the company's mission, while resonating with their Asian audiences,'" says Gee. "Patrick-Ezzell was very pleased that after one press conference, a reporter interviewing her commented, 'That is really a nice logo.'"

# TIPS FROM THE EXPERTS Experiment...be flexible...build in practicality

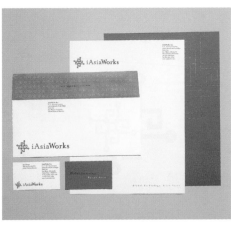

**CREATE VISUAL METAPHORS**

iAsiaWorks' logo and variations of it created a visual metaphor that link Asian cultures and technology.

**KEEP LOGOS FLEXIBLE**

Designers created an outline version of the iAsiaWorks logo as part of a secondary system that dresses up the letter-head system and presentation folder.

**MAKE BROCHURES HARD TO DISCARD**

iAsiaWorks' presentation folder incorporates a string tie clasp, embossed pockets, and special die-cutting that transforms an ordinary presentation folder into a special gift that prospective clients will be hesitant to throw away.

**PRACTICAL ITEMS HAVE STAYING POWER**

iAsiaWorks' trade show promotion defines who iAsiaWorks is on one side, while the reverse works as a handy reference for business travelers throughout the twelve regions where iAsiaWorks has facilities, detailing the language, climate, currency, and business protocol.

**HAVE FUN WITH PARTY INVITATIONS**

iAsiaWork's party invitation provided entrée to a must-attend event and developed an invitation in the form of a large drink coaster, which was effective despite the low budget.

**BREAK THE RULES**

The Web site, www.iasiaworks.com, incorporates a vertical navigation on the right side of the page, reflecting how Asian cultures read from right to left—in stark contrast to typical Web page formatting.

# A UNIVERSAL SYMBOL (symbol graphics) PROPELS THE GRAPHICS FOR ANNUAL GLOBAL CAMPAIGN

## The Client

Like many graphic design firms, Pepe Gimeno—Proyecto Gráfico inherited a problem when, in 1998, it was awarded the job of promoting the 36th annual Valencia International Furniture Fair scheduled for September 1999. The fair, the third biggest trade fair in Europe and one of the biggest in the world in its sector, annually attracts exhibitors and visitors from around the globe. That was the good news.

**CLIENT:**
Valencia International Furniture Fair

**DESIGN FIRM:**
Pepe Gimeno—Proyecto Gráfico

**DESIGNERS:**
Suso Pérez, José P. Gil, Didac Ballester

**CAMPAIGN RUN:**
September 1998 to Present

**TARGET MARKET:**
Furniture manufacturers and industry professionals, the general public

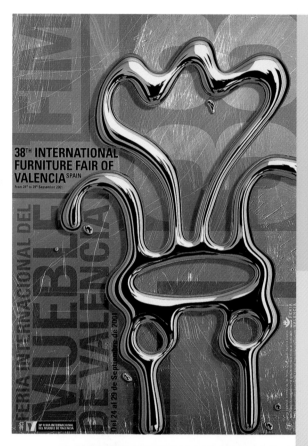

## The Brief

On the downside, designers quickly realized that one of the greatest problems they were up against was the weak and vague image of the fair due to the lack of consistency in the communication and approaches used in previous years. Given the situation, they focused their attention on three primary goals: Creating an image that could be maintained and transformed to get consistent and continuous communication over several years; creating an image that would reflect the variety of styles and trends in furniture exhibited at the fair and the international nature of its visitors and exhibitions; and creating a style of its own to differentiate the Valencia Fair from its competitors.

LEFT AND BELOW: **The designers' interpretation of the chair symbol that identifies promotional materials for the 2001 fair as applied to a poster and a direct-mail postcard.**

LEFT: Designed fashioned the symbol of the chair from wide black, blue, and pink brush strokes to represent the 36th annual Valencia International Furniture Fair in September 1999.

## Creating a Campaign That Translates

One of the biggest problems facing designers was the vast number of countries and variety of languages that had to be considered in the promotional materials. Designers had to translate copy into eight languages and address the corresponding semantic problems in each country that could hinder communication.

Dealing with language barriers made the use of the chair system that much more important to successful communication. The chair—a dynamic, globally recognized symbol—worked as well at communicating as any headline could do.

## Crafting a Symbol to Differentiate

Designers pored over old promotions and brainstormed in an effort to find a means of achieving not just one, but all three of their goals. Surprisingly, they found a solution in a promotion created for the fair in 1991 by Mariscal—a chair. If they made the chair the standing symbol for the event and used it annually, designers reasoned, they could achieve the consistency and continuity that they wanted.

## The Common Denominator

They made their recommendation and, anticipating their client's reaction, was ready with a response: To avoid the monotony of using the same symbol year after year, they would craft different interpretations of the symbol using different graphic styles and techniques. The client signed onto their proposal and the firm set to work on the 1999 event, seemingly fashioning the chair from wide black, blue, and pink brush strokes.

When the time came to get to work on the 2000 event, designers wiped the slate clean of everything but the chair, and this time, gave it an abstract interpretation, coloring it in warm shades of orange, gold, red, and rust.

LEFT: Designers interpreted the chair in abstract patterns and colored it shades of orange, gold, red, and rust for the 2000 event.

## Carrying Out the Theme

Designers targeted the general public through traditional materials including a poster, display unit, and an advertising insert in the press and specialized magazines, the latter of which was limited due to budget restrictions. In addition, a parallel campaign targeted manufacturers and other professionals in the furniture sector with a direct-mail promotion. The imagery in all the supporting materials remained consistent regardless of which market was targeted as designers applied the common denominator for the whole campaign—the chair—to all supporting materials.

## Regular Direct Mailings

Other mailers included the seven-adjective postcards where designers attempted to define the fair using seven different adjective ranging from *fascinating* to *pioneering* and *profitable*. Each adjective was given its own postcard and its own interpretation of the chair icon. The seven postcards were bound in the form of a booklet and, yet, could be separated easily.

Designers used a clear plastic CD-ROM jewel case as a display unit and container holding the sheets of a 2000 calendar. Once again, each month featured a different stylized illustration of the familiar chair symbol. The calendar also included a registration form for those wanting to sign up early to attend the event.

Since the designers' goal was to develop pieces with staying power, a mouse pad was included in the direct-mail mix. It was lightweight, useful, and easy to mail in quantities of 70,000 in its handy cardboard envelope.

## Weighty Issues

As with any direct-mail campaign, one of the greatest concerns when designing objects for mailing is their weight. The other is finding an item that will be something the recipient will use, which extends its lifecycle and keeps the promoter's name top-of-mind. Designers found that a metal page marker solved both issues—being lightweight and practical. They attached it to a large card and mailed it to the trade group—a mailing of 70,000 pieces.

A high-end book, detailing the entire history of the fair, its present and its future aims, was created as a special promotional item for 1500 recipients. The book featured new iterations of the chair along with full-page, full-color photography. Totaling 108 pages, the book was printed in four colors, bound with a hard cover, thermoprinted on the cover and spine, and accented with a tip-on label. A smaller version of the book, summarizing the history of the fair, was produced in a larger quantity of 70,000. It, too, was printed in four colors and featured abundant photography and included a CD-ROM with additional information.

Other items produced included a bag to carry materials picked up at the exhibition and animated graphics that opened and closed a series of advertising-report features broadcast on television.

The designers' hope was that recipients would find the materials so useful and ingenious that they would keep them around until the next year.

## Consistency, Yes—Monotony, No

Designers had created a single image, which underwent successive transformations and yet still retained its visual interest with each iteration. Designers managed give the same image an entirely new look. In some examples, the image is extremely subtle and almost hard to find in the abstract treatment, in others it is bold and fresh, sometimes technological and cold; sometimes it is rendered as a whole and other times its parts are shattered into pieces. Whichever treatment it receives, the image always comes forward as something new and rejuvenated. Designers realized that apart from maintaining visual interest in all the marketing materials, the concept they hit upon accurately described the wide range of products and styles shown at the fair.

LEFT AND BELOW: A smaller version of "history" book, summarizing its past, was produced in a larger quantity of 70,000. It, too, was printed in four colors and featured abundant photography and included a CD-ROM with additional information.

## The Curiosity Factor

The concept has a built-in curiosity factor as well. One can't help but wonder what form the chair will take on next. What could designers possibly dream up that will match what they've already produced? The recipient is intrigued and subconsciously looks toward the next transformation.

The designs are not selling a consumer product but are promoting a service, the potential for business. There are no points of sale; the only channel for communication with potential customers is through the media that specifically talks to the habitat and interior decorating markets. Here is a promotion with universal scope, yet the budget did not allow for a great deal of advertising placements. Consequently, advertisements appeared in a lot of media but with little intensity—perhaps only one or two times per year.

## The Budget

Ostensibly, the overall budget of approximately $800,000 was adequate, but because the promotion was on an international scale and there were many media outlets in several countries that had to be targeted, designers had to be vigilant about costs to ensure that the budget could be stretched to cover all the necessary advertising, as well as the direct-mail campaign, which totaled nearly 70,000. Given the size of the mailing list, the budget for the 2000 mailing campaign was increased by about $19,000 over 1999, while the advertising budget was reduced by close to $11,000 from the previous year. Given the budget restraints, designers took extra pains in researching and choosing the communication media slated for advertising insertions to ensure they were on target and further controlled the budget by keeping a tight reign on the weight of mailers so that postage costs wouldn't escalate out of control.

RIGHT: A CD-ROM, packaged in a thin tin, carries the graphics into another realm.

RIGHT AND FAR RIGHT: The *Full-Time Furniture* booklet asks the question on everyone's mind: What is the shape of the future?

# The results

Exhibitors increased steadily in the years since Pepe Gimeno—Proyecto Gráfico assumed responsibility for promoting the fair—starting at 1203 in 1998 and rising to 1400 by the year 2000. Visitors also were on the rise, up from 67,200 in 1998 to 73,300 in 2000. Similarly, profits rose since the firm took control for promoting the event.

## What Worked

Designers unanimously cite the use of a symbol, which they have successfully reinterpreted in numerous variations, as being the key to the campaign's success because it cleanly cuts across language barriers. They also point to the campaign's supporting graphics—color, texture line, and materials—as helping turn the promotional graphics into a universal language that conveys the diversity and international nature of the event.

"The continuous reinterpretation of the same graphic element without losing sight of the particular evolution of the market itself, the capacity for generating new concepts helping us to extend the standpoint that we have of the furniture industry, and the harmonious use of spaces and proportions in each of the different materials that we generate succeed in giving the image of the International Furniture Fair a dynamic, simple, and extremely compact message," says Didac Ballester, one of three designers on the project.

"The proper functioning of these image campaigns for the International Furniture Fair is, above all, due to the approach that has been implemented in each phase of the work," adds José Pascual Gil, designer. "A well-defined image and differentiating characteristics for the International Furniture Fair as a whole provide a central axis that can be used in all the campaigns and that marks out the boundaries for the message content in each of these.

"In each campaign, we tend to stress only one or two very basic and forceful concepts that we attribute to the International Furniture Fair and that can be understood in all the sociocultural contexts in which they are issued," he says. "Using the image as the real carrier of the message, the texts and the large number of translations…lose their starring role and allow us to use a more universal language. The form of the campaign image is a synthesis of a very large number of different standpoints and techniques from which the treatment of the chair as the main element is tackled. This variety and rich depth of work help the image be expressive and specific, as well as novel, apart from extending the perspectives for the campaign for the following year."

# DESIGNERS PUT A FACE (personal graphics)
# ON THE AUSTRALIAN CHAMBER ORCHESTRA'S IDENTITY

## The Client

The Australian Chamber Orchestra (ACO) wanted to stand out and distinguish itself from other major Australian orchestras. It needed a brand that would carry the orchestra into the future. Youthful, vibrant members characterized the ACO as a dynamic orchestra to watch.

The ACO called upon Chris Perks Design —CPd to create an image that would usher the orchestra into the millennium and beyond. Their branding choice was a fairly obvious one—play up the orchestra's primary asset: its members. CPd proposed photographing the orchestra members. "Because the orchestra is young and passionate about their work, we felt it important to convey that energy and vibrancy through both the photography, how it is used, and the typography. We still needed to portray the ACO as a classical orchestra but with a contemporary edge," says Nigel Beechey, art director.

CLIENT:
Australian Chamber Orchestra

DESIGN FIRM:
Chris Perks Design—CPd

ART DIRECTOR:
Nigel Beechey

DESIGNERS:
Nigel Beechey, Fiona Catt, Donna Taylor

PHOTOGRAPHER:
Greg Barret

COPYWRITER:
Jon Maxim

CAMPAIGN RUN:
1998 through 2001

TARGET MARKET:
Lapsed and new subscribers

ABOVE: The identity for 2000 campaign is built with plenty of white space and a palette of red and black.

## The Brief

The idea arose from a previous campaign that garnered excellent feedback and was on record as the most memorable ACO campaign to date. It involved photographing the orchestra playing their instruments in a running line. "We dissected the campaign to discover why it had been so successful and decided that it was the first campaign that gave the ACO a distinct personality; one that was fun and playful, and which was a departure from the more standard, serious type imagery associated with orchestras," says Beechey.

Based on this philosophy, "We created our first ACO campaign using unusual, dynamic photography teamed with bold typography and layout. We followed this through the following campaigns, each year reinterpreting and reinventing the public face of the orchestra, keeping the language the same— interesting photography of the orchestra and clean typography, but in different ways to avoid the campaign becoming monotonous.

"The campaign's uniqueness lies in its portrayal of the orchestra as vibrant, passionate, and youthful. Many people think of orchestras as conservative, traditional, formal, and somewhat faceless. We have broken this mold and have given the Australian Chamber Orchestra a face—many faces. People are an integral part of the whole look and feature as much as music or instruments," says Beechey.

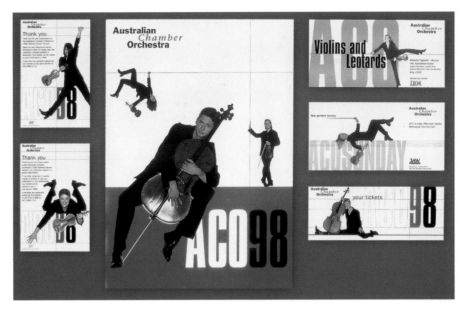

ABOVE: The 1998 season's ACO newsletter.

## Using Type and Photography to Communicate

For the 1998 campaign, designers relied on photography that took a humorous approach, something seldom seen in promotional materials for highbrow orchestras. That is exactly why it worked so well. The sense of humor conveyed by a girl doing the splits with her cello and a woman leaping while clutching her violin all drew attention at the unexpected element of surprise proffered by the design. This approach, when teamed with clean, legible type that has bold and modern lines, allowed the players to interact with the letterforms. Seeing a woman lying on a line of type or a man leaning against a word, made the players, and ultimately, the orchestra, appear approachable, casual, and friendly.

In 1999, CPd once again created a campaign with clean, uncluttered graphics and a subtle sense of humor using only slivers of players' faces and encouraging concert-goers to "Come face to face" with ACO while merging the faces with their instruments. "The players merging with their instruments give a sense of the passion the players feel towards the music," says Beechey.

The 2000 campaign featured extreme close-ups of the members playing their instruments; the grainy photos showcase their intensity and passion. "The photography is more pensive and intense, but the sense of fun comes through the ACO mark, with figures leaping amongst the letters."

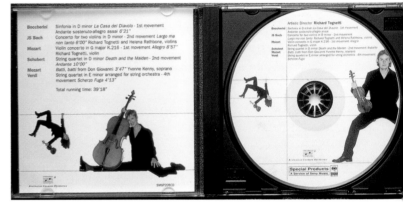

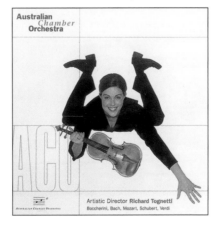

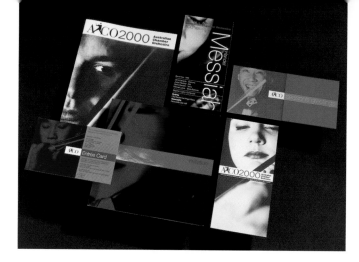

## Distinctive, Yet Unified—Consistent, Yet Flexible

CPd designs for the orchestra's specific seasons, while managing to keep each loyal to the greater whole, despite the numerous elements being produced annually including brand identity, the season brochure, advertising campaign (press ads, posters), direct-mail call-to-action/teaser postcards, stationery for press releases, invitations, order forms, direct-mail acknowledgment of order/thank you pieces, folders for tickets and CDs, concert programs, and a Web site.

"By using key elements in different ways, we manage to keep each item distinctive but also unified. We design the initial concepts with the aim of keeping them flexible, knowing that it is a year-long campaign that should not become homogenized, and that the designs need to be translated into many different formats," Beechey says. "For each campaign, the photography is the most consistent element. To enhance this, we use a typographic style that will complement or contrast them. While the typeface will not change for the season, the way it is used will vary. It may be horizontal or vertical, reversed out of a background, or sit in front, concealing part of the photograph."

Similarly, color is used for consistency, yet it, too, is flexible. CPd works from a primary color palette of red and black on white with the occasional use of a third color. White space was integral to the 1998 design, yet designers added blocks of color, such as the red on the program cover. Likewise, designers added an all over flat color underneath the photographs on the invitations for the 2000 season. For a one-off concert flyer, the photograph was printed as a duotone to differentiate that concert from the rest of the season's concerts.

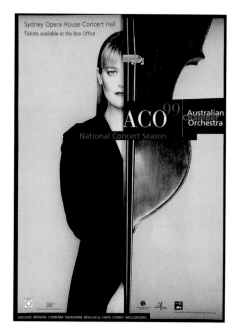

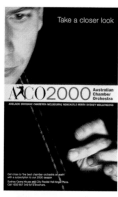

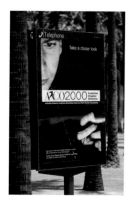

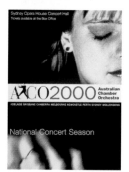

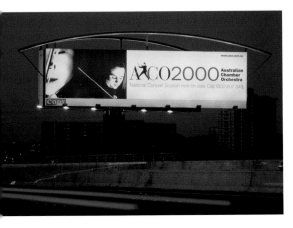

## Season-Specific Campaigns

Each season's campaign needed to be unique in order to increase general awareness and sales from lapsed and new subscribers. As such, the annual promotion consists of many elements, targeting urban areas throughout Australia.

The first item produced for each campaign is the seasonal subscription brochure, detailing the entire season. A total of 250,000 four-color brochures are printed annually to launch the look of the new season; some are mailed while others are distributed at the venues and inserted into major newspapers and publications. The brochure includes detailed information on the concerts, dates, and guest artists. The designers' challenge is to fit all this copy onto a ten-page roll fold brochure, the size of which is determined by the publications into which it is inserted.

The paper stock used for the centerpiece brochure changes annually based on the design. In 1998, CPd's first year on the project, designers specified a satin stock to complement the fun, leaping figures and striking typography. In 1999, the imagery was more intense and moody, so designers chose an uncoated stock to give the brochure a gritty, tactile quality. The brochure included black-and-white photography, but designers printed it in four-color process to create a richer grayscale spectrum. For the 2000 campaign, a coated, glossier stock to contrast against very grainy photographs was chosen. In this instance, designers added a metallic blue-gray to the four-color process, which gave the photography a subtle shimmer and added a sense of glamour to specific typographical elements.

Immediately following the seasonal subscription brochure, designers launch the first round of advertising material, which is designed to generate an immediate response, motivating recipients to call for a brochure or visit ACO's Web site for more information. Initially, the emphasis is to get people to subscribe to the entire season. Once the concert season begins, the focus shifts to promoting the individual concerts, highlighting the guest soloists, and providing information on dates and concert venues.

Next, supporting materials are rolled out including posters, CD covers, ticket holders, and venue banners. Designers allow the printer to determine the stock and printing processes for these pieces based on the intended use. For example, banners for outdoor display are silkscreened onto waterproof fabric; indoor posters are digitally printed onto a stock that will fit through novajet printers. "Other brochures and printed material will generally use the same stock as the brochure to maintain a consistency throughout the year and often print two-colors for cost-saving purposes," explains Beechey. "Due to the great volume of items produced, we need to vary each item to avoid the designs from becoming monotonous."

## Targeting Two Markets

For designers, the trickiest part of the job was establishing an image that would attract and hold the attention of an older, more conservative audience base while appealing to a more youthful market, in essence, the new generation of subscribers.

"The biggest design challenge was to create a campaign that appeals to the more typical orchestra subscribers who tend to be older and more conservative, as well as potential concert-goers who are interested in classical music but are perhaps intimidated by the stuffy perception of the classical concert," Beechey says. "As well as playing more traditional music by the better known composers, the ACO also includes in their repertoire more contemporary and obscure composers. The campaign needs to convey that the ACO is an innovative and experimental orchestra, while still following the traditions of good classical music.

"We solved these challenges through the way we used typography and photography together to achieve a lightheartedness but also a sense of the intensity of music playing. This way, we could make classical music feel accessible but also as something taken seriously by the orchestra."

Designers managed to blend the likes of both target audiences by crafting an identity that is contemporary but not faddish. Typography is bold, yet elegant, which gives the pieces a timelessness that doesn't lock it into a particular niche. "One campaign featured the classic, traditional typeface Bodoni, but used in a fresh and innovative way," explains Beechey. "This has been extended to the redesign of the Australian Chamber Orchestra logo, which uses Bodoni but breaks the letters with one of the long, leaping or running figures."

## It's All in the Details

Other, smaller promotional items are produced throughout the year to reinforce the ACO brand, including much overlooked details such as a ticket wallet. "We feel it is important, for example, that subscribers receive their tickets in a branded ticket holder. We also come up with some inexpensive novelty items such as concert reminder diary stickers," says Beechey.

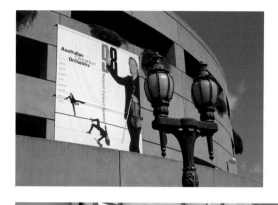

LEFT: A banner promoting the 1998 concert season.

BELOW: In 1998, CPd's first year on the project, designers specified a satin stock to complement the fun, leaping figures and striking typography as seen on this poster.

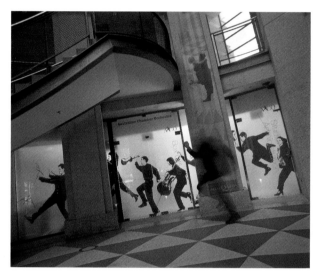

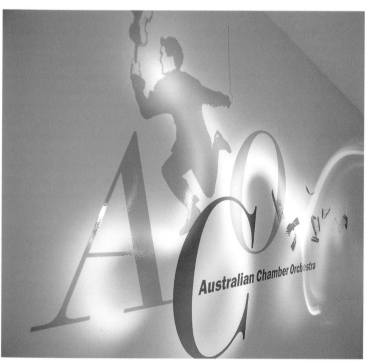

TOP: Taking the now famous running line image, CPd created frosted-glass panels, internal murals, and signage for the foyer of ACO's new space at Circular Quay.

BOTTOM: Photography used in the 2000 campaign is pensive and intense, but ACO's approachability comes through the ACO mark with figures leaping amongst the letters as seen in this wall graphic.

## The Budget

The budget arrangement is an unusual one, but one that works as well as the promotion. CPd is paid about one-quarter of the amount spent on design work, and in return, receives "the opportunity to work with a passionate and talented arts organization that appreciates the importance of good design in their promotional material. Therefore we ensure that at every step we use as many cost-saving measures as possible, without sacrificing the integrity of the design," says Beechey. Free concert tickets are an added bonus that is part of the fee arrangement.

Because of the unique budget structure, funds are limited. Typically, printing is sponsored and, consequently, designers stick to standard sizes for printed material and don't use special printing techniques, such as embossing or die-cutting. "This urges us to make the design striking with fairly limited resources, something which is exciting for anyone who works on the ACO. When designing the ACO material we are aware that we need to be budget conscious, however, we would never produce compromised work due to money constraints," says Beechey.

"We try to work as closely as possible with the printers, finding out techniques to achieve certain effects within budget. For example, when we wanted to use a metallic on a four-color process print job, we were able to cut costs by replacing the cyan plate with a metallic blue. While we tend to stick to standard paper sizes such as DL and A5, we use dynamic design techniques such as bleeding type or a figure off the edge of the page to create drama."

For the first two campaigns, designers used digital photography to cut the costs of processing and scanning. Due to the relative newness of the technology during the first year, the resulting images were a very low resolution. Rather than reshoot, designers converted the poor-quality images to black and white and added noise in Photoshop to give the photographs a gritty look that suited the close-up and intense nature of the shots.

# The results

To date, market reaction has been positive. Subscriptions have increased steadily over the last three years. Admittedly, there were concerns that the Olympics and an increase in arts events in 2000 would provide tough competition for the ACO, but these fears were never realized as subscriptions for the 2000 season were up over 1999. Name awareness is also up, and both CPd and the ACO have received positive feedback on the campaign. "The ACO is now arguably one of the best-known arts organizations in Australia," says Beechey.

## What Worked

"Working closely with the client, meeting members of the orchestra, watching them rehearse and experiencing their concerts, has given us the insight we need to create a successful promotional campaign," says Beechey. "By understanding that, as a group of young, passionate, and very talented musicians, the ACO wants to share their music with the world, not just an elite group of people, we are able to channel our passion for design to visually express the personality and vision of the orchestra."

# SIMPLICITY IS KEY
## TO GRAPHIC CAMPAIGN LAUNCHING DELIVERY SERVICE
### (brown paper wrapper graphics)

## The Client

Esprit Europe takes a novel approach to shipping parcels in Europe—it runs its delivery service on the Eurostar train. This fact alone makes the delivery service different, but how could the company communicate its uniqueness to mailroom managers, its primary target market?

**CLIENT:**
Esprit Europe

**DESIGN FIRM:**
HGV Design Consultants

**ART DIRECTORS:**
Pierre Vermeir, Jim Sutherland,
Martin Brown

**DESIGNERS:**
Pierre Vermeir, Jim Sutherland,
Martin Brown Vermeir, Jim Sutherland

**PHOTOGRAPHER:**
Alan Levett

**COPYWRITERS:**
Pierre Vermeir, Jim Sutherland

**CAMPAIGN RUN:**
1995 through 1999

**TARGET MARKET:**
Mailroom managers

**ABOVE AND RIGHT:**
Designers branded watches and clocks as promotional items, blurring the numbers to communicate speed.

## The Brief

Esprit Europe tapped London-based HGV Design Consultants for help. The assignment: Create an identity and promotional items that would allow Esprit to launch its new service. HGV conducted a visual audit of the competition and discovered that no other delivery service communicated its delivery of parcels very clearly. From there, the concept fell into place. Designers tackled the identity by emulating the shape of the Eurostar train, which has a distinctive blunt nose shape, so that it appears as a "speeding parcel" to remind the public that all Esprit packages are uniquely delivered by Eurostar—a distinct advantage over the competition. To drive home the message, designers used brown paper and urgent labels to communicate parcels delivered with speed.

"Launching a new parcel service amongst severe competition on a medium-sized budget is a tough call," says Pierre Vermeir. "The strength of the promotion is its impact, the clarity of the key message: We deliver parcels to Brussels and Paris on the same day."

## Standing Out in a Crowded Market

"The most difficult problem was to stand out in a crowded market, as is the case with any new identity, and to win clients for a new service. The marketing materials had to have immediate impact and hook potential clients, reinforcing speed of delivery and reassurance that parcels would arrive...the same day, a unique offer," says Vermeir, adding that Esprit Europe offers the fastest service in the sector.

To overcome this hurdle, designers gave the word *urgent* a bold, uppercase graphic type treatment and applied it to the brochure, posters, and supporting promotional materials to communicate speed and reassurance. A high-quality image was combined with minimal copy to deliver the message immediately to the target audience, not unlike how the parcels themselves are delivered. Likewise, designers integrated plain brown wrapping paper into the design, which is unique to Esprit Europe, and used it as the backdrop for the company's key message, immediately suggesting the delivery of packages.

## The Launch

Esprit didn't have a name when it approached HGV for marketing assistance in launching the new service, so HGV participated with the client team to develop the name Esprit, which they chose because it lent a European sound to the company. As part of the marketing mix, the client asked HGV to design a launch brochure and supporting promotional materials.

Designers maintained consistent branding across all items but retained enough flexibility to heighten interest while differentiating the pieces. Promotional materials included a calendar made up of origami brown paper parcels, as well as clocks and watches, which were branded with blurred numbers to communicate speed. Brown paper wrapping and the urgent stickers were used to link disparate marketing items together as part of a cohesive campaign, a tactic that was used to dress up delivery trucks as well.

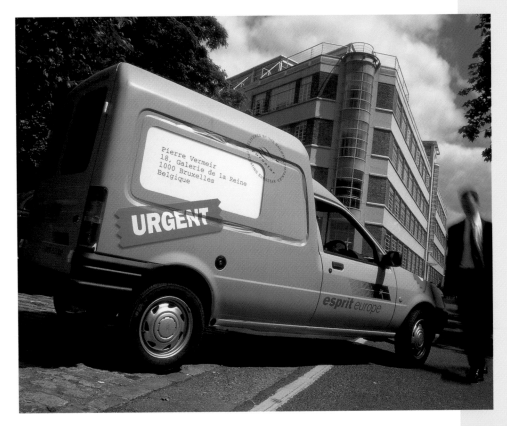

ABOVE: **Esprit Europe's trucks carry the promotional package motif.**

BELOW: **Esprit Europe announced its new sameday parcel service between London and other cities in the United Kingdom with a mailer that features blurred scenes from the cities along the route as if seen flying by from a window of the train.**

To proclaim the news, "We deliver parcels to Brussels and Paris on the same day," designers crafted a promotion using a French newspaper with a bellyband announcing that "News Travels Fast." As the service grew, additional promotional mailers were added. Interestingly, all feature a railway motif, characterized by train schedules, maps of train lines, and images of the cities and countryside along the route as if seen from the window of a speeding train.

Also added to the promotional mix was Esprit Europe sponsoring a competition for the fastest tennis serve and a drawing to win a pair of first-class return Eurostar tickets by simply completing the reply card built into a mailer.

ABOVE AND RIGHT: **Rail lines are included in this slim mailer that informs recipients that now "your parcel can travel as fast as you can."**

LEFT: **Esprit Europe sponsored a competition for the fastest tennis serves in a poster announcing the event.**

Ashford to Europe, the UK and the world
Introducing the fastest parcel delivery service

*esprit* europe

### The Budget

The total budget for developing the company name and designing the logotype, launch brochure, and promotional items was £45,000 or nearly $64,000, excluding printing. Was the budget lean? "Yes! But the client supported the design by investing in high-quality printing," says Vermier. "The initial design budget was extended over five years and we enjoyed a great relationship with the client, working on sports sponsorship deals, designing the UK rail parcels brochure, the international courier service brochure, and their Web site."

**The A-B brochure creatively illustrates the morning and afternoon service available, while announcing a drawing to win a pair of first-class return Eurostar tickets by simply filling out the reply card built into the mailer.**

RIGHT AND BELOW: When Esprit
Europe expanded its service,
it required a new brochure
announcing its additional
offerings.

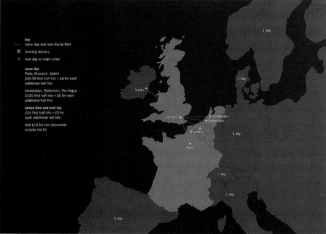

RIGHT AND FAR RIGHT: Many of
the mailers, including this
brochure, feature railway
timetables showing exact
delivery times to the stated
destination.

LEFT: A heavy pocket
folder, in the distinctive
brown wrapping, includes
a spiral-bound brochure
with the recognizable
"Urgent" artwork, a
timetable, and pricing
schedule.

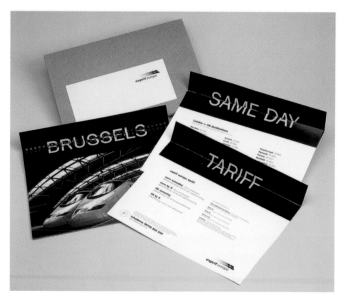

# The results

As a result of the plain brown-paper promotion, the company grew from nothing to sales of £600,000 or approximately $850,000 in just five months. The direct-mail campaign generated an unprecedented 85 percent response rate. So positive were the early results that Esprit Europe extended its original promise of delivering parcels the same day to Brussels and Paris to include deliveries by rail within the United Kingdom along with an international courier service as well. If that wasn't good enough, HGV won a DBA Design Effectiveness Award for the launch brochure, supported by client sales data.

## What Worked

"Targeted mail shots delivered the launch brochure to the right audience," Vermeir explains. "The logotype and brochure communicated the key messages clearly. The launch was followed-up by a personal visit from a sales representative who presented potential clients with a clearly branded, high quality promotional gift. The service was proven to be reliable, unique, and cost-effective."

# PRODUCT LAUNCH FOR HAWORTH INC. DOESN'T TAKE ITSELF TOO SERIOUSLY (lighthearted graphics)

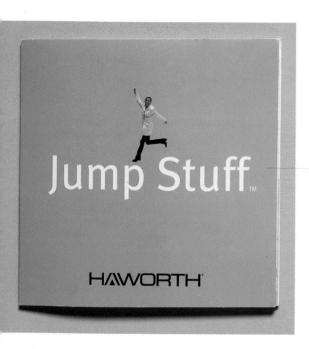

**CLIENT:**
Haworth Inc.

**DESIGN FIRM:**
Square One Design

**ART DIRECTOR:**
Mike Gorman

**DESIGNERS:**
Mike Gorman, Martin Schoenborn

**PHOTOGRAPHERS:**
Effective Images, Tim Parenteau

**PRINTER:**
Ethridge Co.

**CAMPAIGN RUN:**
December 1999 to Present

**TARGET MARKET:**
Facility managers, architectural
and design community

ABOVE AND BOTTOM OF
OPPOSITE PAGE: **Central to
the campaign is a minia-
ture 3" x 3" (8 cm x 8
cm) brochure that folds
out to nearly 39 inches
(99 cm) to tell the story
of Jump Stuff. Designers
created the brochure to
be small and intimate to
get people interested in
the product, yet it had
to be affordable enough
to be printed in mass
quantities that would
allow Haworth to satu-
rate the market.**

## The Client

Cognitive artifacts—that is what the Jump Stuff campaign for Haworth Inc., a manufacturer of office furniture, is all about. Yet, you won't find the words *cognitive artifacts* anywhere in the campaign. Why? Because this campaign doesn't take itself too seriously, which just might be the single most important reason it works so well.

Jump Stuff by Haworth comprises a family of desk accessories with a difference. These work tools get everything up and off the desk, leaving a clutter-free work surface because in and out boxes, paper trays, paper sorters, and telephone, among scores of other items, are suspended above users' desks. The philosophy behind this innovative product is that desks are cluttered enough with daily paperwork; desk accessories meant to assist the user don't need to add to the commotion. The Jump Stuff system builds extra functionality into desk accessories. It works for the user by reminding them of things they can't keep in their head anymore—cognitive artifacts. The product can be purchased piece by piece or in kits, where all the desk accessories attach to a rail that is either mounted to the desk, a wall, or panel.

"Grip clips put items up there where they stay in front of you. The two-way tray and three-layer display also put things out in front of you," says Mike Gorman, creative director of Square One Design, which coordinated the campaign. "The main point is that a lot of accessory and furniture makers ascribe to workers a workstyle for them versus saying, 'Work however you want to work. This can be moved around. We're not prescribing what's right.' Jump Stuff is the ideal product for a person who has a really messy desk, but understands it and knows where everything is."

## The Brief

Recognizing that the primary selling point of the product is its flexibility and ability to adapt to numerous workstyles versus dictating one way or the highway, Square One Design took a humorous approach to the project and looked around their own offices and others to find distinct office personalities with their own quirky workstyles to illustrate the product's versatility. In short, the concept, which they developed from a brainstorming session during a two-week period, was based on developing promotional pieces that focused more on the product's uses than its features and benefits. All the ideas came together at once, then designers prepared each element of the campaign in sequence.

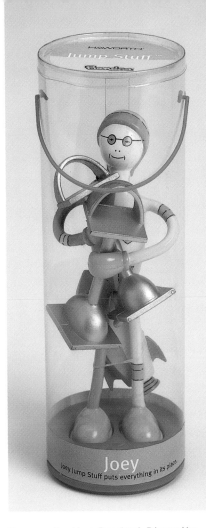

LEFT: Among the highlights in Haworth's arsenal of follow-up components was a direct-mail piece consisting of a Bendo™ doll, aptly named Joey Jump Stuff.

## Reaching Two Separate Audiences

Communicating to two distinct audiences—facilities managers and the architectural and design community—was one of the design team's challenges. To that end, they created office characters that everyone could relate to. That, in combination with color, simple photography, and humor, assisted in engaging all audiences.

From a design point of view, however, the office characters that made the promotion so intriguing also presented problems executing the layout of pieces such as the spec brochure. Gorman says it was tricky to have the cut-out office workers interact with the product without it looking too trite. "We didn't want it to appear like we were doing Photoshop tricks. The trick was to avoid having them [the people] react too much in the third dimension. The guy on the rail goes the farthest," explains Gorman, citing that other characters react more with the elements of the brochure, including the edge of a page or a line on a page, and less so with the product.

## Communicating Product Diversity

Central to the campaign is a miniature 3" x 3" (8 cm x 8 cm) brochure that folds out to nearly 39 inches (99 cm) to tell the story of Jump Stuff. Designers created the brochure to be small and intimate to get people very interested in the product, yet it had to be affordable enough to be printed in mass quantities that would allow Haworth to saturate the market. It tells the story of three office types that virtually everyone recognizes: Corporate Wonder Woman—a type A personality, who is very busy and probably doesn't have a whole lot of paper on her desk, but uses a lot of reminders. There's a Jump Stuff configuration for her. Then, there is Tall Guy, who oversees the human resources department and has just developed a new filing system; he works with lots of paper. There's a Jump Stuff kit for him, too. Finally, there's B.M.O.C., otherwise known as Big Man Off Campus. He works from a home office and needs help organizing and integrating his work and home lifestyles. The minibrochure was distributed with other Haworth products and includes a toll-free 800 number to call for more information and the Jump Stuff Web site where potential buyers could design their own Jump Stuff configuration on the Web.

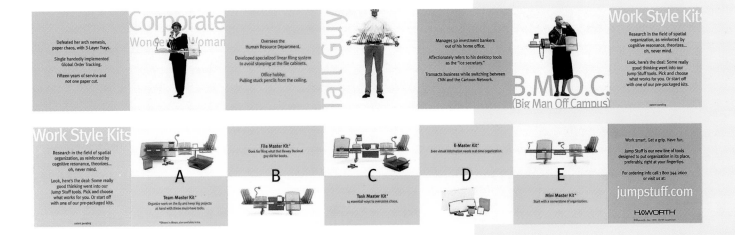

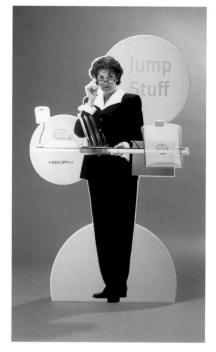
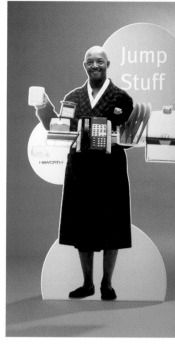

## The Rollout

Those responding to the miniature brochure received
the Jump Stuff spec brochure in answer to their
request for more information. The spec brochure
continued the initial premise—only now the cut-out
office characters interact with the product and the
brochure in a clean, fresh layout that is inviting and
makes for easy reading.

Other components followed suit with various office per-
sonalities populating everything from a series of small
—approximately 7 inches (18 cm)—point-of-purchase
displays that fit into the rail of a Jump Stuff system to
full-size, 6-feet (1.8 m) tall point-of-purchase displays.

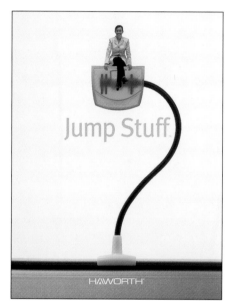

In addition, Square One created ancillary materials including gimmicky tattoos and a
"mock-up" brochure to convince office-furniture dealers to include Jump Stuff along
with their sales pitches for office furniture or panel systems. Desktop point-of-pur-
chase displays included a plastic tray that holds the miniature Jump Stuff brochure.

Square One Design didn't overlook any details in this multipart campaign. They
created campaign complementary packing slips, package labels, and even translu-
cent sheets, which were used as props to dress up paper trays and clip grips in Jump
Stuff displays.

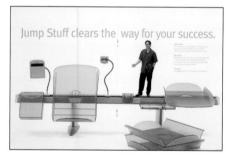

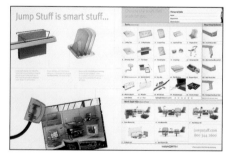

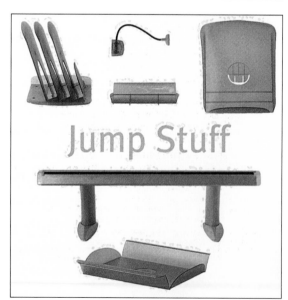

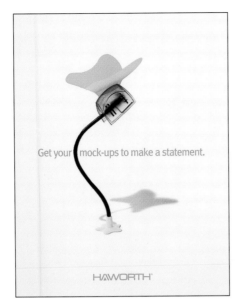

Get your mock-ups to make a statement.

HAWORTH

LEFT AND BELOW: A mock-up brochure convinced office-furniture dealers to include Jump Stuff along with their sales pitches for office furniture or panel systems.

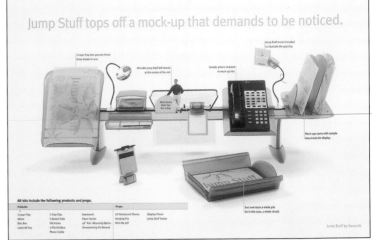

Jump Stuff tops off a mock-up that demands to be noticed.

## Bending the Message

Among the highlights in Haworth's arsenal of follow-up components was a direct-mail piece consisting of a bendable doll, aptly named Joey Jump Stuff, sent specifically to the architectural and design markets to create goodwill toward Haworth. Square One Design initiated the project by contacting Kid Galaxy, Inc., of Manchester, New Hampshire, the creators of Bendos™. The toy company was enthusiastic about working on the project, so designers downloaded blank Bendos characters and designed Joey for Jump Stuff. Designers gave Joey a pair of stilts that raised him off the ground —echoing the fact that the rail system gets everything up and off your desk—and a rocket booster to signify the fact that he boosts productivity. They dressed him in the Jump Stuff colors and sent their Freehand files to China for production. In return, they received a hand-painted proof for approval prior to mass production.

"We were looking for something to send out to 9,000 people that would be impactful, yet affordable," says Gorman. In the end, the unit price on Joey Jump Stuff was $2.50. With Joey completed, Square One Design created their own mailing label and a call for action to round out the mailing. The Bendos vendor could have handled both items, but Square One Design preferred keeping them in-house to retain more control on the project.

The three-dimensional character and his addictive playfulness promoted Haworth's Jump Stuff in a truly unique and memorable way. "People have been taken aback by getting a toy of this substance as a giveaway mailing. It's really a keeper," says Gorman, noting that it was also a big hit around the offices at Haworth where people were snatching them from the marketing department. Joey marks the first of several Bendos being used by Haworth, each representing a different product line, effectively setting the stage for several more to be created in the future to comprise a Haworth Bendos team.

RIGHT: Four point-of-purchase displays were designed to fit into a Jump Stuff rail.

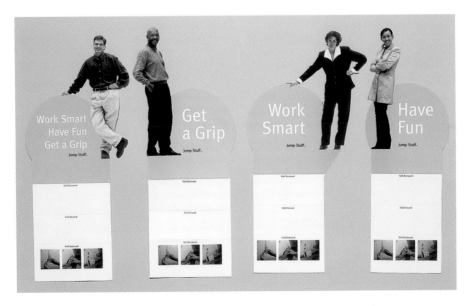

## Blending Diversity with Continuity

To maintain continuity between everything from point-of-purchase standees and brochures to a bendable doll, designers worked with a color palette of three primary colors, which are used throughout the campaign, in addition to a consistent typeface. Designers used very little bold or italic type, but instead relied on type size for impact, so there's a lot of scaling. Also notable is the amount of white space that dominates each piece and the fact that there is very little black text; most text appears in green. Also maintaining continuity are the people who appear as cut-outs throughout the campaign. These standards were not set in stone from the outset, but developed from one piece to the next. "Going into the minibrochure, I don't think we knew these would be the key elements, but when we were done with it and were starting on the spec brochure, it was clear that this was what the brand would be about," says Gorman.

Get to know
Jump Stuff!

Included:    Teaser
             Product Brochure
             Mock-Up Flyer
             Dealer Display Flyer
             Handbook
             USA Today Reprint
             Price List
             Service Parts List

jumpstuff.com

Work Smart
Have Fun
Get a Grip

Jumpstuff.com

Your
Jump Stuff
inside.

ABOVE AND LEFT: **Square One Design didn't overlook any details in this multipart campaign. They created campaign-complementary packing slips, package labels, and even translucent sheets, which were used as props to dress up paper trays and clip grips in Jump Stuff displays.**

# The results

This product introduction was one of the most successful campaigns that Haworth has launched. The strong branding, use of humor, and its down-to-earth appeal all combined to generate an enormous response from their dealer network, clients, and internal staff. It marked the beginning of what has now become a much larger movement toward making the communication characteristics of the Jump Stuff launch filter into all Haworth communications.

Haworth has compiled hundreds of comments from the architectural and design community as a result of the bounce back cards included in the Joey Jump Stuff Bendo mailer. "From the 15 percent return, we have heard nothing but appreciation for the playfulness that these characters have brought to offices around the world," says Gorman.

## What Worked

"The promotion worked so well because it doesn't take itself too seriously," he adds. "We just say this product works the way you do. It's fun. People don't want to read a lot of copy, so we put an incentive in there—humor. They read a little bit, enjoy what they are reading, and are inspired to read on. They have some fun. [The campaign] pulls people in and humanizes the product so everyone can relate to it in a fun and friendly way. The campaign combines a mixture of worktime and playtime and capitalizes on that."

# A PARTY AND A SERIES OF POSTCARD MAILERS BUILD AWARENESS FOR DESIGN FIRM

### (variety spices up self-promotion)

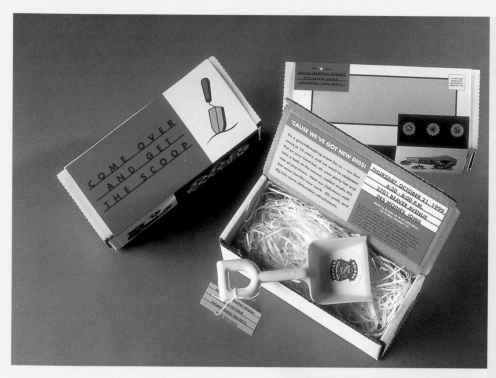

**CLIENT:**
Sayles Graphic Design

**DESIGN FIRM:**
Sayles Graphic Design

**ART DIRECTOR:**
John Sayles

**DESIGNER/ILLUSTRATOR:**
John Sayles

**PHOTOGRAPHER:**
Bill Nellans

**COPYWRITER:**
Kristin Lennert

**CAMPAIGN RUN:**
Spring 1999 to Present

**TARGET MARKET:**
Buyers of promotional materials
and advertising

**ABOVE:** To celebrate their move to a new location, Sayles Graphic Design hosted an open house in the firm's studio. A box mailer arrived with the request to "come over and get the scoop" about the firm's new digs.

**RIGHT:** Party guests received a custom watch signed by John Sayles and presented in a metal box.

Sayles Graphic Design had moved into a new studio, but having spent so much money relocating, there was little left over to promote the firm's new digs. To keep costs low, staffers were assigned various tasks and as many pieces as possible were ganged into a single print run.

The new move proved to be a good time to update the firm's look. In doing so, Sayles kept the identity's existing colors and logos while adding bold lines, color blocks, and a collage effect in all new printed materials. One of the first pieces to debut was an invitation to prospects, clients, and vendors asking them to celebrate the firm's New Digs.

"Events like these allow for the prospects and clients to talk with each other, as well as vendors also in attendance. Naturally, they discuss collaborations with Sayles Graphic Design," says Sheree Clark, managing partner. "We have gained new clients from our social events and maintained relationships with guests who may use our firm in the future."

"Sayles Graphic Design's self-promotional campaign is unique because it involves such a variety of pieces with different purposes," explains Clark, adding that in addition to mailings and electronic promotions, the campaign included postcards, T-shirts, a watch, and even a jacket.

Additional mailings followed showcasing, through photos, Sayles Graphic Design's recent work; these postcards mailings are no ordinary postcards, but work as an ongoing series to update recipients on new projects. "The postcards are sent to our entire mailing list of media contacts, vendors, clients, and prospects," says Clark. "For example, some of our clients may just require flat print collateral or direct mail and not realize that we design interior spaces as well. Self-promotion allows us to display and promote our wide range of design work."

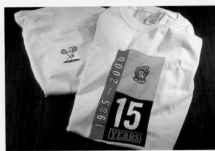

LEFT: T-shirts printed in the firm's corporate colors were gifts to staff, clients, and friends.

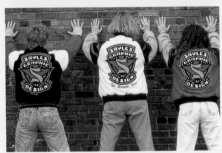

ABOVE, TOP: To commemorate their fifteenth year in business, Sayles developed a series of postcards—one for each year—that highlighted the firm's history and work.

ABOVE, BOTTOM: Sayles Graphic Design jackets feature an oversized logo on large blocks of color.

ABOVE: Sayles Graphic Design's letterhead uses solid blocks of red, black, and mustard as sites for Sayles' shield logo, three icons, and the company's address information.

ABOVE, TOP AND BOTTOM RIGHT: John Sayles designed a series of graphic icons representing various areas to visit on the Sayles Web site, including corporate identity and logos, custom gifts, company literature, direct mail, environmental design, packaging, and more.

# AWARENESS CAMPAIGN SELLS BERTHS ON CRUISE WEST ALASKA (up-close and casual graphics)

## The Client

Cruise West ships are unlike the mega cruise ships popularized on television shows and by celebrities in glitzy advertising campaigns. Cruise West doesn't offer the traditional luxury amenities one so often associates with cruise ships. There are no spas, pools, Broadway theaters, midnight chocolate buffets, pizza bars, or gambling casinos, yet the cost per passenger is much higher than a cruise on a mega ship. Sound like a marketing dilemma? Perhaps. But Cruise West does offer advantages that the mega ships don't—an intimate traveling experience only possible on a small ship. So, when Cruise West challenged Belyea with selling as many berths as possible on its Cruise West ships for the Alaska 2000 season, the Seattle-based design firm took the job and got up-close and personal.

**CLIENT:**
Cruise West

**DESIGN FIRM:**
Belyea

**CREATIVE DIRECTOR:**
Patricia Belyea

**DESIGNERS:**
Ron Lars Hansen, Naomi Murphy, Anne Dougherty, Kelli Lewis

**COPYWRITERS:**
Floyd Fickle, Liz Holland

**CAMPAIGN RUN:**
August 1999 through July 2000

**TARGET MARKET:**
Travel agents and sophisticated, affluent consumers over 55 years old

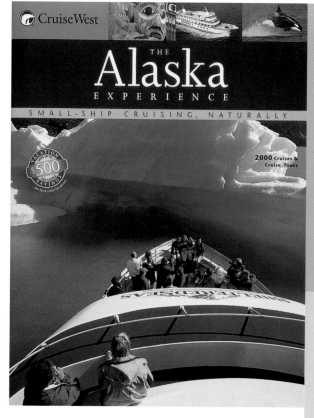

ABOVE: The centerpiece of the campaign, this sixty-page brochure sells small ship cruising and the up-front, casual atmosphere of Cruise West trips through its easygoing writing style and imagery that shows guests and crew gathering together for photos on its cover.

## The Brief

In startling contrast to mega cruise ships that routinely carry anywhere from 1500 to 2500 passengers in a floating city, Cruise West is part of a niche category within the small-ship cruising industry, carrying ninety to 100 passengers with minimal luxury amenities. The appeal of the small ship comes from the intimate and low-key nature of the experience that promotes interaction with nature and wildlife along with education on the cultural surroundings. Instead of gambling in the evening, passengers listen to experts talk about the region; instead of being fourteen stories up when a whale breaches beside the ship, prompting passengers to run for their binoculars, they can view the whale up-close from a 4' x 5' (1.2 m x 1.5 m) picture window in their stateroom while writing a postcard home.

"You get more and more involved with your surroundings," says Patricia Belyea, creative director, of the time passengers spend onboard. As a result, passengers "gain so much on this cruise because they learn so much." If wildlife comes near the ship, the captain will stop the engine so everyone can enjoy the scene. If the ship went by too fast to catch a wildlife show, the captain will turn the vessel around and go back for another look. If something happens outside during dinner, everyone goes on deck—including the staff. "The whole world stops for a wildlife experience. People get such a kick out of it. It is what makes their trip...these events just burn into their memories. It is really very, very different from the big cruise ships."

Given these strengths, it is little wonder that Belyea promotes the Cruise West experience with two simple messages—up-close and casual. These messages are evident throughout the Alaska 2000 campaign's collateral material, which while very simply produced, is totally unlike any other travel brochures.

TOP AND BOTTOM RIGHT: **The Ice Box bulk mailing, sent to large travel agencies, contained three sets of seven brochures with three "Win a dream cruise" postcards. Agents participating in the contest had to include their preference for itinerary, sailing date, and ship so that they really had to give the Alaska trip some consideration. This mailing, like the rest of the collateral pieces, promotes the up-close and casual theme— to the point of showing a photo of a woman touching a glacier from the bow of a Cruise West ship.**

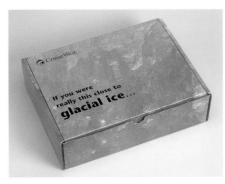

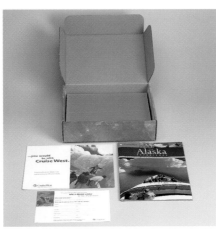

BELOW: **Belyea developed a national advertising campaign for national magazines, local newspapers, as well as AAA publications, emphasizing the up-close aspects of small-ship cruising with Cruise West.**

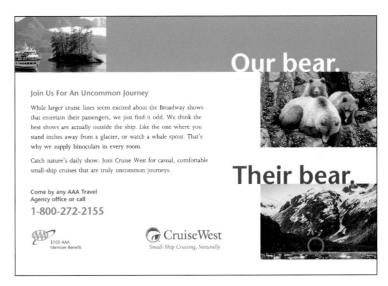

### The Strategy

There is a multitude of items in the Alaska 2000 campaign, the centerpiece of which is the Alaska 2000 brochure. The up-close and casual messages are evident immediately in this campaign component. "There's nothing stuffy about the cover—that's the crew and passengers," says Belyea. Within this piece, and everything else that follows, Belyea uses a casual, friendly, and inviting approach. Everything from the photos and the tone of the copy to the layout reinforce that this cruise line is up-close, casual, and offers a unique experience. In all, the packaged campaign underscores the relaxed nature of the travel product and the company's family values, while appealing to the trend toward younger people taking cruises. "You can see the age dropping on who we are trying to appeal to. It used to be [people] over seventy, then it was over sixty, and then it was over fifty. Now, we can actually say we're working on the over-forty group. We've seen a huge change in the demographics. Now, we have this opportunity to talk to people who have never even gone on a cruise...and the only thing they will probably touch or feel before they go on the cruise is this brochure."

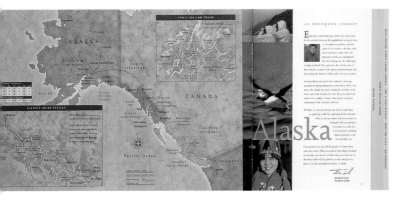

LEFT: **Vivid colors and lots of white space with a larger than typical typestyle combine to invite the reader in; the staggered informational pages make it easy for the inquisitive prospect to navigate the details.**

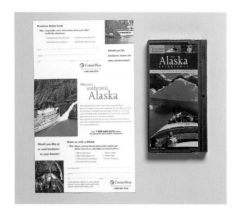

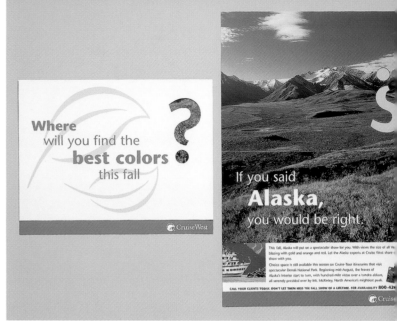

Where
will you find the
**best colors**
this fall ?

If you said
**Alaska,**
you would be right

## Involving the Audience

Designers crafted each component of the campaign to
maximize its selling potential. This was done through
design, the message, and a strong understanding of
the target audience. For instance, travel agents were
sent a simple contest with their Alaska 2000 brochure.
To win a free Cruise West Alaska cruise, agents were
asked to choose their own trip and provide their pre-
ferred itinerary, sailing date, and ship of choice. This
meant that the agents needed to get fully involved
in the process of choosing a vacation through the
brochure—something that their clients do," Belyea
explains. "The response rate for this contest was 25
percent. More importantly, it meant that 25 percent of
the recipients had actually read through the brochure
and become familiar with the Alaska product."

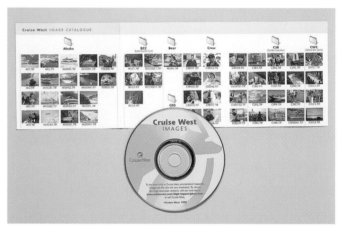

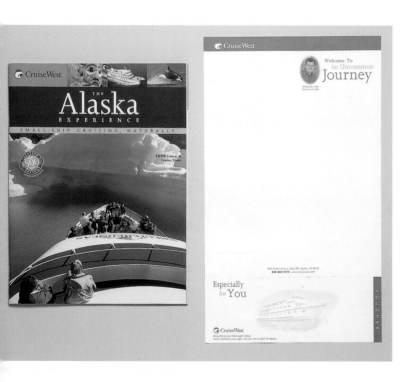

## Choosing the Imagery

Since the collateral's job is to sell prospective customers through their visual imagery, the choice, quality, and color reproduction of the photography can make or break a campaign. Some photos are client-supplied, while others are purchased through photo houses where images cost an average of $1500 each. The job of overseeing photography is so enormous and detail oriented, it requires a full-time person to head up the effort, make purchases, and ensure that stock images, if used previously, are paid for again. Photo requests are typically handled on the Internet, but Belyea doesn't risk finalizing its choices from the Web. The firm insists on reviewing all transparencies first before finalizing the sale. "We may sound low-tech, but once before transparencies received were not the quality needed. We don't have the time to waste with bad film," says Belyea. "Ensuring images are correct is part of our job."

## Proofing the Color

With so much attention devoted to choosing the right image, equal priority is given to ensuring that the color in the photos is as gorgeous as it should be. Belyea works closely with a printer on color issues. Pick-up and new transparencies undergo the same thorough process. When scans are returned from the color house, two designers will examine the color and mark up the artwork before showing the adjustments to the client. Once they have client approval, Belyea will send the images back to color house and await a corrected set of proofs. Proofs will be corrected until they are perfect. "If the color isn't right, it won't be as inviting," says Belyea. "It's a part of the project we make sure is absolutely right." All this attention to detail pays off in Cruise West ships that are whiter, Alaskan skies that are bluer, and water that is not murky but refreshing shades of teal.

## Simplifying the Process

Information about the final product offering came late to Belyea and was continually modified. Working with thirty-six itineraries, maps, schedules, and price charts that kept changing required highly detailed production management. Belyea side-steps a potential proofing nightmare by creating a three-person proofing team to check and recheck all documents. They also created all maps in-house to accommodate frequent changes to itineraries.

Throughout the production process—a year-long task—it was Belyea's job to oversee that each piece integrated with the other campaign components and recognize when things needed to be better coordinated. Designers received the campaign project by project and worked on everything over the course of a year, which could make for a scheduling headache and rushed deadlines. Fortunately, Belyea, long accustomed to travel work, had learned that organization and advance planning is key. "When we start in the spring, we know what needs to be done by fall," she says.

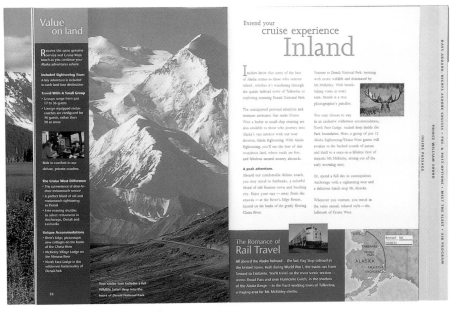

ABOVE: The small photo in the far-left margin was client supplied, while the image of a yellow school bus making its way toward Mount McKinley was a stock image where special care was paid to ensure the sky was as blue as possible and that the snow was a dazzling shade of white.

RIGHT: Travel agents promoted the Alaska 2000 cruise with these ticket stuffers, inserted into airline ticket packages and other documents.

RIGHT: The Cruise West Alaska Web site offers comprehensive information for consumers, including itineraries, ship layouts, and travel tips; while a password-protected section for travel agents includes PDF files of collateral, a media center, and other updated information on rates, group policies, and more.

ABOVE AND RIGHT: Belyea worked with Cruise West to redesign the graphics on their tour buses, where the land arm of their businesses is called Alaska Sightseeing. Designers integrated the polar bear logo with new type that emulated the Cruise West logo, making these buses the most colorful vehicles on Alaska's highways.

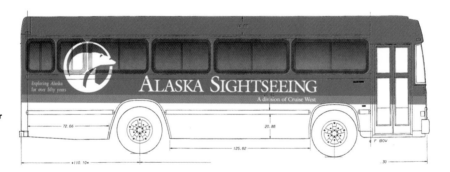

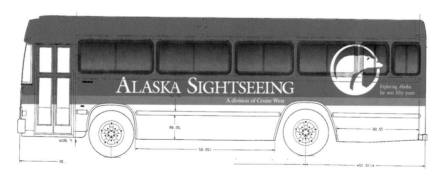

# The results

When the Alaska 2000 ship set sail, all indicators pointed to a successful campaign. The travel-agent photo contest generated 3700 responses from a mailing of 15,000, where agents were asked to select their favorite photo for a chance to win an Alaska cruise of their choice, and was among the individual winning elements of the campaign. However, no one doubted that the most important element of this campaign was creating awareness in the Alaska products that translated directly to increased sales.

When all the tallies were in, the campaign delivered on its promise to sell as many berths as possible on the Alaska sailings. In 1999, Cruise West bookings were 79 percent of capacity. At the end of the Alaska 2000 season, bookings had risen to a phenomenal 95.4 percent of capacity. "The 2000 season was successful due to focus-targeted communications to the appropriate audiences in a timely manner. The training programs, collateral, and advertising were consistent to the brand image and supported by strong creative and training of our reservations department," says Mary Novak-Beatty, vice president of sales and marketing, Cruise West.

Also indicative of a healthy promotion is that Cruise West just bought a new ship and is planning on buying another ship in the near future.

## What Worked

"It captured the readers' hearts and minds," says Belyea. "I think they could truly begin to visualize what this whole experience could be about and choose to buy it because it would match who they are as people. Not everyone wants to go on this cruise ship because it costs more and [they're asking] 'Hey, where's the spa?' For those people, it's not the right match. But for people looking for an experience that's a cut above, we did a good job helping them choose the right product."

# Tips from the experts Get close...get involved...make it easy

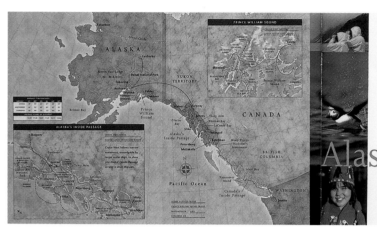

**GET UP-CLOSE AND PERSONAL**

Don't hesitate to bring photography up close if the application calls for it. Close-ups can bring the prospect into the experience.

**MAKE DETAILED COPY EASY TO READ**

Use lots of white space and stagger paragraphs to make copy-heavy pages less intimidating and easy to read and navigate.

**COLOR-PROOF PHOTOS**

If your photo looks lackluster, so will your product. Be sure colors are as sharp and vivid as they should be.

 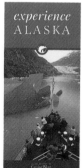

**MAKE IT EASY FOR AGENTS OR DISTRIBUTORS TO SELL YOUR PRODUCT**

Travel agents were supplied with ticket stuffers so they could promote the Alaska 2000 cruises to their clients by stuffing them into airline ticket packages and other documents.

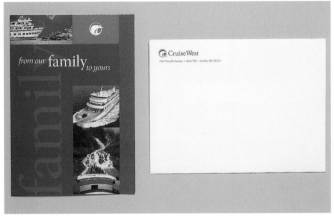

**ENCOURAGE WORD-OF-MOUTH BUSINESS**

Cruise alumni can sign up for membership in the Quyana Club (Q-Club) while they are on their cruise. The newsletter comes out biannually and is designed to encourage word-of-mouth business. Members who refer other guests can win a free cruise.

**USE EVERY OPPORTUNITY FOR CONTACT**

Cruise West delivered holiday greetings to travel agents and business associates.

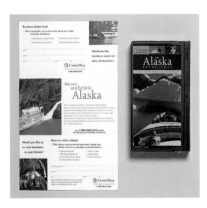

**SELLING IS SERIOUS BUSINESS, BUT KEEP IT FUN**

Cruise West distributed its Alaska video to consumers through ads and business reply cards; it was also sent to travel agents where it was shrinkwrapped with microwave popcorn.

**MAKE IT EASY TO BUY**

Belyea placed this Web banner—three variations of which promote the up-close message—on *Alaska* magazine's Alaska Directory index page. When readers clicked on the banner, they were instantly linked with the Cruise West Web site.

# A LAW FIRM'S AWARENESS (manipulated graphics) AND EXPANSION CAMPAIGN GOES TO THE DOGS

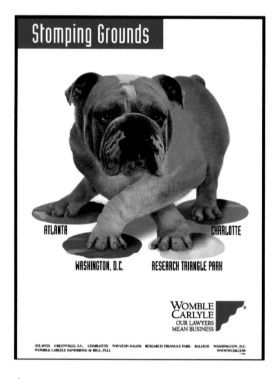

**Stomping Grounds**

ATLANTA    CHARLOTTE

WASHINGTON, D.C.    RESEARCH TRIANGLE PARK

WOMBLE CARLYLE
OUR LAWYERS
MEAN BUSINESS

ATLANTA  GREENVILLE, S.C.  CHARLOTTE  WINSTON-SALEM  RESEARCH TRIANGLE PARK  RALEIGH  WASHINGTON, D.C.
WOMBLE CARLYLE SANDRIDGE & RICE, PLLC                                             WWW.WCSR.COM

**CLIENT:**
Womble Carlyle Sandridge & Rice

**DESIGN FIRM:**
Greenfield/Belser Ltd.

**CREATIVE DIRECTOR/DESIGNER:**
Burkey Belser

**PHOTOGRAPHER:**
John Burwell

**DIGITAL/PRODUCTION ARTIST:**
Margaret Quan
(Transcend Old Business Methods ad)

**COPYWRITER:**
Lise Anne Schwartz

**DESIGN/PRODUCTION:**
Janet Morales

**MARKETING CONSULTANT:**
Diane Hartley

**CAMPAIGN RUN:**
Overall: November 1995 to Present;
Bulldog Campaign: Fall 1998 to Present

**TARGET MARKET:**
CEOs, VPs, and corporate counsel doing
business in the southeastern U.S.

## The Client

In the early 1990s, Charlotte, North Carolina, emerged as a banking center and high-tech hub in the southeastern U.S. The booming economy attracted larger law firms from surrounding areas including Richmond and Atlanta, as well as New York City, just as Charlotte native Womble Carlyle Sandridge & Rice was becoming the state's dominant law firm. The firm recognized that to survive and thrive in its new, competitive environment, it would have to expand beyond North Carolina and target the entire southeast. Seeking guidance before making any drastic moves, Womble Carlyle approached Greenfield/Belser Ltd. with two goals: Help us become a key player in the entire southeast, and help us create a distinct image that transcends a traditional law firm.

Womble Carlyle may have wanted something atypical when they first encountered Greenfield/Belser, but never did they imagine that five years later a stubby-legged bulldog would be the mascot of their firm and that their awareness would be soaring as a result.

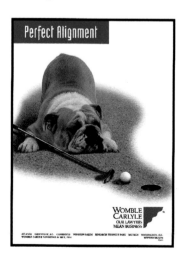

**Perfect Alignment**

WOMBLE CARLYLE
OUR LAWYERS
MEAN BUSINESS

## The Brief

Womble Carlyle's first priority was to expand, but Burkey Belser, president, Greenfield/Belser, had his concerns. "We needed to identify the new region, but a location-based branding strategy can be risky," he says. "A brand built on one location may be forever limited by that decision. If that area catches a cold, the firm can contract pneumonia." To avoid this pitfall, the design firm, which works with more than two hundred law firms from its Washington, D.C. headquarters, established flexible boundaries that they could push back as the firm expanded. For example, the first series of ads named cities where the firm did business but did not have offices.

Before getting underway with the design effort in 1995, Belser commissioned research on Womble Carlyle, including an image and awareness study, which convinced the firm that an aggressive and sophisticated marketing program was needed. Research focused on key North Carolina cities including Charlotte, Winston-Salem, and Raleigh-Durham where participants were queried as to their level of awareness of the firm name and whether they could associate any practice area with the firm through both aided and unaided questions. Results indicated a very low awareness level with only 3 to 6 percent of respondents recognizing the firm name and some area of expertise.

## A Bold Approach

With this knowledge, designers created a new logo and the first ads for a branding campaign simultaneously. The first ads used bold images—a kid on a skateboard, a 1947 Chevy, and a bulldog and spoke directly to business problems throughout the loosely defined region without making a single claim about Womble Carlyle. Ads did not list practice areas and didn't make statements about client service or expertise—a very atypical approach from a conservative law firm. But the message was clear: "Here are folks who've been around business problems, who have a sense of humor, and who are as sophisticated and savvy as the corporate clients they serve," says Belser.

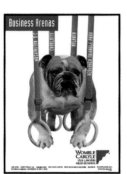

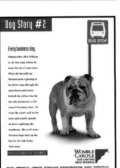

## A Star Emerges

Surprisingly, the favorite ad in the initial series was the bulldog. Some thought he resembled a beloved senior partner; and as a result, he became the icon for the firm's annual client-service award. He also started appearing on the firm's holiday card and on baseball T-shirts. Should this bulldog become the sole image on the second series of ads? Belser wondered.

A bulldog would certainly set the firm apart from other law firms that look alike and where it is difficult to discern or remember differences in personality or style. Moreover, a bulldog could capture the ad reader's attention long enough to create a distinct image, an especially important point when effective branding depends so much on the skillful use of metaphor, especially visual symbols, he reasoned.

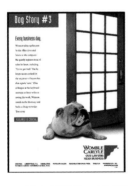

"Dogs provide a source of useful metaphors and an easy entry into the heart of the reader. They are friendly, warm, loyal, smart, watchful, and protective—all the things you want your law firm to be," says Belser. In addition, dogs are territorial creatures, a characteristic that also fits the desired message. As the firm opened new offices in Atlanta and Washington, the dog would play to the expanded image of the firm geographically by designing his turf or stomping grounds as the areas Womble Carlyle does business. When the time came to refresh the branding campaign, the bulldog was the obvious candidate and an essential element that would create a distinct personality for the firm.

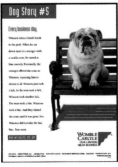

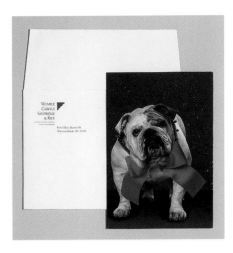

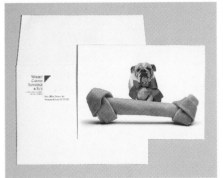

Once Winston, the bulldog, was hired for the job, Greenfield/Belser set out to transform Womble Carlyle, the law firm into a bulldog, just as Merrill Lynch's bull transformed the investment house into a recognizable force. The heart of the concept was to show Winston in various settings—not usually captured by a bulldog, or a law firm for that matter.

## Winston Takes Charge

The bulldog campaign was launched in 1997 featuring a prominent Winston, the Womble Carlyle logo, lots of white space, and headline in a box—all of which comprise the baseline requirements of the series.

The first series of bulldog exclusive ads feature Winston playing Twister and golf among other things. The image ads define Winston's stomping grounds as where Womble Carlyle does business.

Early mandates stressed the importance that the dog never be dressed-up in anything, such as a hat. "We don't want to demean the dog or make the dog look silly. The dog is like the Merrill Lynch bull and he has to come in from a position of strength," says Belser, admitting that one early holiday card just passed muster when they dressed Winston in a red bow-tie—but that's as far as they'll go with costuming their mascot.

The key selling points implied strength, loyalty, and tenacity and, once again, copy avoided making any claims. All ads were designed to appear simply in four-color process. The brand identity was carried through the firm's stationery, advertising, brochures, and other collateral, novelties (mouse pads, T-shirts, coffee mugs, sweatshirts, golf balls), and Web site.

LEFT AND BELOW TOP AND BOTTOM:
The Come. Stay. recruiting
brochure designed for the
1999 season featured
Womble Carlyle partners
and associates with their
own dogs, which like
Winston, humanized the
firm and made recruiting
in an overemployed market
relatively easy.

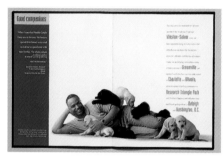

The program hinges on a national advertising campaign with media buys averaging $750,000 to $1 million in the *Wall Street Journal* and targeted business publications. Reinforcing the print campaign are four-color backlit dioramas that can be found in busy airports in the southeast travel corridor including Charlotte, Atlanta, and Washington, D.C.'s National and Dulles airports.

The Come. Stay. recruiting brochure designed for the 1999 season featured Womble Carlyle partners and associates with their own dogs, which ironically, like the bulldog, humanized the firm and its partners. Results were off the charts. Every lawyer wanted one

and everyone still wants one. "From a recruiting standpoint, kids coming out of law school don't want stuffy. They want dot-com. They want friendly," says Belser, who adds that while other law firms are having difficulty finding people to do the work, Womble simply has to answer the phone to find people who want to work for them. "In a marketplace where qualified lawyers are scarce, it has helped them to recruit, but it has also helped them grow by bringing them merger candidates who see the firm as having its act together."

Greenfield/Belser provided Womble Carlyle with a flexible brochure system that enables the law firm to easily update information, laser print pages, and insert them into this spiral-bound brochure by following a template.

BELOW LEFT AND RIGHT:
Greenfield/Belser provided
Womble Carlyle with a flexi-
ble brochure system that
enables the law firm to easily
update information, laser
print pages, and insert them
into this spiral-bound bro-
chure by following a template.

LEFT, ALL: The Womble bulldog is animated in a scrolling ticker on the firm's Web site.

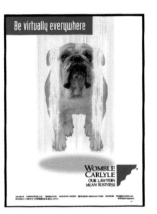

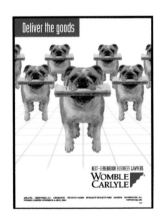

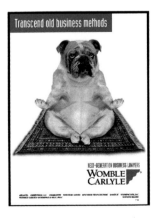

## Reselling the Concept

Despite proven results time and again, Greenfield/Belser must resell the lawyers at Womble Carlyle on the campaign, which has proven to be one of the design firm's biggest challenges. "The more creative the campaign, the more unexpected and edgy, the greater the need to sell it internally. At Womble Carlyle, launching and maintaining the branding campaign has consumed two firm retreats and dozens of presentations each year to partners, associates, and staff. The campaign's goals, philosophy, and budgets must constantly be resold," says Belser.

## Gaining Consensus

Developing a consensus within the partnership, as well as establishing the value of a brand in the minds of the partners, particularly around a bulldog, is unheard of in legal marketing. The design team has managed to overcome this hurdle developing interviews, resulting in a brand platform followed by multiple presentations to the partnership in different cities.

## Production Headaches

Ad production isn't easy either—particularly since most stubby-legged bulldogs don't take well to playing Twister. As part of the planning for a new series of ads, designers will contact Winston's handler in North Carolina and book the dog for a full-day photo shoot. They will shoot the dog in dozens of poses and angles to get as many "dog parts" as photo images as possible. Back at the studio, a digital artist will cut and paste Winston's parts into the poses required by the upcoming ad series. This detail work alone can average forty to sixty hours of Photoshop time. In some cases, ads require even more time to create the desired illusion.

The most recent series of ads places Winston in new, innovative settings, which proved particularly difficult for designers to execute and required a lot of digital artistry to get Winston into the precise pose designers wanted. The Transcend Old Business Methods ad required placing about fifty-five individual pieces of photos into the final composition, taking an astounding 160 hours of work in Photoshop. "It's tricky when you want a dog with short stubby legs, a big barrel body, and zero flexibility to be graceful and flexible," says Belser.

TOP, MIDDLE, AND BOTTOM LEFT: The most recent series of ads places Winston in some new, innovative settings, which proved particularly difficult for designers to execute and required a lot of digital artistry to get Winston into the precise pose designers wanted. The Transcend Old Business Methods ad required about 160 hours of digital manipulation in Photoshop.

RIGHT: The 1999 holiday card earned enormous positive response.

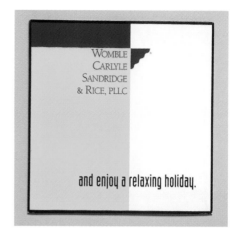

The 1999 holiday card earned enormous positive response from clients, but getting it into production was a tough sell for the design team. "Typically in law firms, the management is willing to take risks, but the lawyers in the partnership are not," says Belser. "When they are involved with crossing t's and dotting i's and the minutia of language, anything that has got this much personality, this much color, this much humor, is very frightening to them. They want to be perceived as trusted advisors, as conservators of the law. It is hard for them to portray themselves as people. That's exactly why this campaign is so successful. So, [having the] dog, which has become a symbol of the firm, illustrated and used in a holiday card rather than something that says Joy or Peace was a big leap for them."

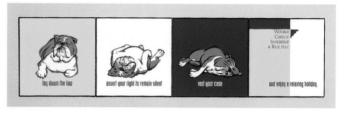

The Womble bulldog is animated in a scrolling ticker on the firm's Web site. The brand identity is so strong, it appears on virtually everything, including novelties such as a mouse pads, T-shirts, coffee mugs, sweatshirts, and golf balls. Womble Carlyle's stationery is the one place where the renowned bulldog does not appear. Likewise, a gusseted pocket folder doesn't feature the bulldog on its cover, but places him on the back with the company's name and address.

BELOW: The look of Womble Carlyle's stationery is the one place where the renowned bulldog does not appear.

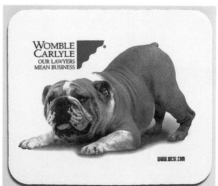

ABOVE: A gusseted pocket folder doesn't feature the bulldog on its cover, but places him on the back with the company's name and address.

ABOVE: The brand identity appeared on everything, including novelties such as a mouse pads, T-shirts, coffee mugs, sweatshirts, and golf balls.

# The results

Some of the time spent in attention to detail and molding Winston into a dog that will reflect favorably on Womble Carlyle may seem excessive, but it has paid off in a dramatic increase in name awareness proven by research that has led to strong regional growth. Moreover, the firm grew from 175 to 360 lawyers and opened three additional offices since the campaign began.

## Awareness Soars

In the summer of 2000, Greenfield/Belser conducted follow-up research on name awareness in Atlanta, Washington, D.C., Research Triangle Park, North Carolina, in addition to the three cities tested in 1995 throughout North Carolina. While other firms ranked in low percentiles, Womble awareness spiked in the 25 percent to 60 percent range, a variance Belser attributes to heavier media buys in Charlotte and Atlanta that saturated the marketplace compared to the other target cities. "If I had just gotten a 25 percent—if that were it alone—that would have been enormous, but in some cases, we had 60 percent," says Belser.

In the fall of 2000, Greenfield/Belser conducted three focus groups in Charlotte, Washington, D.C., and Atlanta consisting of ten to fifteen participants including buyers of legal services, both in-house and general/corporate counsel, and CEOs. Among the ads shown, the Womble ads ranked the most popular and the design firm was gratified to discover that the ads communicated exactly those qualities they hoped they would.

## What Worked

"Branding takes years to be effective. Branding works only when the message is presented consistently in hundreds of impressions on the reader. Few firms have mustered that degree of stamina. We see it only in firms where all or most lawyers have internalized the brand promise and have begun to live it and that happens only in firms that practice constant and effective internal communication. A brand is a distinct identity that holds a promise of value that is different from any other. Creating a brand for a law firm is the process of burning a personality into the long-term memory of the business community.

"…A successful promotion communicates a market position with unbridled enthusiasm," adds Belser. "This dog doesn't look very enthusiastic…but he is a powerful image [that delivers] an incredibly simple message for busy readers. We sell at heart level versus head level. A great campaign has a great personality, and it has heart."

# CELEBRITY SPOKESPERSON TAKES THE DRAG OUT OF MEETINGS

(spokesperson graphics)

## The Client

"Make it work!" That was the dictate from WebEx's David Thompson, director of marketing, when he suggested designers at Free Range Chicken Ranch construct a consumer campaign to get the word out about California-based WebEx Inc. prior to the dot-com's initial public offering and use transvestite RuPaul as the spokesperson.

CLIENT:
WebEx Inc.

DESIGN FIRM:
Free Range Chicken Ranch

ART DIRECTORS:
Kelli Christman, Toni Parmley

DESIGNER:
Kelli Christman

PHOTOGRAPHERS:
Nadulli (retouching),
Alan Purcell (photography)

COPYWRITER:
Barry Feldman

CAMPAIGN RUN:
January through April 2000

TARGET MARKET:
Business professionals

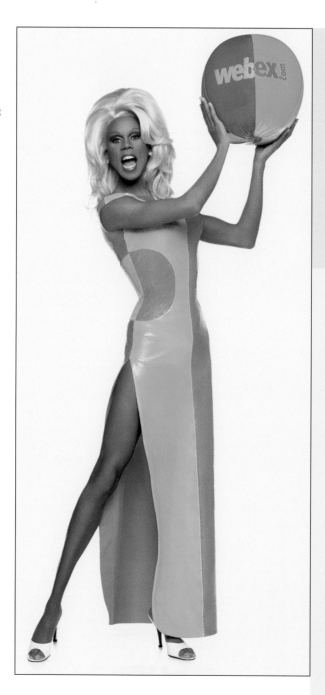

## The Brief

Designers walked away from the meeting wondering how they were going to pull this off. Sure, RuPaul had the potential to create a stir, but could the 7-foot (2 meters) tall diva with big, blond hair and seemingly unending legs drum up enough interest in WebEx pre-IPO to drive people to its site? WebEx promised to spend millions on the campaign to launch its service, which allows people to meet on-line and share documents and files instantaneously, and yet, designers were being asked to use a famous drag queen to pitch a serious business. The message and the messenger seemed at odds. Could they make it work?

They brainstormed and arrived at a solution: Meetings can be a real drag. Voilá, the RuPaul connection. Designers agreed, it was different, wild, and out there, but it could work. "We told Thompson, 'There's no way we're going to get this past your CEO,' who is pretty conservative…We didn't think there was any way he was going to accept RuPaul. David just kept telling us, 'That's why you have to make it work,'" says Toni Parmley, art director.

LEFT: **This image of RuPaul with a clipping path appeared in many of the PR placements as well as a direct-mail piece produced by Free Range Chicken Ranch.**

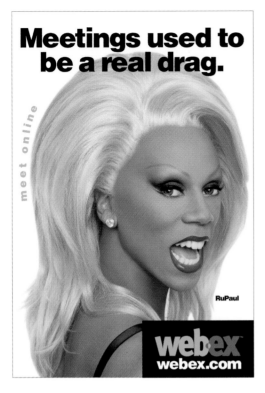

# Meetings used to be a real drag.

meet online

RuPaul

**webex**
webex.com

LEFT: RuPaul's image, coupled with the WebEx message, adorned city buses as well as bus transit shelters.

BELOW: Outdoor advertising appeared in all shapes and sizes, each requiring different production techniques. Here, this 48' x 14' (14.6 x 4.3 meters) billboard with extensions to accommodate RuPaul's head and feet in stiletto heels is relatively small when compared to other outdoor advertisements that varied in size from 20' x 40' (6.1 x 12.2 meters), 22' x 32' (6.7 x 9.8 meters), and 86' x 78' (26.2 x 23.8 meters) to enormous triple wall advertisements.

When asked what challenges they faced creating this campaign, designers enumerate them quickly—the rushed production schedule and, most notably, working with a celebrity the likes of RuPaul.

### Getting the A-Okay

"RuPaul is very professional and you get everything you want from him," says Christman. "He took direction well and was great to work with." But as anyone knows who has worked with a celebrity, they require approval on everything, which can slow production down to a frustrating crawl when time is of the essence.

Designers worked around RuPaul's schedule and closely with his agent to secure approvals on everything from the promotion's concept, script, and copy to the final images. "He wants to look good...as I'm sure most celebrities do, but he takes a little bit more work," says Christman, citing the amount of airbrushing needed and the fact that a team of very detail-oriented people were involved in the approval process. "Six people needed to see stuff and sign-off everything, and Ru was one of them, which was difficult given the time restraints."

"In all the process took three to four times longer than an otherwise normal approval process would expect to take," adds Parmley.

### Selling a Spokesperson

They finalized the campaign's theme—"Meetings Used to be a Real Drag!"—and rolled out the promotion before WebEx's CEO, who wasn't familiar with the drag queen diva. He loved it.

Designers especially liked the selling points of the promotion. Visually, they had signed a well-known celebrity, yet RuPaul isn't exactly a household name. Like WebEx's own CEO and a multitude of consumers, RuPaul, at a statuesque 7 feet (2 meters) tall with a sexy purr and wardrobe to match, is simply an attention getter—a factor that had the potential to hinder the campaign; yet, it was this mix of celebrity and unknown that appealed to the designers. There are going to be a lot of people, designers surmised, who won't have a clue that she is a he and won't get the "drag" pun, but that was a risk they were willing to take.

"It came about at a time when celebrity spokespeople were being used in a very serious fashion... We wanted to come out with Ru, who is funny, and make fun of that whole dot-com approach to using celebrity. We wanted to do something really different and use a celebrity that was just outrageous," Kelli Christman, art director and designer on the project.

### The Art of Compromise

Designers liked using full-shots of RuPaul, which showed the performer's best assets, but not every advertising format lent itself to full body poses that exposed Ru's glamorous gams. "It was definitely a design challenge," explains Christman. "When shooting various formats of photography for outdoors, we wanted to make sure everyone knew it was RuPaul, but in some formats, without a full body shot, he is not always recognizable."

Similarly, the television shoot was a study in compromise. Designers wanted a director who was an expert at humorous spots, while RuPaul's group favored a director who was skilled at shooting fashion-oriented glamorous spots and music videos. "We had to compromise. They okayed our director as long as the director of photography was one of their glamour guys. They ended up working well together. We had the humor and RuPaul was lit well, too," says Parmley.

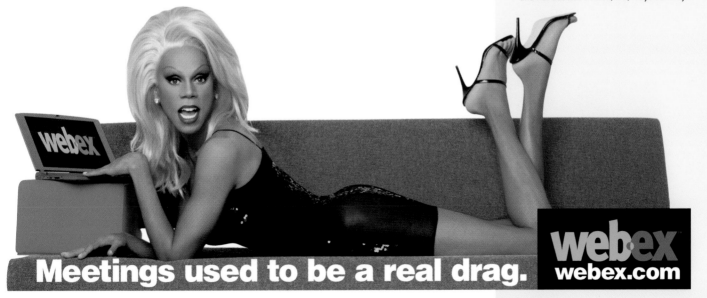

webex

**Meetings used to be a real drag.** **webex** webex.com

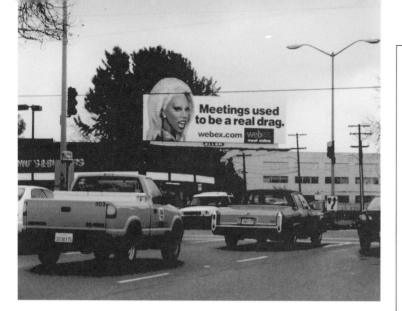

### Risk Taking 101

The campaign would kick off with a live appearance by RuPaul in December, followed by a TV spot to air in major markets during the January 30 Super Bowl, costing about $1.2 million for the time alone.

The highly visible commercial would, in turn, trigger phase two of the campaign—Web Attack, a New York party that would culminate the campaign, two radio spots to launch the Monday following the Super Bowl and run through May; a series of print ads scheduled for monthly magazines March through May; and outdoor advertising in the San Francisco Bay area January through June, on New York City walls and buildings during February and March, and on New York buses in April.

Reinforcing the advertising blitz would be a direct-mail campaign as well as a comprehensive public relations effort. The sum total of which represented a lot of details to pull together over a period of approximately six weeks including the week between the Christmas and New Year's holidays.

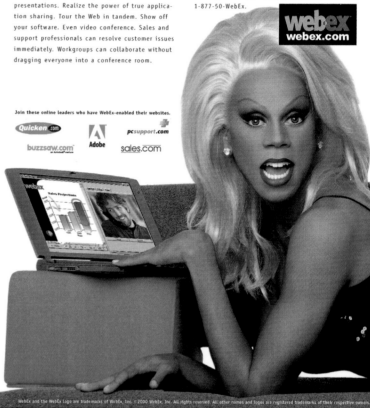

## Meetings used to be a real drag.

Forget about dashing off to endless meetings and meet online instead. Thanks to WebEx, a browser is all you need.

Then you can pitch your products with live presentations. Realize the power of true application sharing. Tour the Web in tandem. Show off your software. Even video conference. Sales and support professionals can resolve customer issues immediately. Workgroups can collaborate without dragging everyone into a conference room.

See for yourself why over 600 corporations like Ricoh® Canada, Full Spectrum® Lending, and Resumix® are already using WebEx Meeting Center. Meeting-enable your website at WebEx.com or call 1-877-50-WebEx.

webex
webex.com

Join these online leaders who have WebEx-enabled their websites.

Quicken.com    buzzsaw.com    Adobe    pcsupport.com    sales.com

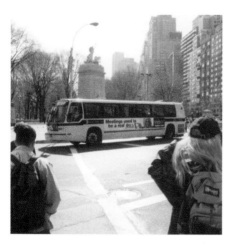

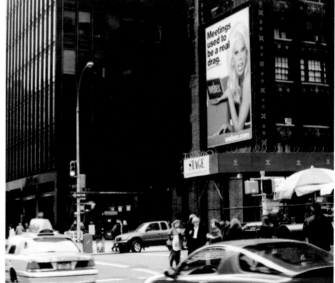

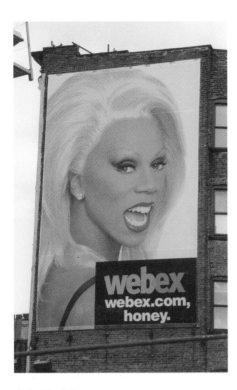

## A Rush Job

Using a celebrity was the biggest challenge, Christman and Parmley agreed, but running a close second was the rushed production schedule during the end of the year holidays that allowed little time to create and produce a multimedia campaign. The team executed the first step—an initial photo shoot—the second week of December 1999. With holiday parties, offices closures the last week of December, and RuPaul's busy schedule competing against one another, designers had to grab production time wherever and whenever they could. In fact, after the initial photo session, they snuck in additional shots between takes of the television commercial.

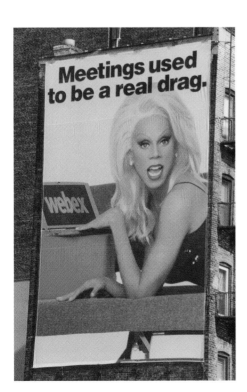

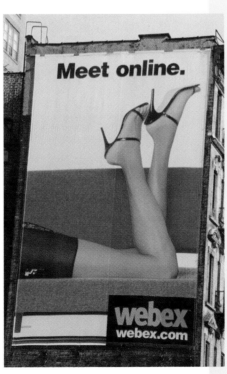

# "Tinsel Talk" — 60-Second Radio Spot

| | |
|---|---|
| **Mick:** | Hi, Mick Martin here with another edition of "Tinsel Talk" bringing you superstar RuPaul. Ru, I wish our radio audience could see how gorgeous you look today. |
| **RuPaul:** | Aren't you sweet? |
| **Mick:** | Hey, tell me Ru, what's the life of a supermodel like? |
| **RuPaul:** | (sigh) Meetings...with agents, directors, designers ...all kinds of people, all the time. But now I can take care of all that at home in bed. |
| **Mick:** | (Alerted and a little scared.) Well, maybe we shouldn't talk about that while we're on the air. |
| **RuPaul:** | Oh, no honey, we should talk about WebEx. The service has saved me from a life of meeting hell. All I need is a browser and I can take care of all my business in real-time. |
| **Mick:** | Well yes, you can buy stocks or get a book, but surely you can't work together on costumes or scripts with this WebEx thing. |
| **RuPaul:** | Indeed you can my sexy man. You can dazzle customers with sassy sales presentations, give spectacular software demos, tour the Web in tandem... Sweet thing, you can even videoconference. So do you see now why meetings are no longer a real drag? |
| **Mick:** | A real drag. Good one, Ru. |
| **Announcer:** | Meet on-line at W-E-B-E-X-dot-com. WebEx. We've got to start meeting like this. |

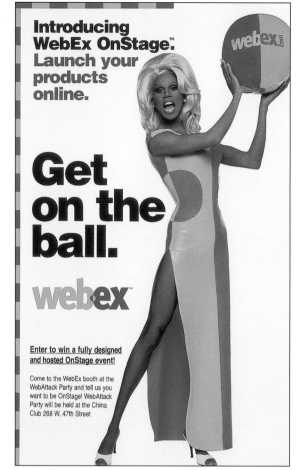

### A Learning Experience

The television commercial and radio ad were firsts
for the team at Free Range Chicken Ranch. "It was
our first TV experience. We're working with a celebrity
and it was for the Super Bowl. We had just a little
bit of pressure," laughs Parmley. "Our client just says,
'of course you can do it.' He had no qualms about us
being able to pull off anything."

### The Budget

WebEx's confidence in Free Range Chicken Ranch was
justified. The design team exhibited plenty of savvy,
not only in their creativity, but production-wise as
well. The budget was a little low for a thirty second
television spot, but the commercial director liked the
script and wanted to work with RuPaul, which gave
designers some leverage in negotiating the price. The
director gave them a deal on his fee as well as costs
from his production house; in turn, he got the job
and was able to use the spot on his promotion reel.
As a result, the television commercial was quite cost-
efficient—particularly for the first-timers.

It was a learning experience for everyone involved,
including WebEx, which had never worked with a
celebrity spokesperson or funded a television spot
either. "When you do print jobs...if your costs go over,
it is so minimal compared to TV. It is a huge budget
that you're dealing with," adds Christman.

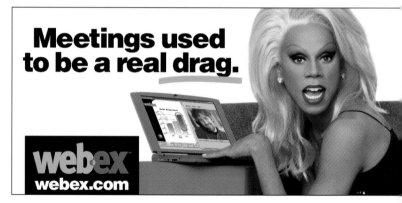

ABOVE: Designers also produced
outdoor posters such as this
thirty-sheet billboard.

BELOW: RuPaul's image, coupled
with the WebEx message, adorned
city buses as well as bus transit
shelters.

# The results

When the promotion officially ended in spring of 2000 and the results were tallied, everyone was astounded and very pleased. WebEx's revenue increased 269 percent or $6.8 million. Customers increased 200 percent to a total of 1130 paying customers including such influential names as AT&T, Global Crossing, and Oracle. Partners also increased 200 percent to 133 distribution partners including Yahoo, SAP, and Deutsche Telekom. The number of meetings conducted on webex.com also boomed, numbering more than 3000 per day, an increase of 400 percent.

The public relations effort netted numerous winning placements. Stories on WebEx on-line meetings, mentioning the RuPaul connection, appeared in a approximately ten national magazines including *Forbes*, *Fortune*, *Business Week*, and *Entertainment Weekly*. Daily newspapers also ran the story including the *Los Angeles Times*, *Houston Chronicle*, *Boston Globe*, and *San Francisco Chronicle*, while *USA Today* ran the story on its cover and the *Guardian*, in the United Kingdom, gave it ink as well. The story was a hit on the airwaves, too. National Public Radio aired the story on "All Things Considered," while various local television stations also took notice. "The PR was very effective," says Parmley, pointing to placements that appeared prior to and after the Super Bowl commercial.

### What Worked

"[The promotion] made a huge splash and did everything it was supposed to do. They did an excellent media plan that hit key spots, and I feel that even though they didn't have a ton of money...to blast it everywhere, they made a lot of smart choices so it was very effective," says Christman of the PR effort. "A lot of people kept telling us, 'He's everywhere,' despite the fact that it was a very short-lived campaign. You couldn't turn around and not see RuPaul. He was truly around a lot and even though it was such a short time, the budget was adequate to blast out in those few months."

# DESIGNERS BUILD IDENTITY (digital graphics)
# AND INNOVATIVE PRODUCT FROM SCRATCH

## The Client

Adomo, then known as BV2000, approached Diesel Design with the idea of promoting Walk by Computing for the home—a wirelessly networked, sleek, slim network that connects to virtually everything from the home stereo to the microwave and networks all the solutions, while offering e-mail, an address book, and many more conveniences tailored to individual family members. Not only would Adomo's system enhance family life, it would be affordable to the target audience, simple to set up, and easy to use. The product would be sold as a package, much like WebTV or DirectTV, through computer and high-tech gadgetry retailers. The idea sounded great—but the company lacked an identity and a product.

**CLIENT:**
Adomo

**DESIGN FIRM:**
Diesel Design

**ART DIRECTOR:**
Jeffrey Harkness

**DESIGNERS:**
Amy Bainbridge, Josh Glenn,
Aaron Morton, Shane Kendrick

**ICON ILLUSTRATION:**
Amy Bainbridge

**CAMPAIGN RUN:**
February 2000 to Present

**TARGET MARKET:**
Primary Audience:
Consumers: Technology-savvy, affluent consumers, with one or more children 8 to 18 years old.

Secondary Audience:
Investors/partners

logo.01

logo.02

logo.03

logo.04

logo.05

logo.06

logo.07

logo.08

logo.09

logo.10

ABOVE: **Twenty logo treatments were presented for review, which ran the gamut from pure type logos to those with a house and several that used high-tech imagery such as a computer chip. Logo choices one, three, and five were selected for round-two modifications.**

## The Brief

Diesel Design's concept behind the entire Adomo campaign was to enforce a brand that would differentiate Adomo from other standard home applications. The goal: Make Adomo's product a major departure from the conventional way people store and access data and media in their homes.

Their thinking had to target families who own multiple computers and digital devices with DSL/cable Internet access in the United States, particularly the San Francisco Bay area of California, before expanding to target a similar demographic in Denmark, and eventually, a global audience. At the same time, the campaign had to speak to investors and partners, including software developers, Web-based service providers, wireless device manufacturers, and distributors, many of which are Danish due to Adomo's roots.

Because the message had to speak to so many diverse audiences, designers knew the message had to be presented cleanly and elegantly while being compelling, friendly, and intelligent. To ensure they developed a targeted identity, designers put the project through Diesel Design's standard five-phase creative process.

RIGHT: The final logo symbol-
izes a family and the many
lives that revolve around a
common solution at its cen-
ter. Designers colored the
logo in shades of gray and
blue since the palette is uni-
versally recognized as sym-
bolizing a corporate nature
and because they echoed
Danish trends in design
where lines are very clean.

Adomo

## The Creative Process

### Phase I: Discovery

First, they delved into the discovery phase, which
helped designers define and access their client's vision,
needs, and ideas. Through this discovery phase it
became apparent that the new Adomo brand should
communicate elegance, a family lifestyle, and ease of
use. Adomo would in turn work with product designers
to create a sleek packaging/product design to ensure
cohesive branding. During this phase, designers sug-
gested replacing the name BV2000 with a new
moniker—Adomo—from the word adobe, meaning
home, house, or living space.

### Phase II: Define

Next, they defined the identity through conceptualized
storyboards that presented the overall positioning.
The storyboards also served other purposes—they
helped ensure that the messaging was correct and
allowed designers to test the appearance of different
identities. The storyboards included rough concepts
of how the logo would play out on everything from
a Web site to T-shirts.

### Phase III: Design

With twenty logo treatments presented for review,
the project officially entered the design stage; Diesel
Design asked Adomo to choose their top three prefer-
ences. There was little concern that twenty choices
were too many; designers felt that they needed to
show all the possible treatments, which ran the gamut
from pure type logos to those with a house and several
that used high-tech imagery such as a computer chip.

"We helped them narrow it down by pointing to the stronger ones," says Amy
Bainbridge, designer, Diesel Design. Adomo chose three, which designers modified
and refined, before the final version was approved—one that symbolizes a family
and the many lives that revolve around a common solution at its center. Designers
colored the logo in shades of gray and blue since the palette is universally recog-
nized as symbolizing a corporate nature and because the colors echoed Danish
trends in design where lines are very clean. Colors were also kept understated to
ensure they would complement each of Adomo's products.

### Phase IV: Deployment

Designers placed the final choice onto the letterhead, business card, envelope, and
mailing label, producing separate versions of the letterhead and mailing envelope
to accommodate the different sizes commonly used in the U.S. and Denmark. With
client approval, the identity system went into the deployment phase, where design-
ers oversaw the print production.

### Phase V: Delivery

Finally, they launched the delivery stage, where the corporate system and logo were
delivered to the client. Similarly, Adomo's marketing brochure was created to target
a family audience, not just potential partners and investors.

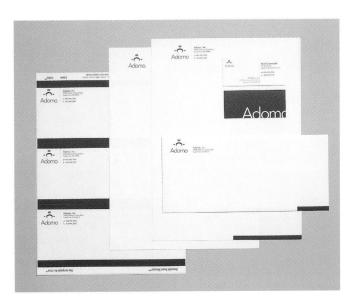

RIGHT: Designers placed the
final logo onto the letter-
head, business card, enve-
lope, and mailing labels, pro-
ducing separate versions of
the letterhead and mailing
envelope to accommodate
the different sizes commonly
used in the U.S. and
Denmark.

## Taking the Message Beyond Print

In addition to the brand identity and letterhead system, Diesel Design created a multipurpose brochure for Adomo, along with the company's Web site, and trade show booth before tackling the ambitious task of the graphic user interface (GUI). Interestingly, the promotional elements in this campaign were deliberately kept to a minimum for both strategic and economic reasons. This minimalist approach parallels the graphic style and is a good example of the new thinking that start-up companies are employing in today's electronic marketplace.

The marketing brochure was designed to serve several purposes. Foremost, it was designed to direct end-users to Adomo's Web site, where they could access the demo as well as product and purchasing information. It was created to function as a direct-mail piece and as the only hand-out at trade shows and was used both in the U.S. and overseas. Light in content, yet specific in the messaging, the brochure has enough built-in visual appeal to motivate users to visit the Web site, which was engineered to do the bulk of the selling. Adomo didn't have a lot of money to sink into its marketing effort, yet wanted to appeal to an upscale audience. Rather than allocating funds to several smaller sales pieces or trade show gimmicks, designers urged the company to invest a sizeable share of the budget into a single marketing brochure that would appeal to its upscale audience. By assigning the brochure multiple jobs, they were able to maximize the investment and keep the marketing effort as streamlined as the graphics.

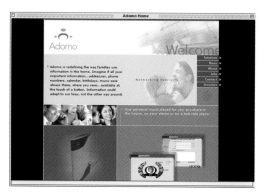

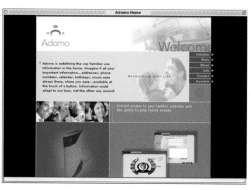

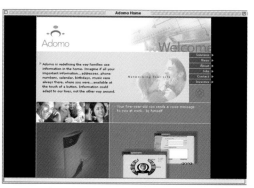

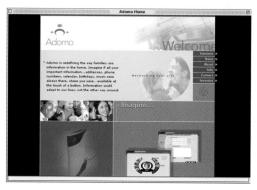

**RIGHT AND BELOW: Adomo's marketing brochure was created to target a family audience, not just potential partners and investors.**

In addition to the brochure, two e-mail campaigns orchestrated by Adomo were the only other efforts that promoted the Web site and trade show attendance; traditional print advertising was deliberately omitted from the mix.

Distinguishing the Web site, is an animated GIF on the home page and an abundant use of color on all the pages that follow—in stark contrast to the simple blue and gray logo, which was a deliberate design choice to attract family members to the site. The layout uses a grid system based on Danish design. Here, the client was not as concerned about a corporate look. Instead they wanted to target the changing family lifestyle with clean colors and focused imagery.

Designers used a simple grid to divide trade show booth walls and applied colors and images (stock and client supplied) that were similar to the Web site.

### Creating an Identity Based on a Concept

Putting an identity on a product that did not yet exist as a tangible, usable interface was among the toughest jobs that faced the design team. In the beginning, it was very conceptual. The idea was there, but Diesel Design had to bring it to life. Designers did this by analyzing the market Adomo was entering, and drafting a visual brand that would reach this sophisticated family audience, as well as potential investors and partners. The logo provided a platform for the growth of a complementary color palette and a tightly knit grid design with a definite Danish influence. This, in turn, provided a look and feel that could roll into every element in the campaign.

The fact that this product presents a new way of storing and accessing media in the home, as well as a new way for families to communicate means the audience needs to first be educated on the product, and then be sold on it as well. "Translating the product into a friendly, easy-to-use system was a huge challenge. Particularly with the GUI—this was a very inventive process. There was no existing model that combined so many features in such a way," says Bainbridge. A solution grew out of a collaborative effort between the Diesel Design team, and Adomo's business development and marketing managers, engineers, and product designers. The process involved conducting internal focus groups, client alpha tests, and feedback channels that helped lead to a more polished end product with all deliverables in the campaign.

### The Budget

Due to the fact that Adomo is a privately funded, early stage start-up company designers worked within a lean budget framework. According to Bainbridge, they were able to accomplish so much despite limited funds because of the client-service relationship Diesel Design formed with Adomo. "It is our philosophy at Diesel Design that maintaining an internal environment that fosters teamwork, passion, and vision, helps us to develop strong partnerships with our clients. When you are passionate about what you are creating, the end result is always more successful. Adomo was able to put their trust in our design expertise, and because of that we were able to streamline the process and cut costs by cutting time," she says.

Similarly, when designers began creating the trade show booth for the big Linux World Show, color was a big issue. A ready-made layout was given to designers, who had to establish a look and feel for the booth and find appropriate imagery—which sounds easier than it was. In actuality, this job was more restrictive than anything else they had done, but because designers had already used a grid layout system with the Web site, they applied it to the booth as well. They used the simple grid to divide walls and applied colors and images (stock and client supplied) that were similar to the Web site. They finished the job in approximately three weeks, and the result stood out amid the crowded trade show floor.

When it came time to design the graphical user interface (GUI), designers encountered a very unique challenge. The user interface expanded to target an audience that included an age range broader than almost any other interface—family members ranging from eight-year-old children to eighty-year-old grandparents, while taking into account the needs of engineers at Adomo

BELOW: The Web site layout uses a grid system based on Danish design. Here, the client was not as concerned about a corporate look. Instead they wanted to target the changing family lifestyle with clean colors, and focused imagery.

whose job it was to implement the design. It meant simplifying without losing the intelligence of the software but also providing some extra kid-friendly visual elements without turning off the adult audience. Designing the graphic user interface was an enormous undertaking, so designers broke it down into small, manageable projects, tackling one category of the interface at a time, beginning with the message center, calendar, to-do list, music section, and so forth and approached the job like designing a Web site, using Adobe Illustrator, Adobe Photoshop, and Macromedia Fireworks. To navigate the system, family members simply click on their pictures to toggle between users.

"The use of Adomo-branded colors, icons, grid, and photographic treatments helps tie all the pieces in the campaign together. With this basis, a full team of designers at Diesel Design is able to integrate each piece while at the same time adding their own flair to the individual campaign elements. This is how the campaign successfully carries a very clear theme into each distinctive medium to attract a wide-ranging audience," Bainbridge adds.

# The results

"The best measure of success is the degree to which we have been able to communicate our idea to potential partners and customers. Adomo's product is a major departure from the conventional way people store and access data and media in their homes. A major challenge is to bridge a gap between the familiarity of some of the functions [such as] music [and] e-mail while demonstrating that this was a big change from the typical computer-based models. I feel that the look and feel of the corporate image pieces have done this very well," says Marc Prioleau, vice president business development, Adomo.

The daily graphs generated by Adomo's Web-usage summary show the typical traffic to their Web site at approximately 200 to 400 requests per day (HTML pages). Higher numbers were generated around the trade show. These numbers have remained consistent since the Web site's February 2000 launch, according to Bainbridge. In addition, the promotion is credited with helping Adomo generate opportunities to demonstrate the Adomo system to investors to secure funding for the company. The company has received positive press coverage and solid results at the Linux World Show.

## What Worked

"This campaign worked ultimately because of the open communication Diesel Design developed with Adomo. Adomo allowed Diesel Design to take the lead on a wide array of projects. We were able to form an excellent understanding of Adomo's product, and turn that into a clearly communicated, distinguished brand," Bainbridge concludes.

# EDGY GRAPHIC CAMPAIGN PRESENTS A NEW WAY OF SELLING

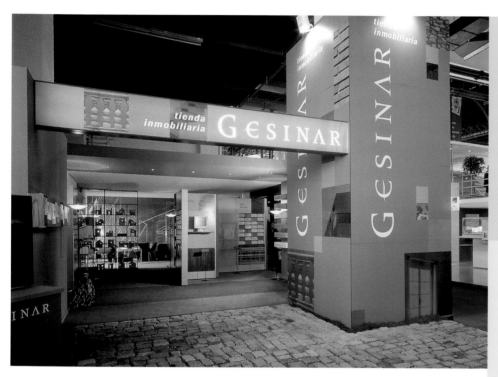

### The Brief

Gesinar wanted designers to help them create an environment that would be more like a shop than a standard real estate office. Gesinar's vision allocated eighty percent of the space to customers' free autonomous use; customers could research and select information directly from computers and printed information sheets available from specially designed panels. Employees working on the acquisition, management, and sale of real estate would occupy the back of the office; yet, the staff would need to access the whole shop to walk customers through the purchase process.

"Up until this point there had not been a company in the real estate trade that used the word 'shop' (tienda inmobiliaria)," says Jorge García, art director. "Our concept was to take this basic high street principle and apply it to real estate. The customer would be able to see and consider properties as products in a regular shop available to buy—a completely fresh approach in this particular market. Finally, we used the product as a starting point for design solutions, utilizing architectural forms throughout the design process."

**CLIENT:**
Gesinar

**DESIGN FIRM:**
Tau Diseño

**ART DIRECTOR:**
Jorge Garcia

**DESIGNERS:**
Jorge Garcia, Francisco Ortigosa

**ILLUSTRATOR/PHOTOGRAPHER:**
Francisco Ortigosa

**ADVERTISING AGENCY:**
Sintesis

**VIDEO PRODUCTION:**
Video-on

**CAMPAIGN RUN:**
1999 to Present

**TARGET MARKET:**
General Public

### The Client

Imagine shopping for real estate like you shop for books, groceries, or clothing in a wide-open, well-lit retail space with all the product information you need at your fingertips and salespersons available when you need them. It's no dream for real estate buyers in Spain, who now enjoy the convenience of visiting a real estate shop when they are looking for their dream home or office location.

The innovative idea came from Gesinar, a real estate company that is owned by the second most important financial group in Spain, BBVA, which has branches in various Latin American countries. Gesinar tapped Tau Diseño and assigned the firm the task of crafting a globally coordinated image for a chain of real estate stores the firm planned to open throughout Spain.

ABOVE AND BELOW:
**Designers adapted Gesinar's retail interiors for use as a trade show booth.**

### A New Way to Shop

"The origin of our objective was derived from the premise that the real estate trade usually builds their outlets focusing on their corporate needs, rather than focusing on the leading character of the business. Thus, Gesinar decided to create places for the real estate consumer; the customers themselves, and also incorporate the consumer experience into our shops," says Ricardo García, marketing director of Gesinar. "We formulated a plan to organize the shops into different consumer areas along the lines of the standard high street shopping model. Next, we needed to build on these preliminary ideas with a fresh and creative approach.

"The result was the real estate shop—a new category in this trade—a place to meet the exclusive needs and requirements of our customers, something which would be an obvious and fundamental principle in other market sectors, but which has represented a minor revolution within ours."

### Establishing Objectives

Based on the task, Tau Diseño established two objectives: first, create a new style radically different from similar stores, and second, design the stores in a manner that allowed the clients to inform themselves without needing the help and constant attention from sales people.

To achieve their goals, designers decided that Gesinar's shops required a distinct graphic style that could be applied as easily to the interior design and furniture as the corporate identity manual so that all the elements would work as a cohesive whole throughout all the franchised stores.

### Choosing a Name

The first step toward a new visual identity was settling on a name and several were considered including Domus and Gesinaria among others. The final choice was Gesinar Tiendas Inmobiliarias, meaning real estate shops. Typography, a principle color scheme, and basic materials were chosen and approved quickly in keeping with the strict deadline.

### Keeping the Look Consistent

The most challenging aspect of the project from a design perspective was to make the final design one that all the staff involved with the project could make their own. The work process included contributions from the various different architects and other technical support personnel contracted by Gesinar to construct the shops. "The task of maintaining cohesion between all the various elements of the new Gesinar design throughout the varied forms and outlets to which it was applied was without doubt a difficult one, and it certainly deserves mentioning that the design received useful practical contributions throughout the design process from some of the architects involved in the project," says Jorge García.

"Dialogue was of paramount importance throughout the project; we could not lose sight of the complementary (and sometimes difficult) relationship that can exist between architects and designers which can result in conflicting approaches to the final realization of a project such as this."

TOP: **A video ran on television screens in shop windows, stopping passersby in their tracks and encouraging them to enter the shop.**

BELOW: **Designers adapted Gesinar's retail interiors for use as a trade show booth.**

# Gesinar
## UN *Equipo* IDEAL

### Creating a New Image Based on an Old One

The old graphic identity couldn't be used; it was overly complicated and not suitable for the new store project. However, the transition—basing a new image on an old one—while making it modern, attractive, and efficient for application throughout the system proved tricky. "The idea was to create stores radically different from those already existing in the marketplace. We wanted to create a new attractive style, which would invite potential clients to enter and make consultations freely and easily," says Jorge Garcia.

### The Branding

Designers solved their dilemma by creating a new visual identity based on a variety of elements as opposed to just utilizing one unique element, which can often be the case with other logos. They used a variety of easily recognizable colors and images, related to architecture and construction, which allowed designers to mix and match colors for lots of combinations that worked across all applications from shop interiors to printed matter.

Twelve architectural photographs were chosen to compliment a total of eight colors, providing a variety of combinations. Images were selected to represent a different sector of the real estate market and appeared in color when used in conjunction with the Gesinar logo or grayscale when used on larger displays. The images themselves were used across all aspects of the Gesinar Tiendas identity from brochures to interior panels. Designers created the logo using the font Meridien and customizing it to their needs. All the elements of the branding converge in the shop sign, designed as a multicolored light strip.

Finally, designers included some specific architectural elements, including panels that divided the space into zones and small compartments of different colors for displaying product sheets containing information for renting and buying apartments and commercial spaces, spaces reserved for computers, and so on.

### Bringing the Street into the Store

Most important, they managed to create an inviting opening for prospective customers by using yet another architectural solution—bringing the street into the store. "Our company started to work with the idea of a space that would openly invite passers by to enter. This central idea led to…creating a simple, free, and transparent environment that would be the antithesis of the standard real estate office," explains Francisco Ortigosa, art director. "The second general concept was the idea of a pathway that could lead prospective customers clearly through the properties on offer from the most economical to the higher ends of the market. The customer would be free to browse at this stage without the aid of an employee."

While working on the branding, designers simultaneously brainstormed how the shop would look and the how it was going to work.

TOP AND BOTTOM RIGHT: **Inside the threshold, a blue floor to ceiling band forms both an instantly distinctive aspect of the shop and an open invitation for passers by to enter.**

FAR RIGHT: **The self-service area is one of the most characteristic aspects of the Gesinar shops, featuring a large set of folding panels that function as space organizers and as containers for property information sheets, which are color coded for easy reference.**

BELOW: **Television commercials place a Buston-Keaton type of character in typical situations encountered by individuals selling their homes. The actor never speaks; instead a voice-over expresses the Gesinar message.**

## A Walk-Through

The entire layout is very clear, open, and transparent, however, some areas required even more visibility—such as the facade, which was designed to entice customers in from the street. To get complete transparency from double filtered glass and steel wire grids, various options were devised to achieve different levels of filtration. Inside the threshold, a blue floor to ceiling band forms an instantly distinctive aspect of the shop and an open invitation for passers by to enter. During the first stages of design, the special offer area of the shop was a small nest of displays showing the most economical deals. Rather than interactive presentations, the area would display preset presentation reels controlled by a central server. As the design progressed, this developed into a vertical panel containing three monitors.

## The Pilot Store

With most of the store and its elements designed on paper, it was time to test the visual and functional solutions in the pilot store located in Madrid. With construction underway, Tau Diseño handed off the branding to an advertising agency, which took Tau's colors, typography, and images and adapted them to much needed marketing tools. The agency was given considerable freedom in executing the materials yet still retained the clean lines and modular layout that was established in the logo. The result: a brochure, a personalized letter, and a video, all of which were packaged in a custom box and mailed to potential sellers. The agency also created an elegant bound album as a special gift to customers.

The final design elements relied on simplicity to tie together individual elements cohesively. For the purely graphic elements, designers employed a limited number of components: a group of recurring colors, select images, simple, clean type layouts, and straightforward image treatments.

## The Smaller Shops

Gesinar's plan was to first build ten representative shops in separate Spanish cities and then open a second phase of smaller and cheaper outlets that would be franchised. The second phase of smaller shops would require a different take on the design solution; a pared down version just wouldn't work. The most difficult aspect of this phase of the project was retaining the principle functions of the Gesinar shop while condensing the system into a smaller area. "We concentrated on the display stands as a means of organizing the shop space, the installation of these self-standing modules allowed an orthogonal articulation," says Jorge García.

The facades of the smaller Gesinar shops have less ambitious exteriors that those of the larger premises due to both their size and budget. New color images were placed on the opaque areas of the facades as backgrounds for the logo.

Shop windows take a more conventional approach—used simply to display products and promotions. "We decided to use a modular shelf system produced in matt steel tubing that allowed multiple configuration possibilities. This system would turn out to be a major communications device with TV screens displaying offers, small easily printable boards showing special direct messages, and brochure displays. The smaller outlets facades…became a more lively, evolving, and direct area of communications than those of the big shops," says Ortigosa.

Reinforcing the objective of bringing the street into the store, a video, targeted to the general public, was produced for display on television screens placed in shop windows—all to catch the attention of passersby. The video featured the graphic aspects of the Gesinar visual identity and a Buster Keaton–style actor in a series of sketches where the actor never speaks, but uses simple gestures and little sound. Occasionally, some text about the shop appears on the screen, but otherwise the character stands alone. Sketches are separated by kaleidoscope-tweaked images of the Gesinar brand.

Television commercials produced by Video-on spread the word about this unconventional method of selling real estate on local TV and as part of a videotape distributed to potential clients to encourage them to allow professionals to sell their property. Like the comic sketches that were created to run in the shop windows, the television ads place the same actor but place him on a stark set that is transformed into different home sales dilemmas. He wants to sell his house but runs into problems solved by Gesinar.
He never speaks; instead a voice-over expresses the Gesinar message.

## The Budget

"The budget was successfully met. Although the initial stages of design were restricted to the confines of a tight deadline, the later stages were carried out within a looser timeframe," says Jorge García. "This allowed a smaller group to devote itself to design and supervision. As a consequence, the budget could be handled with maximum efficiency."

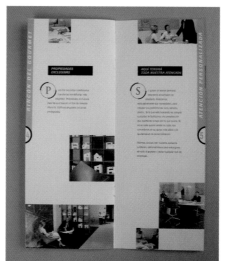

# The results

"The market reacted at first with great expectation and a little apprehension toward the concept of a real estate shop," says Ricardo García. After this brand new space, equipped with the most innovative installations, was in use, however, this initial hesitancy turned into a warm welcome, due to its undeniable functionality."

## What Worked

"Generally, every project requires an implementation period, only after which its success can truly be evaluated. In the case of Tienda Inmobiliaria Gesinar, not only did they immediately attain a unique position in the marketplace as a result of the project, but the figures following the first year's trading confirm the resounding success of the project," says Ortigosa, pointing to the fact that Gesinar now has ten stores successfully trading, generating $7.6 million of income from 3000 operations. Twenty more stores are planned for 2001.

# contributors

**AdamsMorioka**
370 S. Doheny, #201
Beverly Hills, CA 90211
www.adamsmorioka.com

**Belyea**
1809 7th Avenue,
Suite 1250
Seattle, WA 98101
www.belyea.com

**CPd—Chris Perks Design**
333 Flinders Lane,
2nd Floor
Melbourne, Victoria 3000
Australia
www.cpdtotal.com.au

**Carbone Smolan Agency**
22 West 19th St.,
10th Floor
New York, NY 10011
www.carbonesmolan.com

**Cross Colours Ink**
8 Eastwood Road
Dunkeld West
Johannesburg, Gauteng 2196
South Africa
cross@iafrica.com

**Diesel Design**
948 Illinois Street,
Suite 108
San Francisco, CA 94107
www.dieseldesign.com

**Fossil**
2280 N. Greenville
Richardson, TX 75082
www.fossil.com

**Free Range Chicken Ranch**
1053 Lincoln Avenue
San Jose, CA 95125
www.freerangechickenranch.com

**Gee + Chung Design**
38 Bryant Street,
Suite 100
San Francisco, CA 94105
www.geechungdesign.com

**Greenfield/Belser Ltd.**
1818 N. Street N.W.,
Suite 225
Washington D.C. 20036
www.gbltd.com

**HGV Design Consultants**
46A Rosebery Avenue
London EC1 4RP
United Kingdom
www.hgv.co.uk

**Hornall Anderson Design Works, Inc.**
1008 Western Avenue
Suite 600
Seattle, WA 98104
www.hadw.com

**LPG Design**
410 E. 27th Street North
Wichita, KS 67219-3556
www.lpgdesign.com

**Pepe Gimeno— Proyecto Gráfico**
C/ Cadirers, s/n - Pol. d'Obradors
E-46110 Godella
Valencia, Spain
E-mail: gimeno@ctv.es

**Plazm Media**
P.O. Box 2863
Portland, OR 97208
www.plazm.com

**Sayles Graphic Design**
3701 Beaver Avenue
Des Moines, IA 50310
E-mail:
Sayles@saylesdesign.com

**Square One Design**
560 Fifth Street NW,
Suite 301
Grand Rapids, MI 49504
www.squareonedesign.com

**Tau Diseño S.A.**
Felipe IV, 8 - 2.1
Madrid 28014
Spain
www.taudigital.com

**Viva Dolan Communications and Design Inc.**
99 Crown's Lane,
5th Floor
Toronto, Ontario M5R 3P4
Canada
www.vivadolan.com

**Volkswagen of America, Inc.**
Mail Code 4F02
3800 Hamlin Road
Auburn Hills, MI 48326

# the author

Cheryl Dangel Cullen is a writer and public relations consultant specializing in the graphic arts industry. She is the author of *Graphic Design Resource: Photography*; *The Best of Annual Report Design*; *The Best of Direct Response Graphics*; *Large Graphics*; *Small Graphics*; *The Best of Brochure Design 6*; *Then is Now*; and she is a contributing writer to *Design Secrets: Products*. Cullen writes from her home near Chicago and has contributed articles to *How* magazine, *Step-by-Step Graphics*, *Graphic Arts Monthly*, *American Printer*, *Printing Impressions*, and *Package Printing & Converting*, among others.

Cullen Communications, a public relations firm she founded in 1992, provides public relations programs for clients in the graphic arts, printing, paper, and ephemera industries. In addition, Cheryl Cullen gives presentations and seminars on innovative ways to push the creative edge in design using a variety of substrates.